Contant

p.02	子涵 Zihan Weng	@babe.weng
p.08	謝侑芯 Iris	@irisirisss90
p.14	天燈妹	@evelyn1998_
p.20	沈琪琪 377	@377.bb
p.26	謝立琪 Kiki	@kiki_hsieh
p.32	子婷 Chris	@miti391242
p.38	采兒 Claire	@claire886886
p.44	蘿拉 Lola	@chocolee0901
p.50	佳佳兒 Mimi	@mimi112023
p.56	林襄	@95_mizuki
p.62	趙宇喬·Chubby 糖	@choo7077
p.68	珍琳 Jeannine	@jeannine_chen
p.74	韻韻	@coco.8192
p.80	妮婭 Niya	@niya840325
p.86	潔晞 JC	@jie.c.0803
p.92	靡靡 Tiny	@tiny_219
p.98	婷婷兒	@lovemermaid819
p.104	黃艾比 Abbie	@abbie520520
p.110	莉亞 Liya	@liya_0715
p.116	滷味妹 Q 小桃子	@vivi02257
p.122	甄馨 Tiffany	@tiffanylin9000
p.128	魚魚 Fish	@fishhhh220
p.134	韓智恩 Nancy	@hanjren724
p.140	嘉嘉 JOJO	@kity_qq
p.146	Dora	@dora0x0
p.152	施菲亞 Feiya	@feiya131
p.158	又又 黃鈺文	@yuwenhuang0618
p.164	瑤瑤 Nita	@yao_130
p.170	嵐芯語 糖果	@lanxinyu716
p.176	奶妹 Donna	@milk__2020
p.182	小曖 Aihsieh	@aihsieh
p.188	邱比特 Judy	@judy_qqq
p.194	張嘻嘻	@qoomom520
p.200	小蜥晰	@yammy0720
p.206	汪選璇 Shan	@shan_940616
p.212	小林兒 Royi	@yiyibaby02
p.218	甜甜寶 Kawayi	@audy8261300
p.224	阿乃 Sinni	@sinni_yaya
p.230	圓圓 Cynthia	@ccynthia1996
p.236	小皮 楊心美	@zxcapple615
p.242	米娜	@mw00526
p.248	徐恩 Hannah	@tstsmyname
p.254	雲雲 Rachel	@rachel0531520
p.260	吉寶 keppel	@x334567002
p.266	陸上美人魚 & 哈霓萱	@gomyurnew
p.272	莎莎 Lisa	@lisa180883
p.278	芷涵 Han	@han48oxs
p.284	冰冰 Gina	@566gina
p.290	莉娜 Lena	@lena12_31
p.296	妍米兒 Mishonna	@a1793555
p.302	Pony	@p_on_y
p.308	優菈 Yola	@yola0703
p.314	Mi	@jtes4440
p.320	喵嗚	@miao.1027
p.326	糖小果	@candy_09_23

MEI
GIRLS
×
2020

子涵

Zihan Weng

instagram : @babe.weng

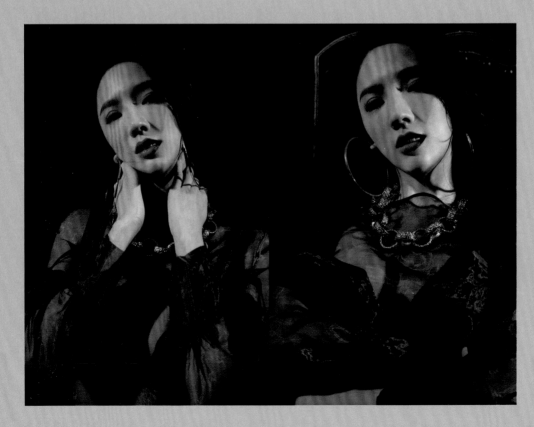

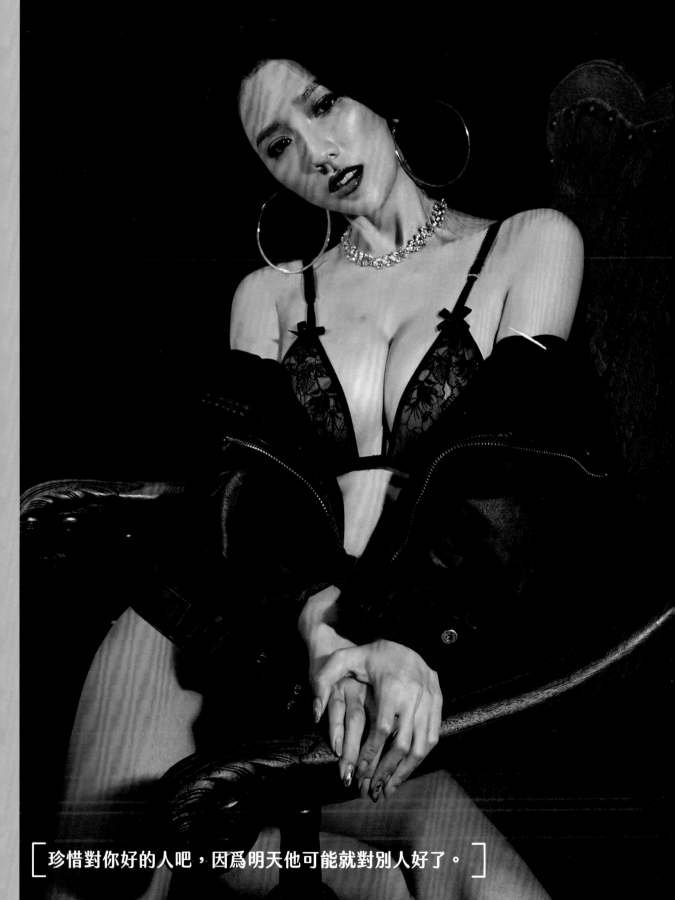

珍惜對你好的人吧，因爲明天他可能就對別人好了。

MEI GIRLS 2020

Love Is An Adventure

-

You are better than all anything

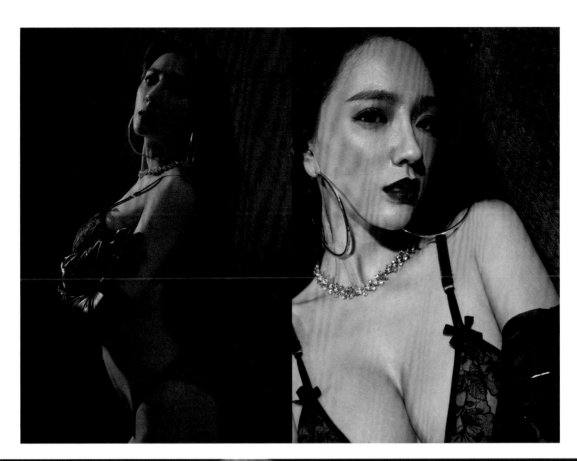

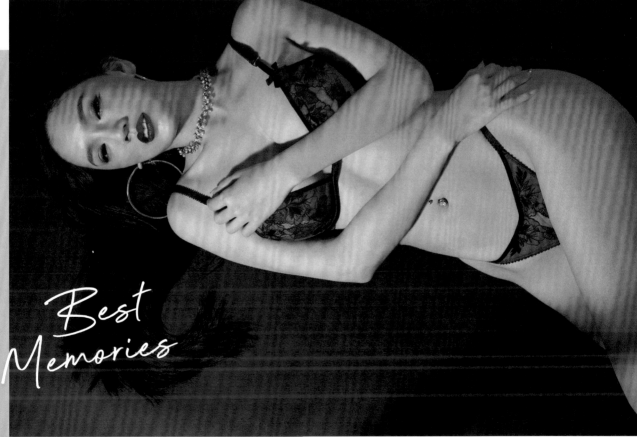

Best Memories

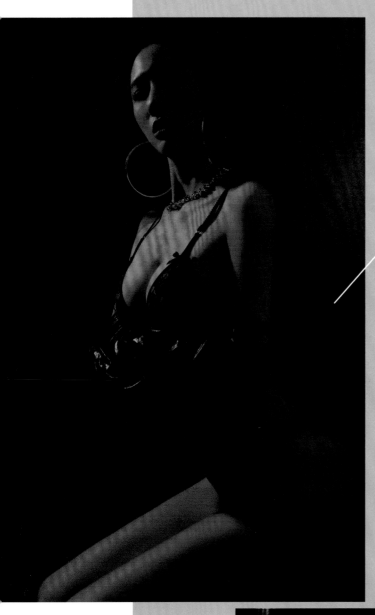

You Are
My New Favorite
Feeling.

Best Memories

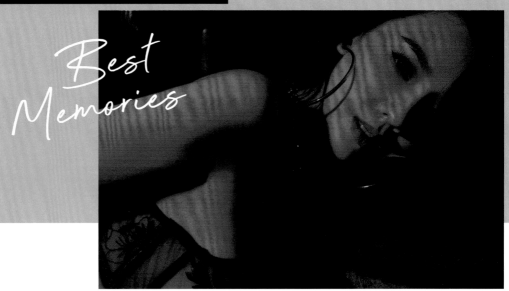

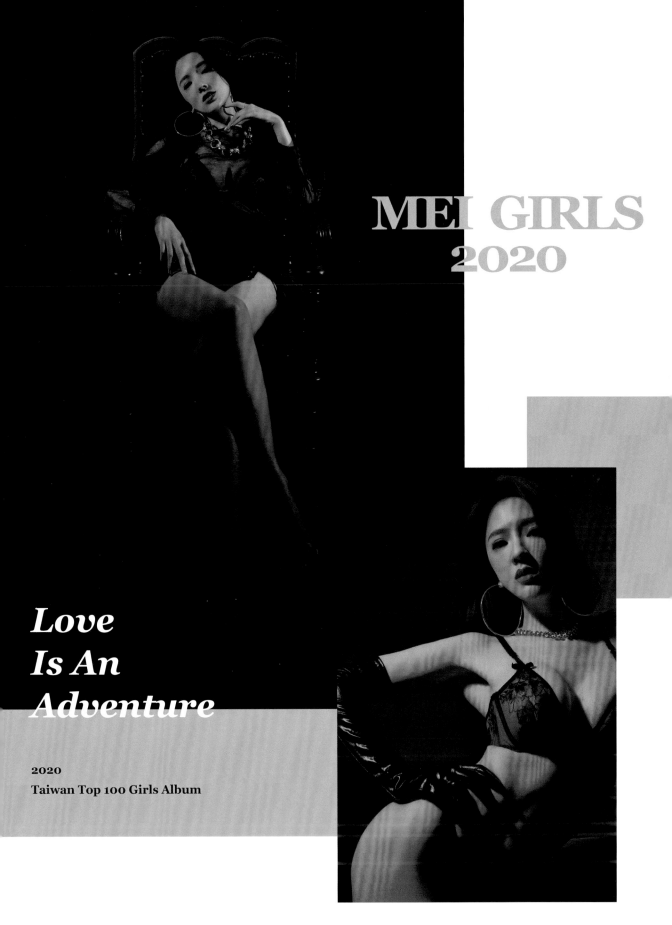

MEI GIRLS
2020

Love Is An Adventure

2020
Taiwan Top 100 Girls Album

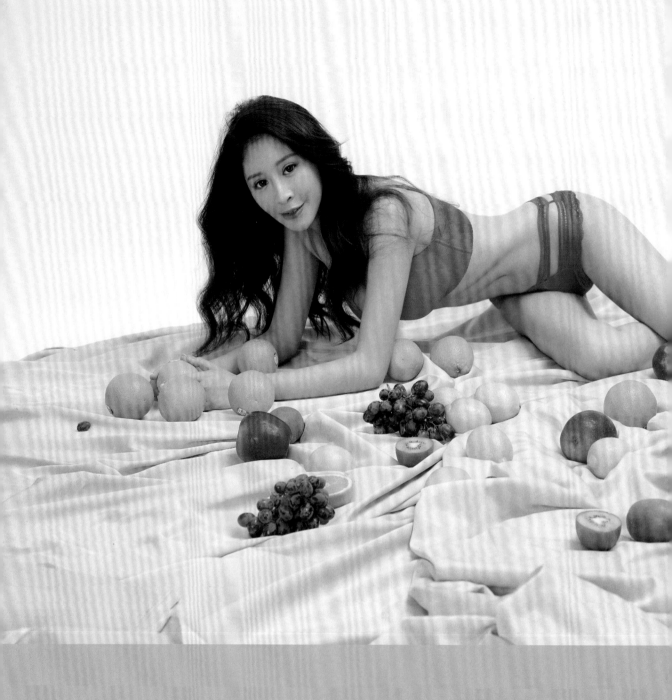

你的下半身和下半生都是我的。

MEI GIRLS

×

2020

謝侑芯
Iris

:camera: instagram：@irisirisss90

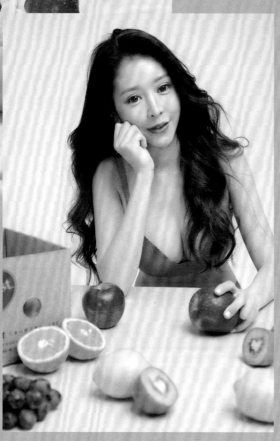

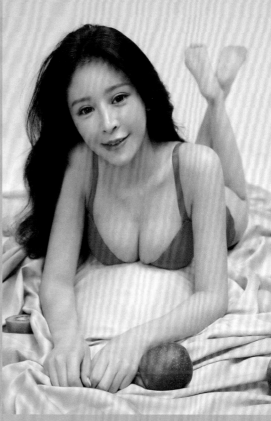

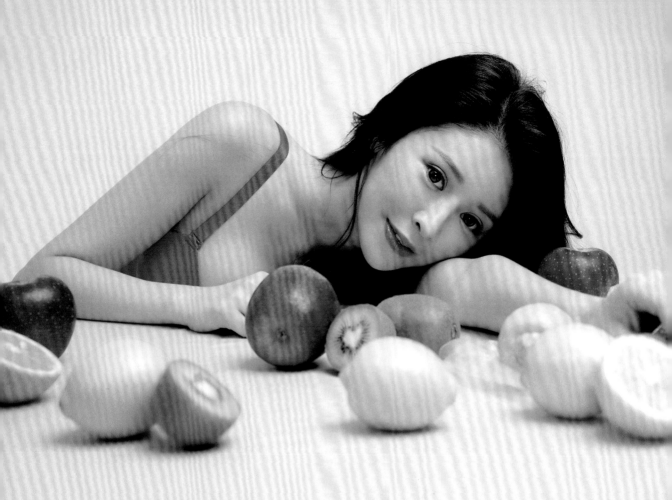

#XOXO

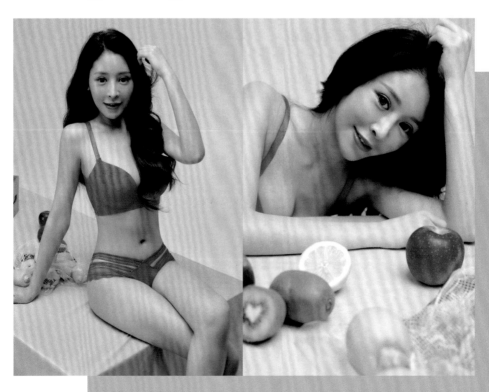

MEI GIRLS 2020

Iris

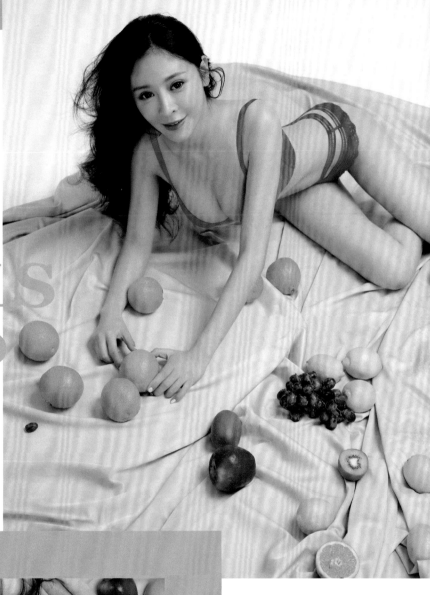

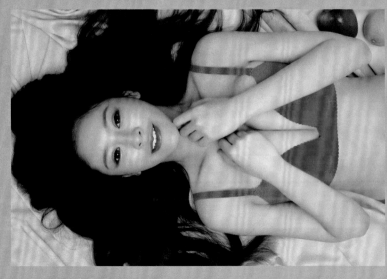

*Life Is Like
A Box
Of
Chocolates*

MEI
GIRLS
✕
2020

天燈妹

⦿ instagram ： @evelyn1998_

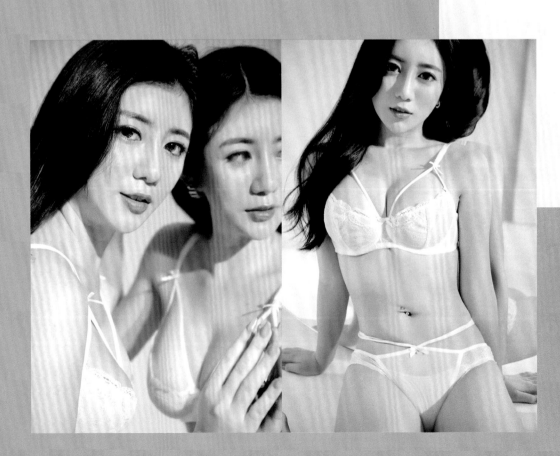

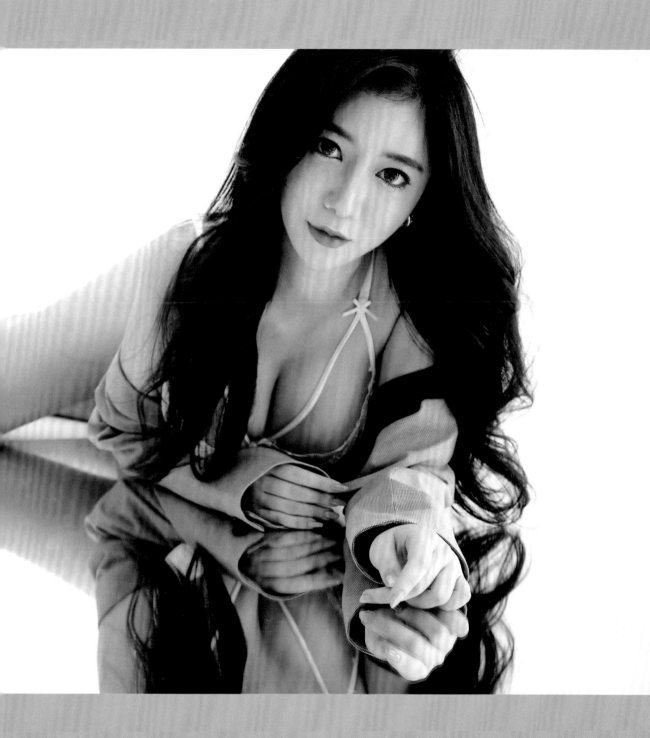

愛我不止要心，還要用力♥

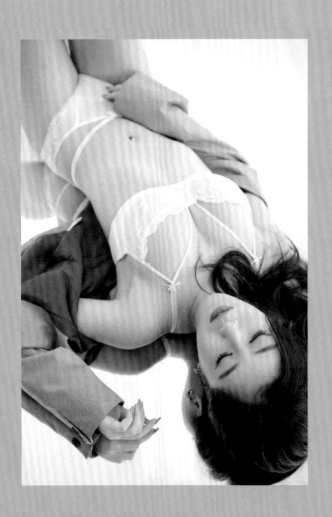

MEI GIRLS 2020

*Be Happy
Always*

2020
Taiwan Top 100 Girls Album

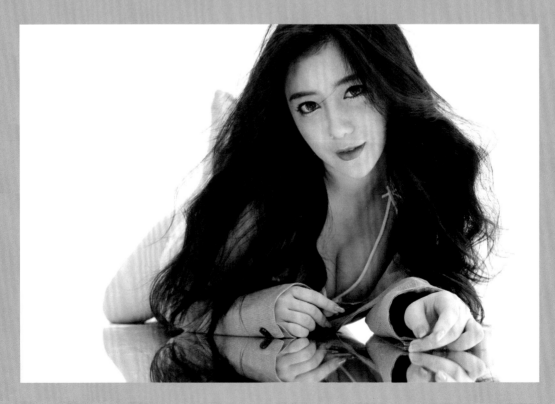

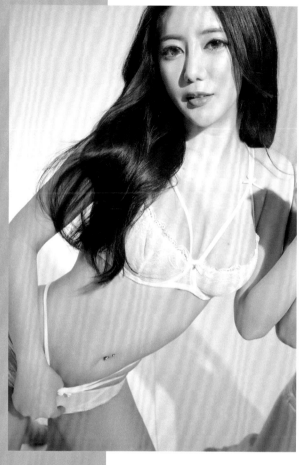

Staying
Here

**Your smile
is a blessing.**

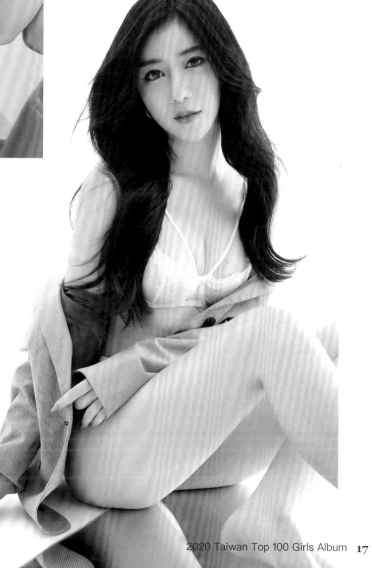

Staying
Here

2020
Taiwan Top 100 Girls Album

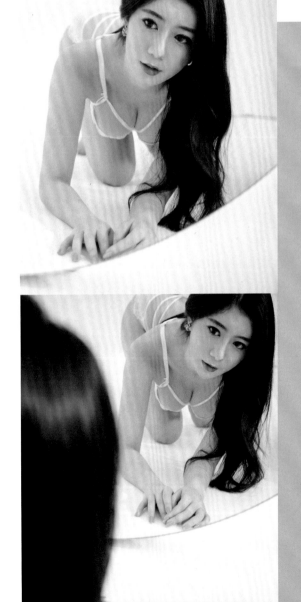

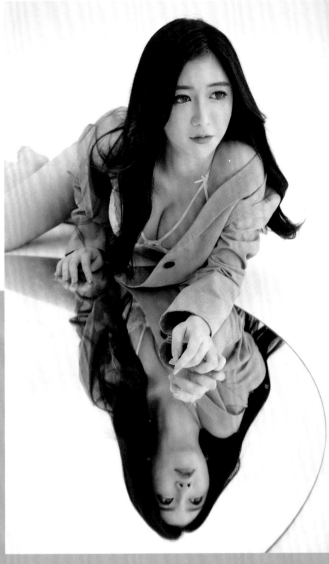

MEI

GIRLS

✕

2020

#XOXO

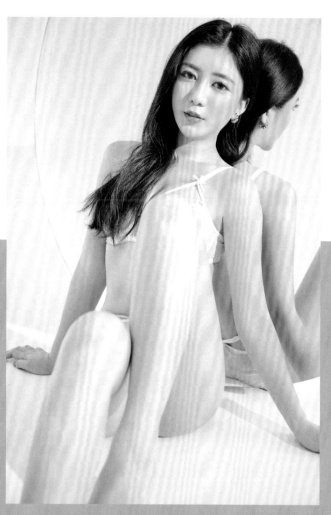

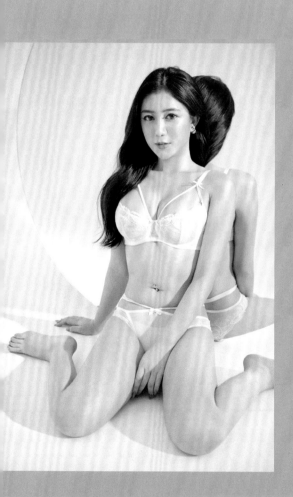

Be Happy
Always

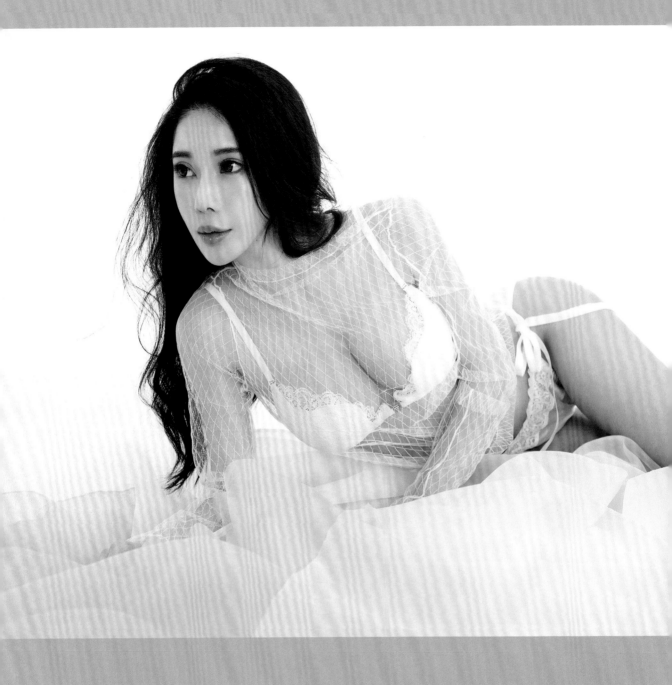

我不是渣女，我只是忘了説分手。

MEI
GIRLS
✕
2020

沈琪琪

377

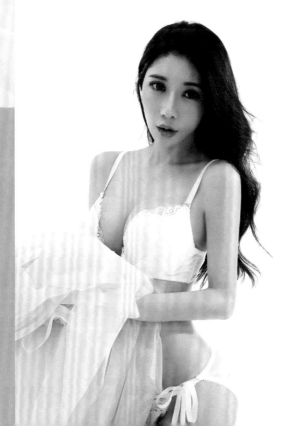
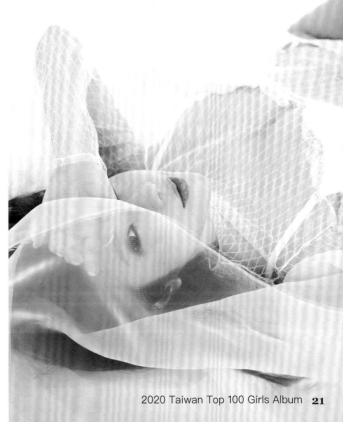

instagram : @377.bb

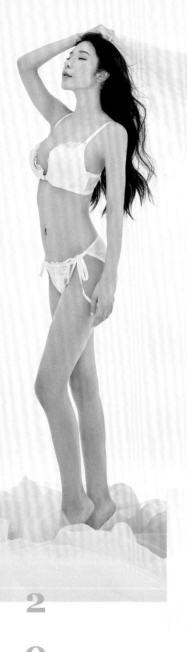

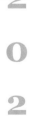

Love In Your Heart

**The best thing
to hold onto in life
is each other.**

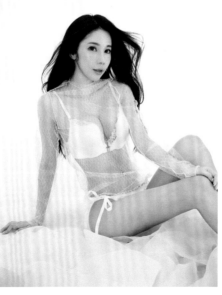

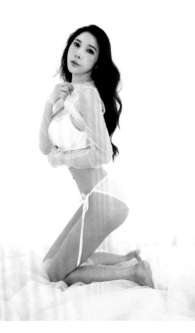

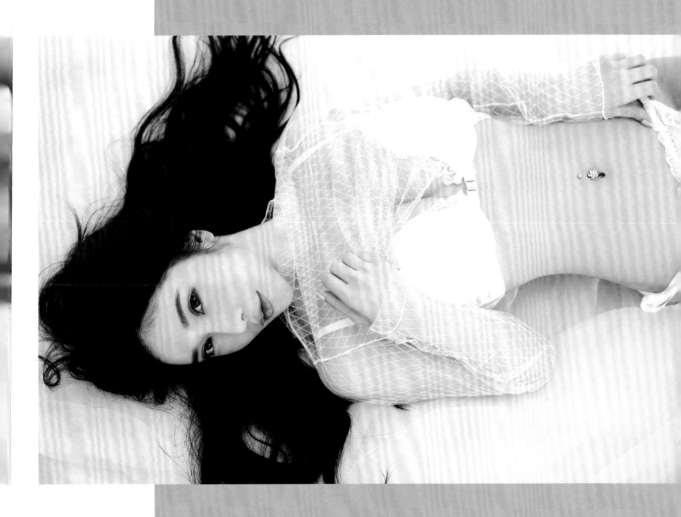

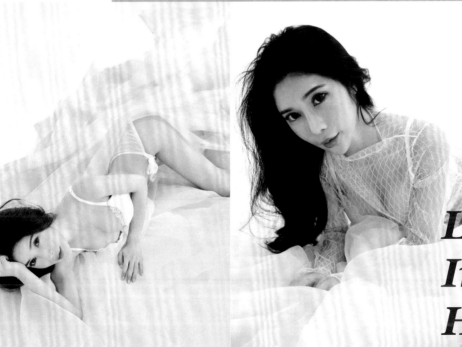

2 0 2 0
Sum
- mer

Love
In Your
Heart

MEI
GIRLS
✕
2020

謝立琪

Ki Ki

📷 instagram : @kiki_hsieh

[我就是你的座右銘（霸氣）]

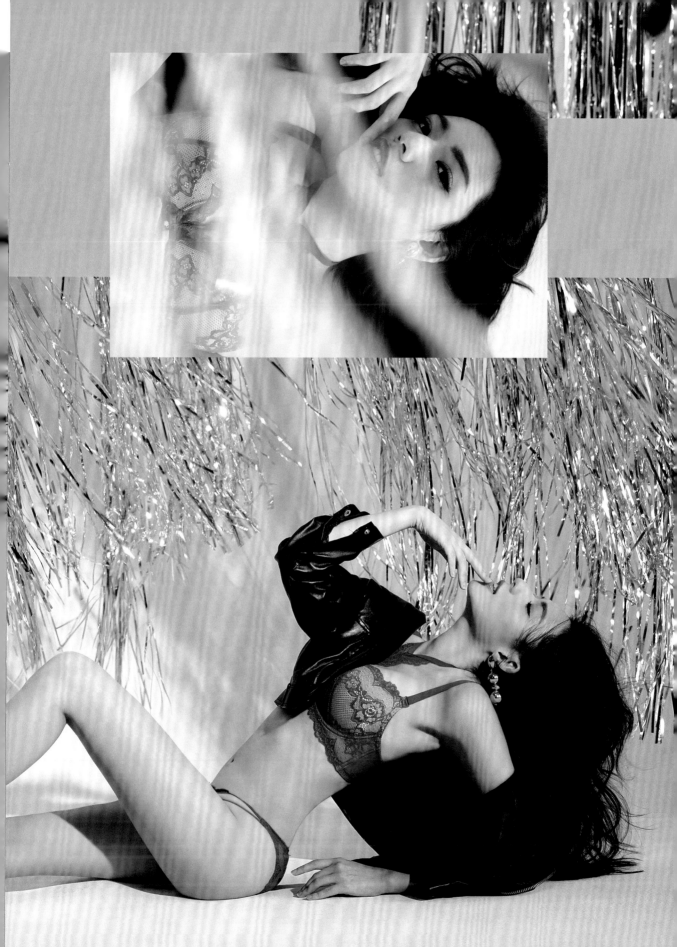

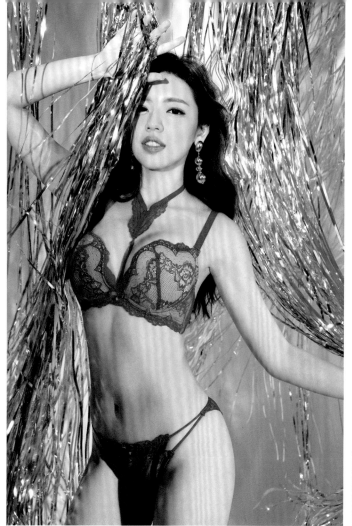

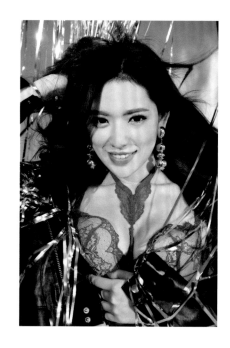

Believe
In
Yourself

-

*I long to be a sunflower
a lover of golden light,
a creator of sweet laughter.*

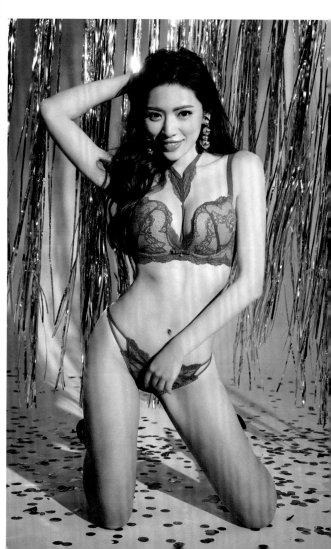

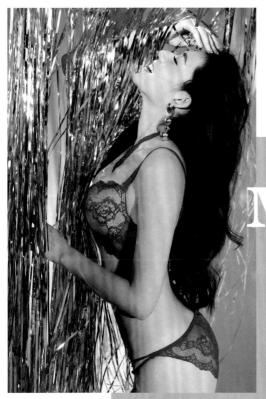

MEI GIRLS
2020
Ki Ki

2020
Taiwan
Top 100 Girls Album

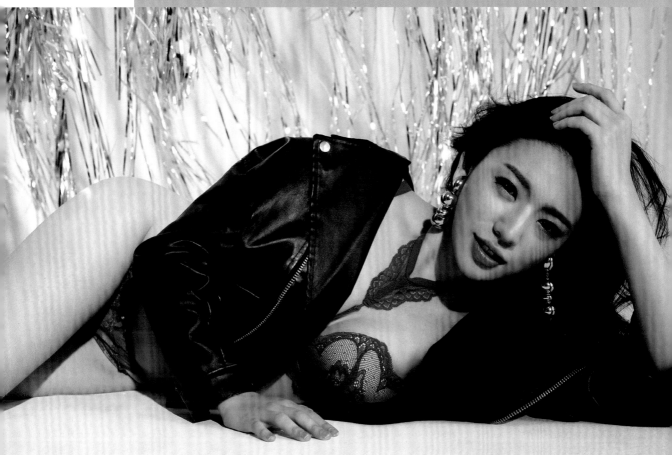

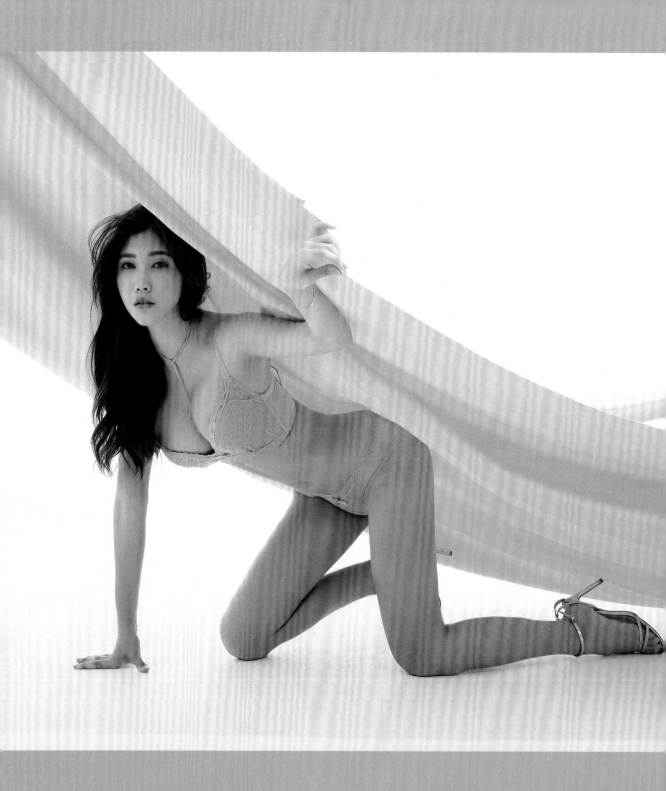

什麼都可以錯 .. 但別錯過我

MEI GIRLS

×

2020

子婷
Chris

instagram : @miti391242

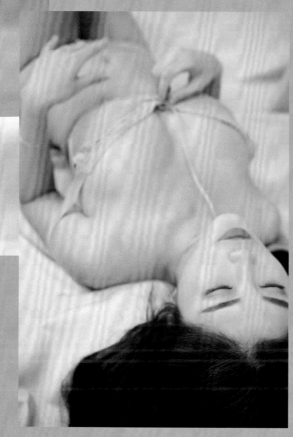

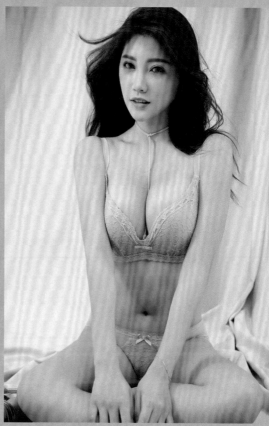

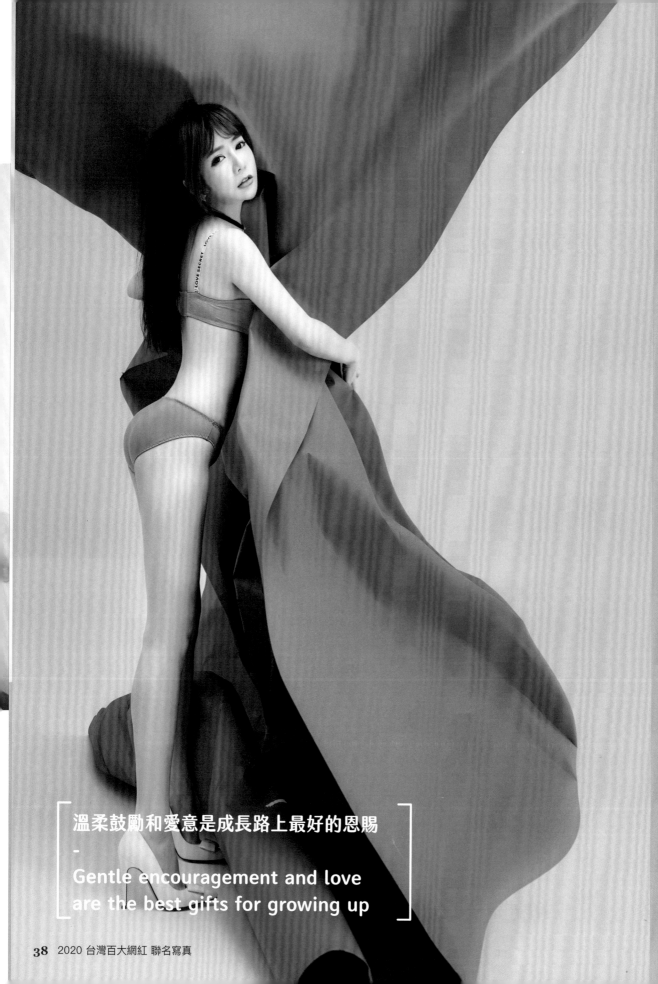

溫柔鼓勵和愛意是成長路上最好的恩賜
-
Gentle encouragement and love
are the best gifts for growing up

MEI
GIRLS
✕
2020

采兒

Claire

📷 instagram : @claire886886

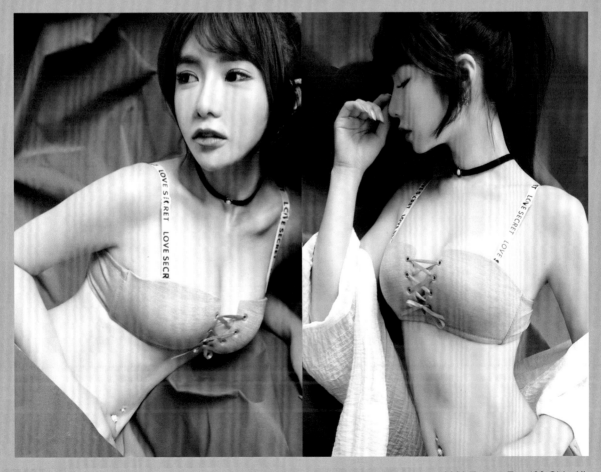

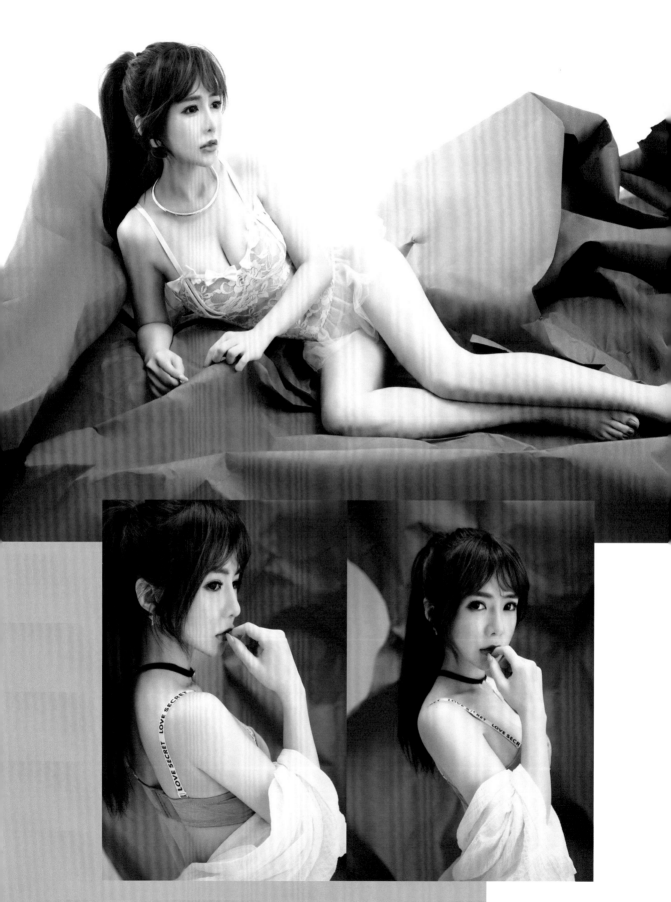

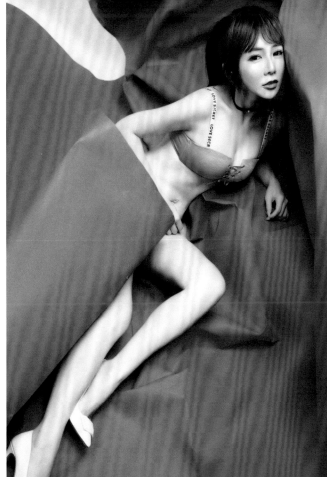

MEI
GIRLS
2020
Claire

-

Find joy in the journey.

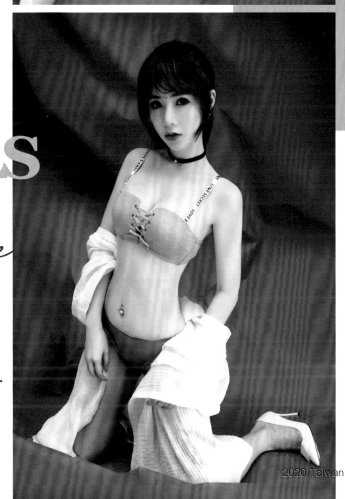

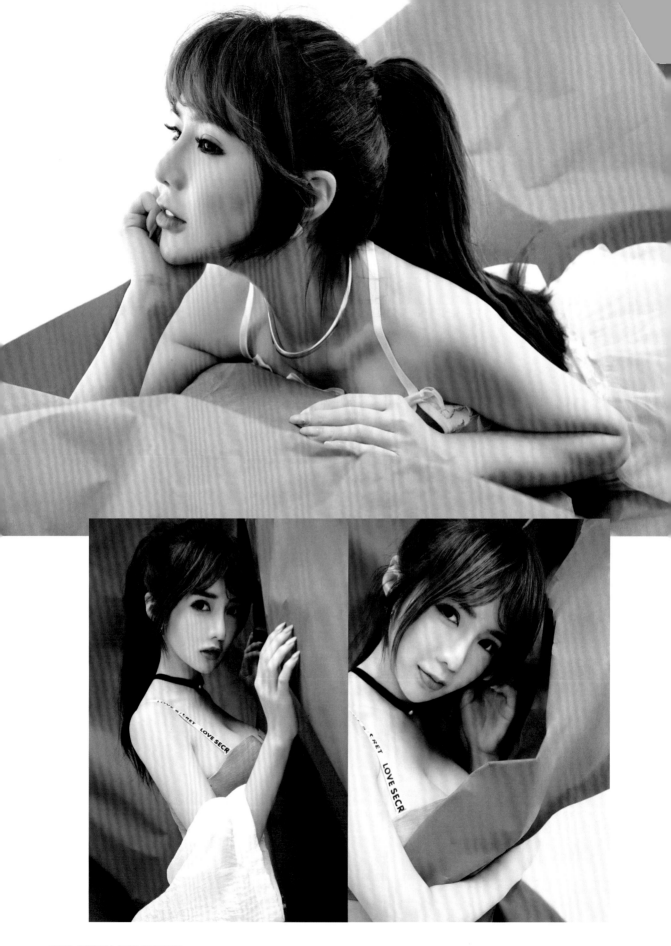

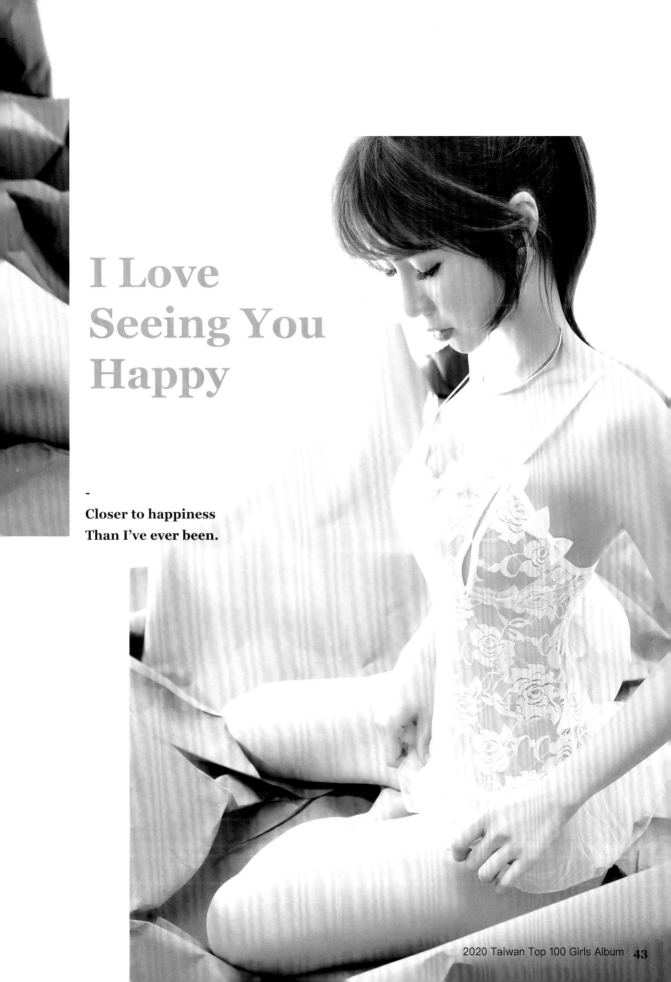

I Love Seeing You Happy

-

Closer to happiness
Than I've ever been.

MEI GIRLS × 2020

蘿拉
Lola

:camera: instagram : @chocolee0901

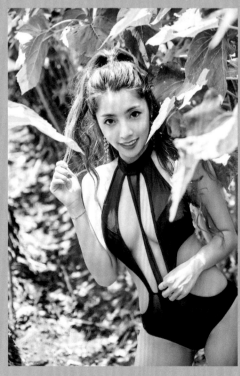
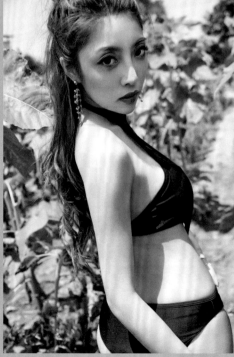

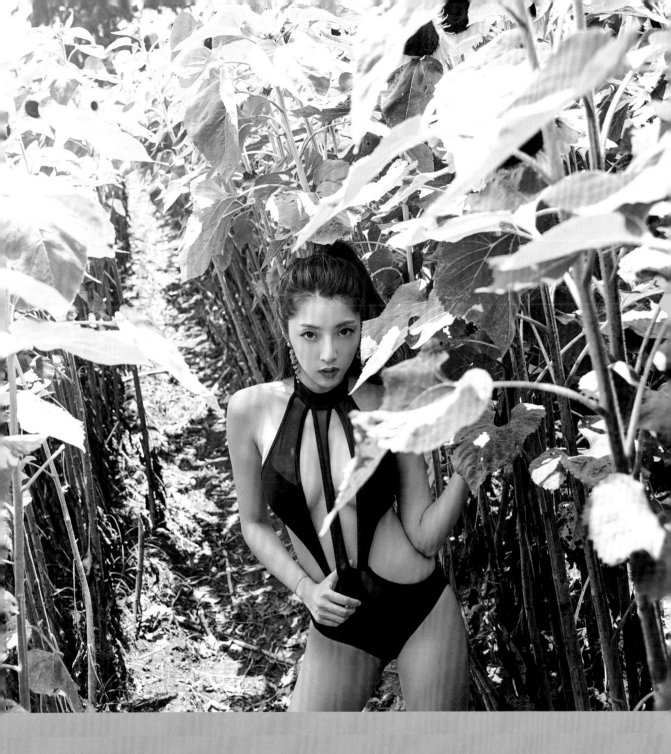

讓你跌倒的事常常也是讓你重新翻身的事♥

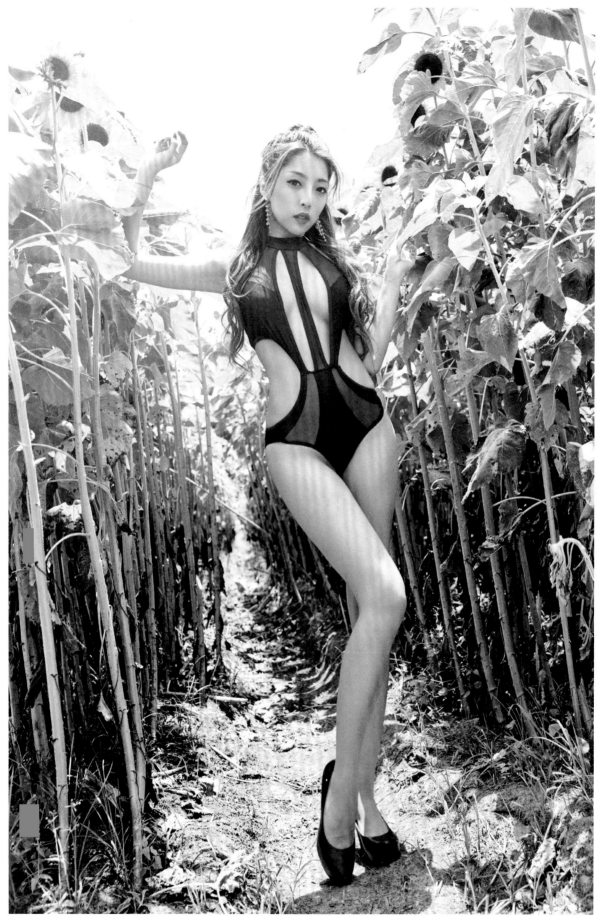

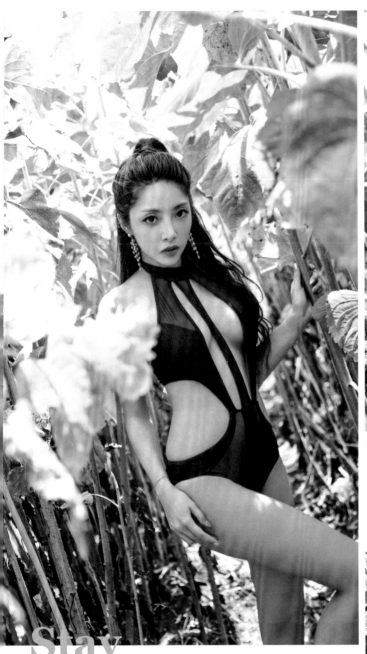
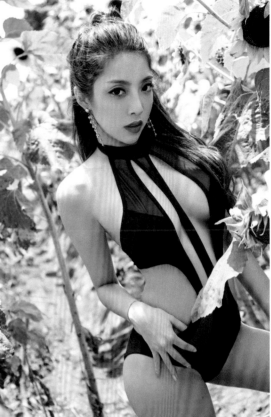
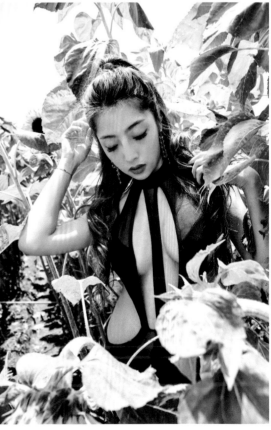

Stay
In Your
Magic

-

I long to be a sunflower
a lover of golden light,
a creator of sweet laughter.



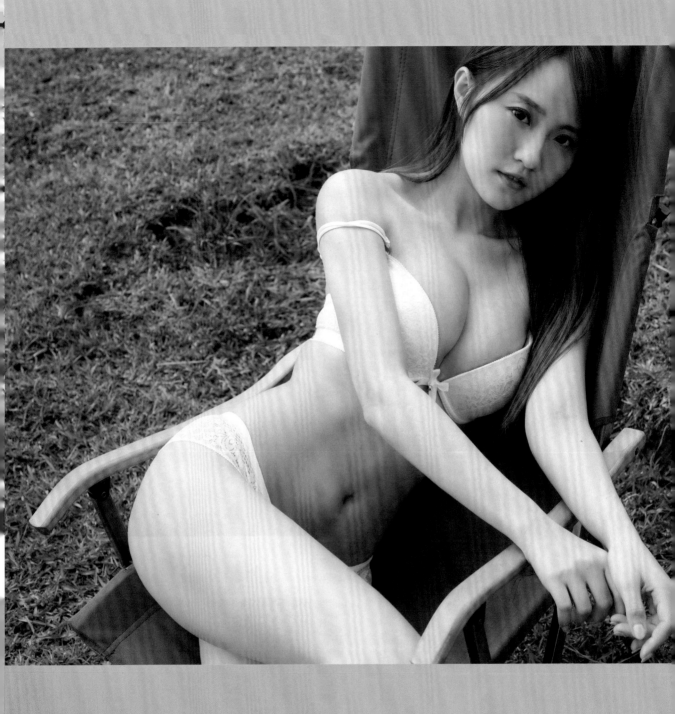

不想做可愛的人，只想做你愛的人。

MEI
GIRLS
✕
2020

佳佳兒
Mimi

📷 instagram：@mimi112023

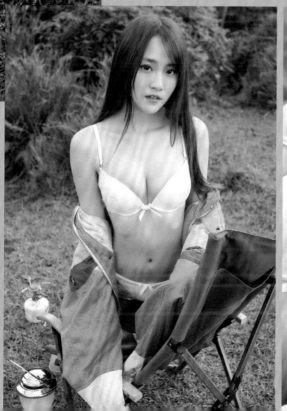

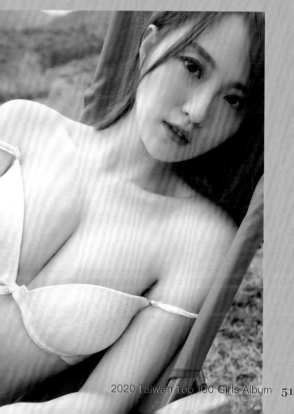

2020 Taiwan Top 100 Girls Album **51**

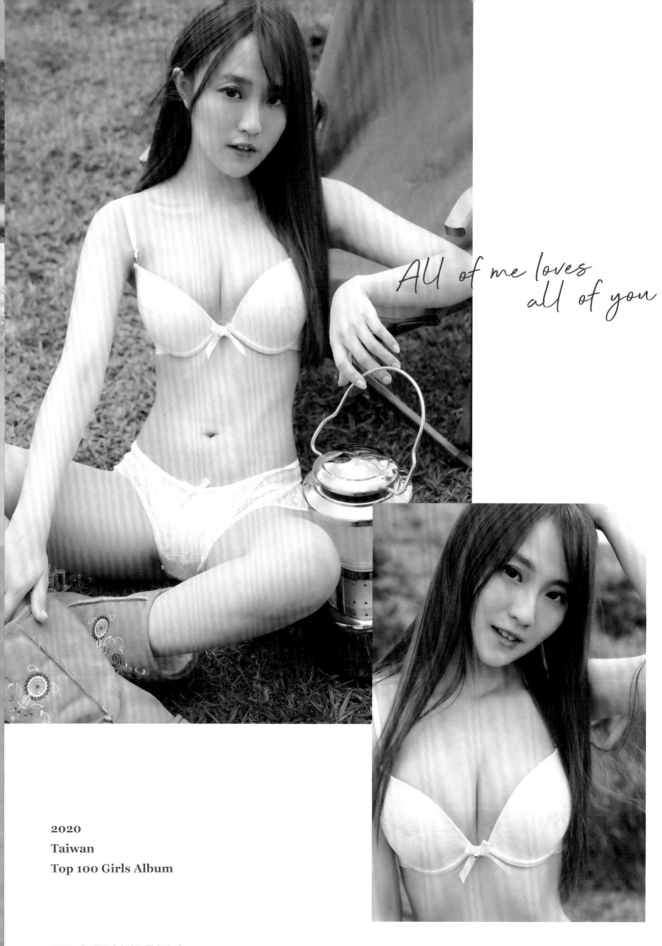

All of me loves
all of you

2020
Taiwan
Top 100 Girls Album

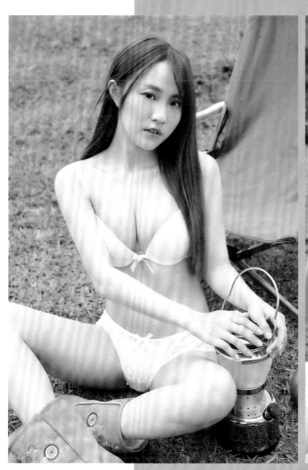

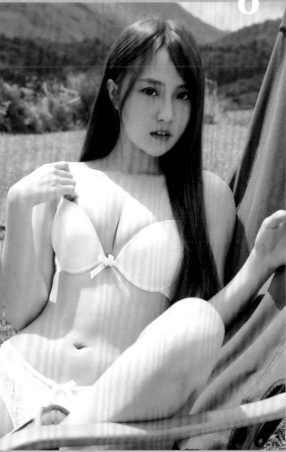

*Make
Today
Magical*

MEI GIRLS

× 2020

林襄

instagram：@95_mizuki

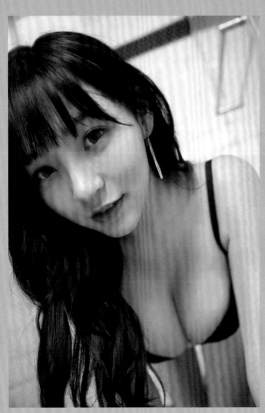

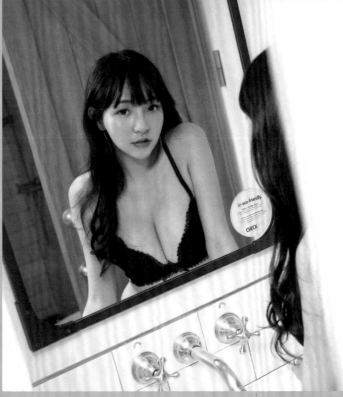

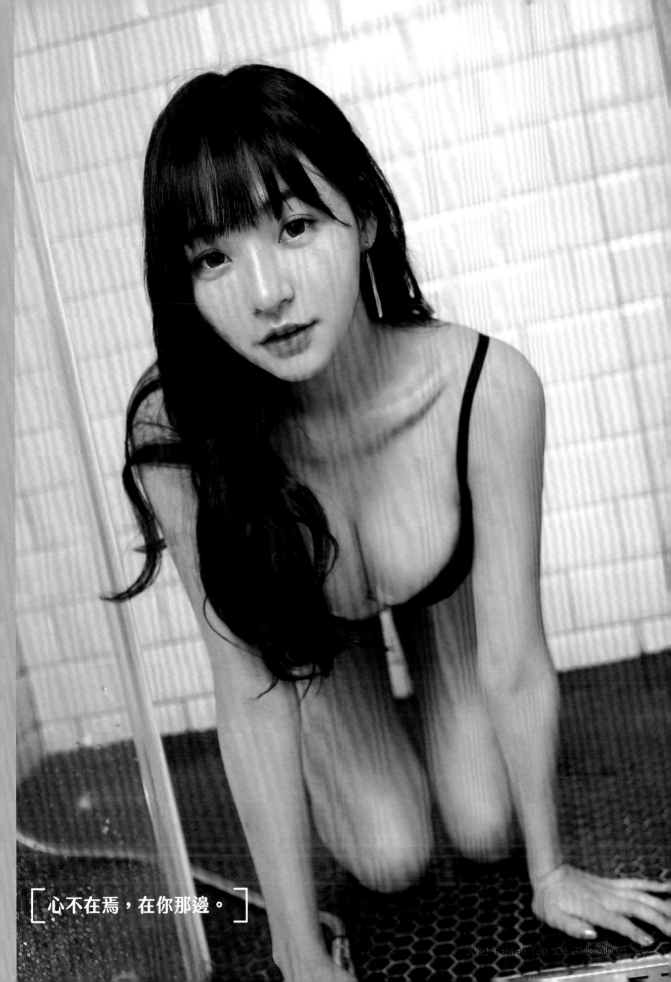

心不在焉，在你那邊。

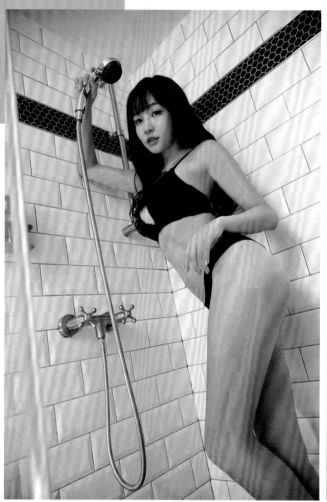

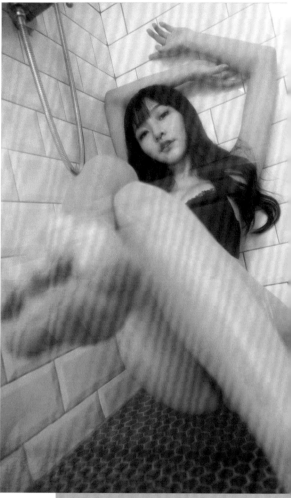

MEI
GIRLS
2020

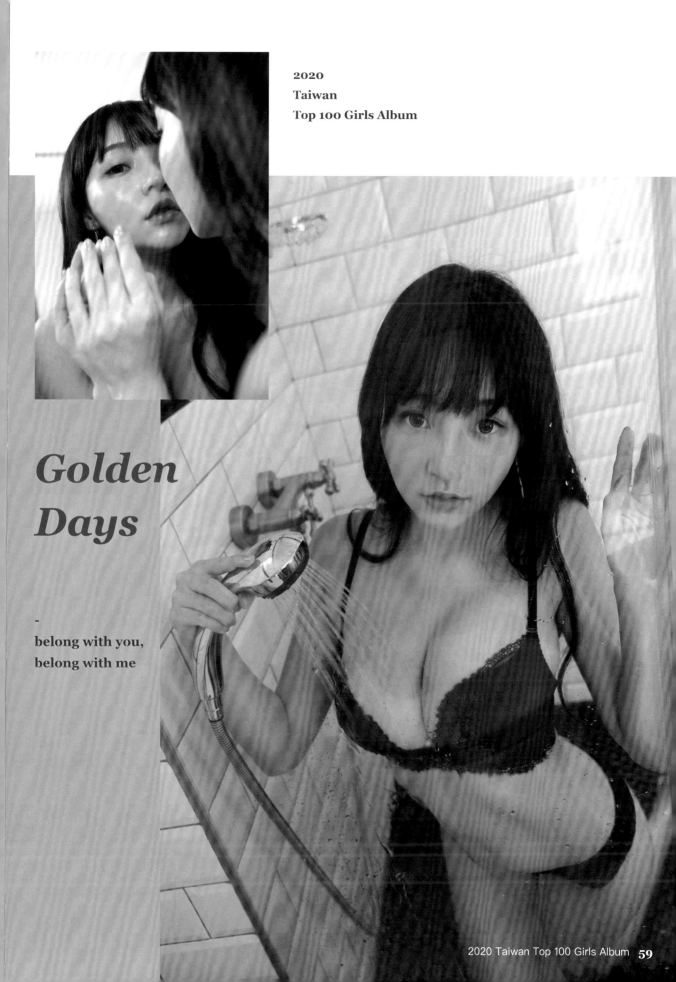

Golden Days

-
belong with you,
belong with me

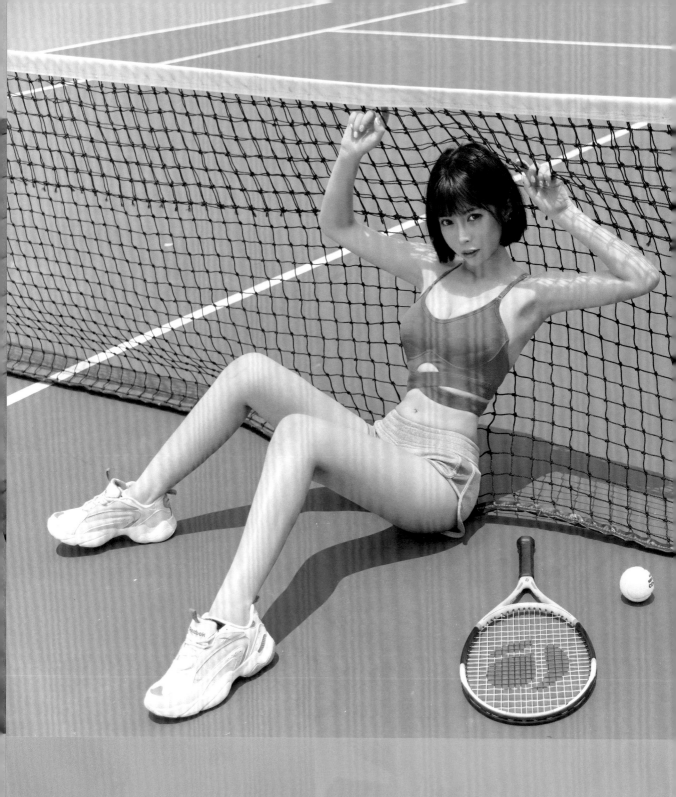

苦海無涯，回頭是我呀～

MEI
GIRLS

✕

2020

趙宇喬
Chubby 糖

📷 instagram：@choo7077

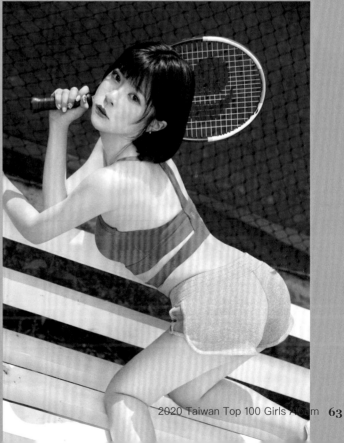

MEI
GIRLS
✕
2020

韻韻

📷 instagram：@coco.8192

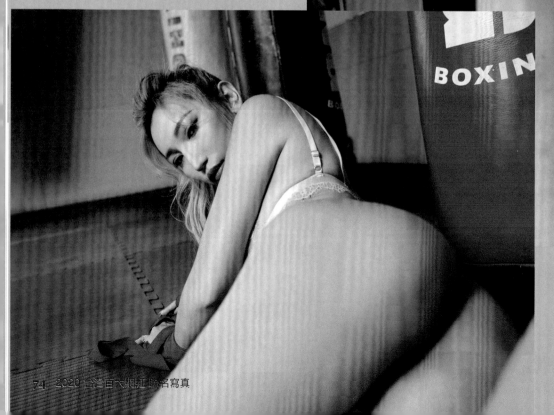

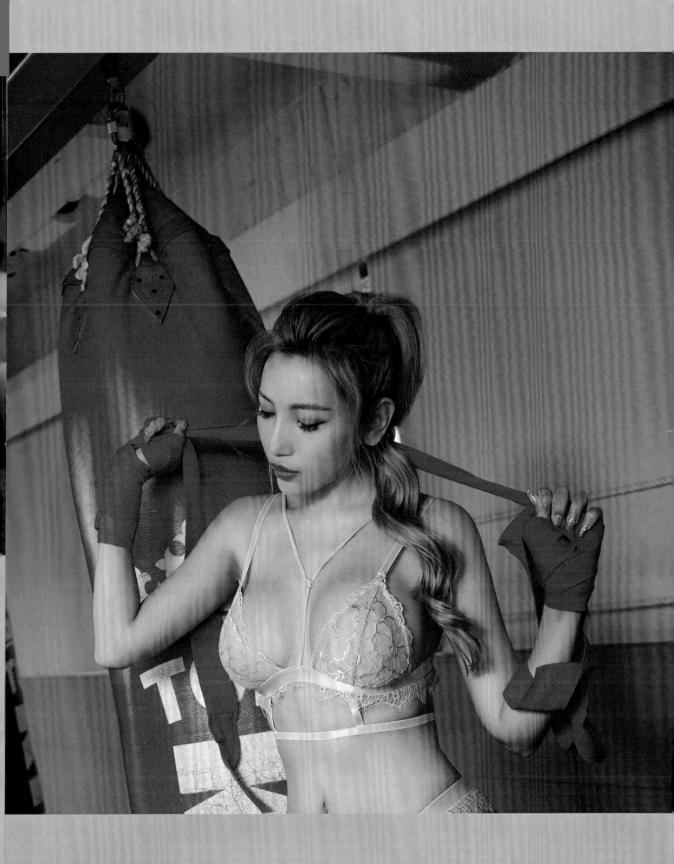

想做你夏天的西瓜，不僅甜❤還多水

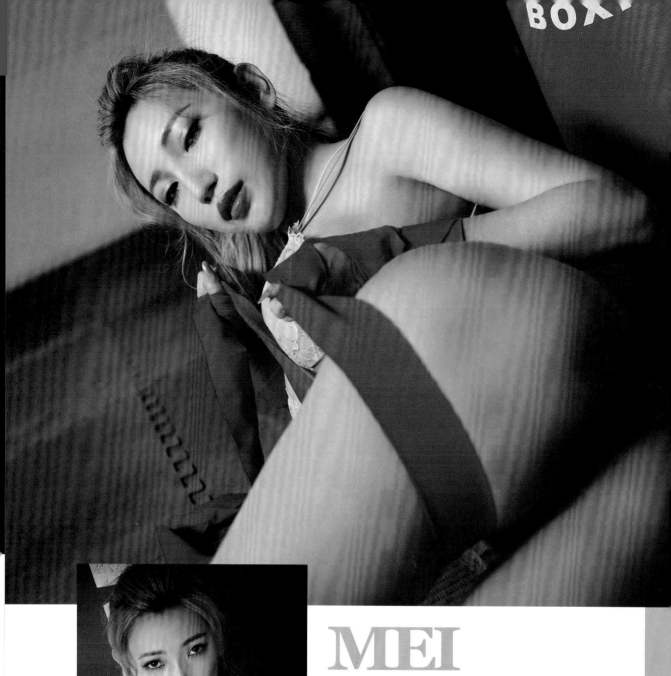

MEI
GIRLS
2020

2020
Taiwan
Top 100 Girls Album

You Are
My New Favorite
Feeling.

POSITIVE.

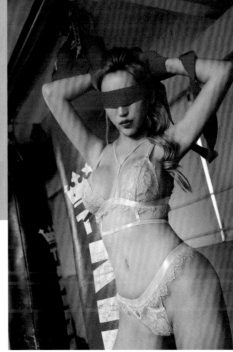

MEI
GIRLS
✕
2020

妮婭
Niya

instagram：@niya840325

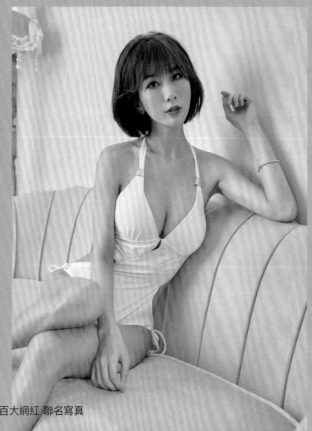

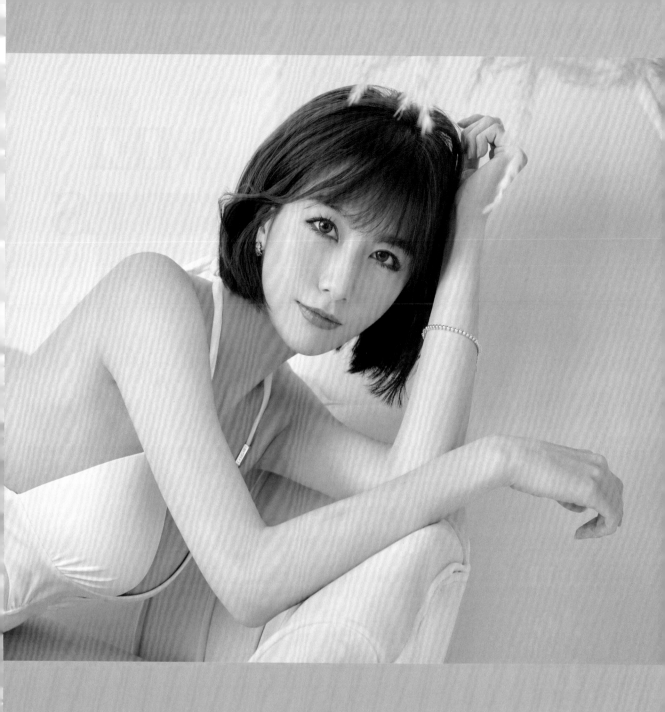

越是沒有信心的事，越要努力去嘗試 ♥

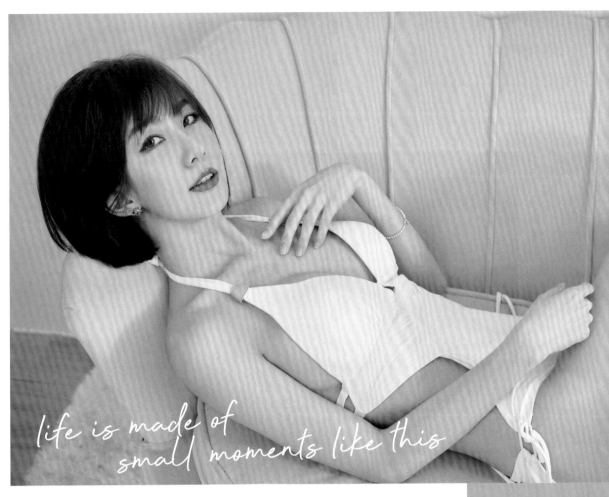

life is made of
small moments like this

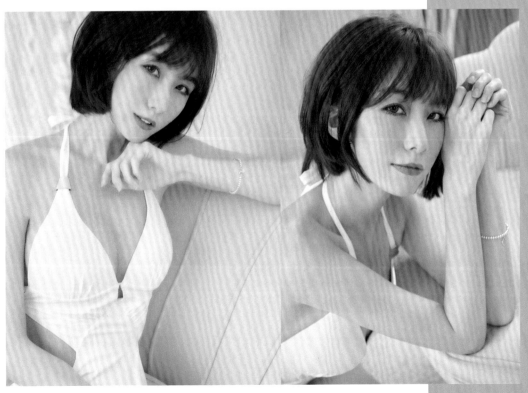

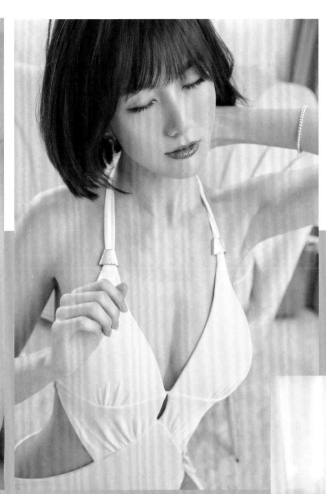

Find
Joy
In The
Journey

-

**You are better than all
anything**

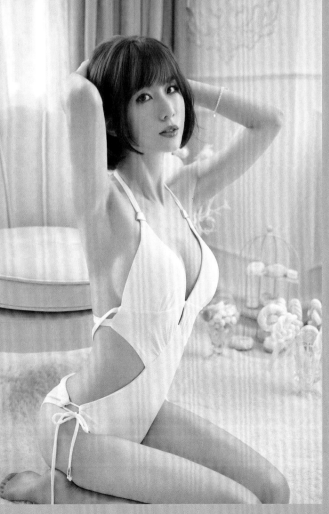

MEI

GIRLS

2020
Niya

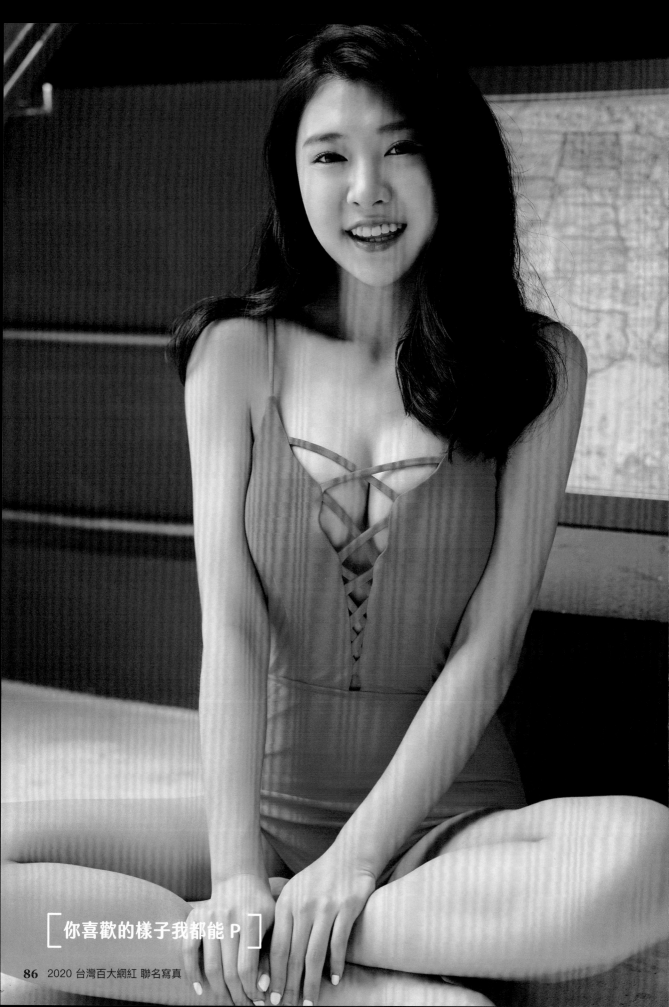

你喜歡的樣子我都能 P

MEI GIRLS

\times

2020

潔晞

instagram : @ jie.c.0803

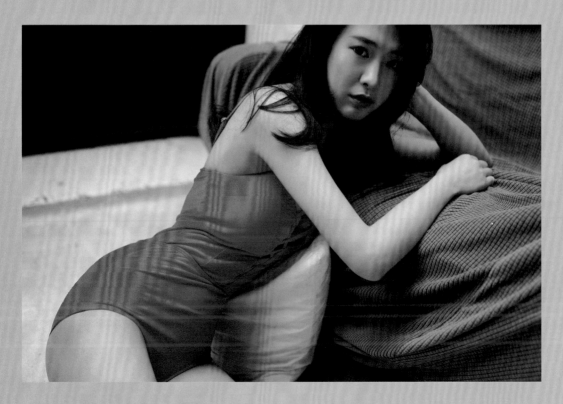

belong with you,
belong with me.

Believe
In
Yourself

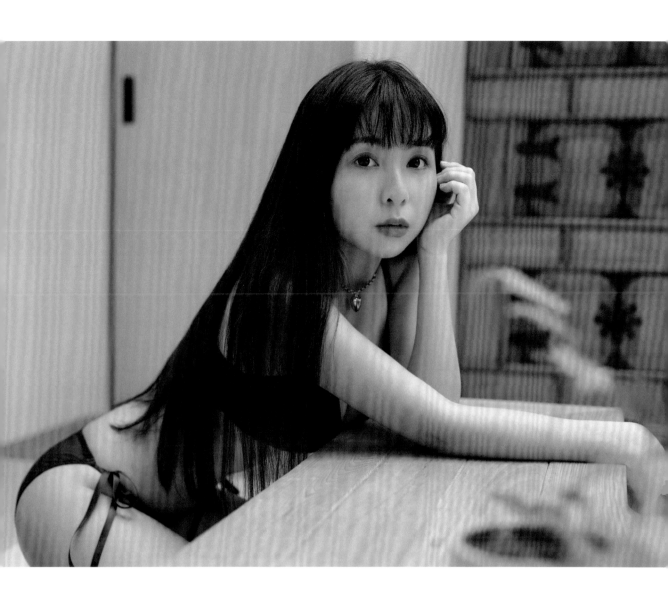

Staying
Here

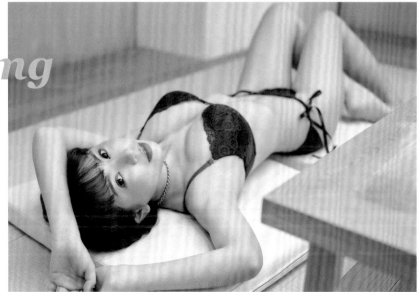

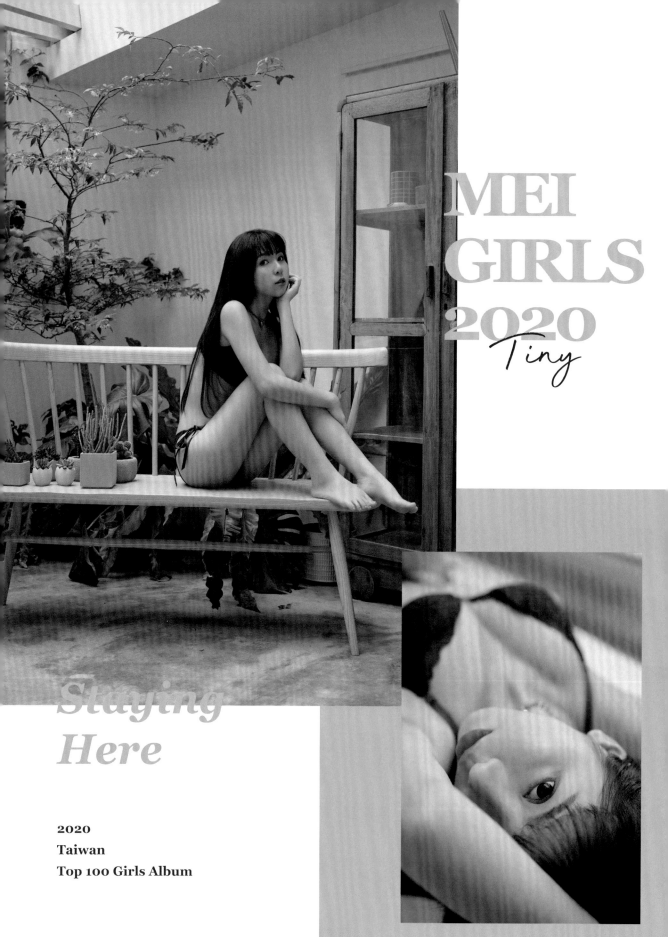

MEI
GIRLS
2020
Tiny

Staying
Here

2020
Taiwan
Top 100 Girls Album

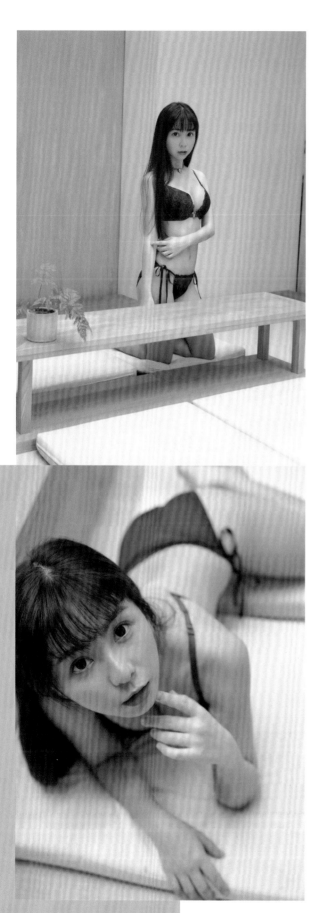

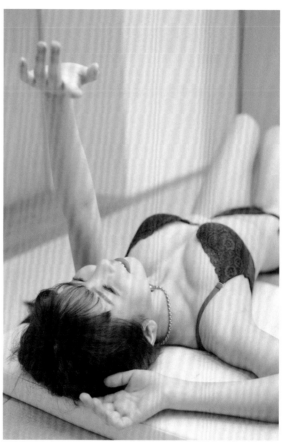

Believe
In
Yourself

MEI GIRLS
✕
2020

婷婷兒

instagram：@lovemermaid819

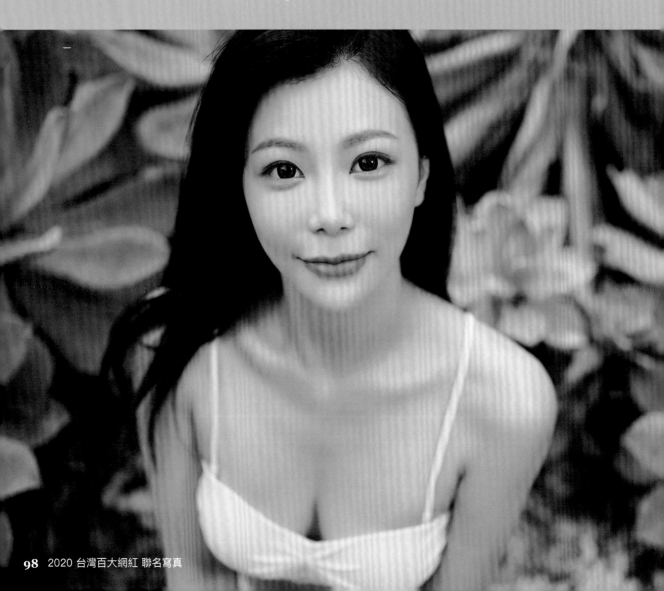

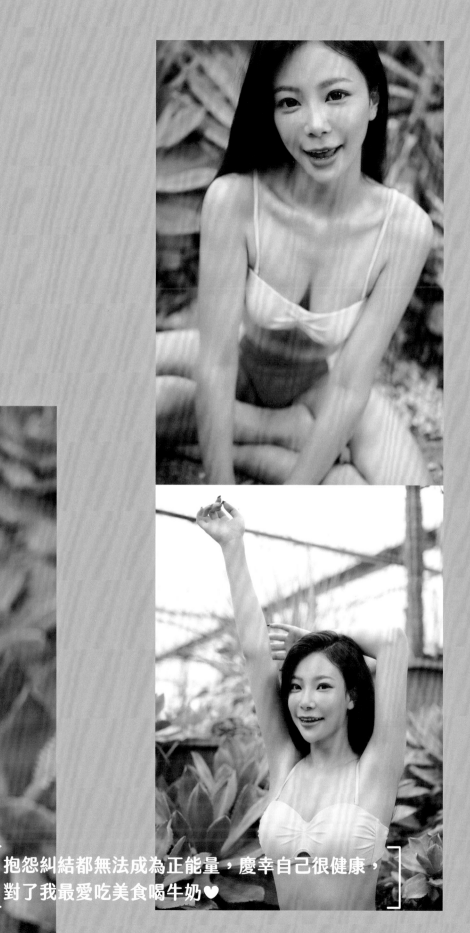

抱怨糾結都無法成為正能量，慶幸自己很健康，
對了我最愛吃美食喝牛奶❤

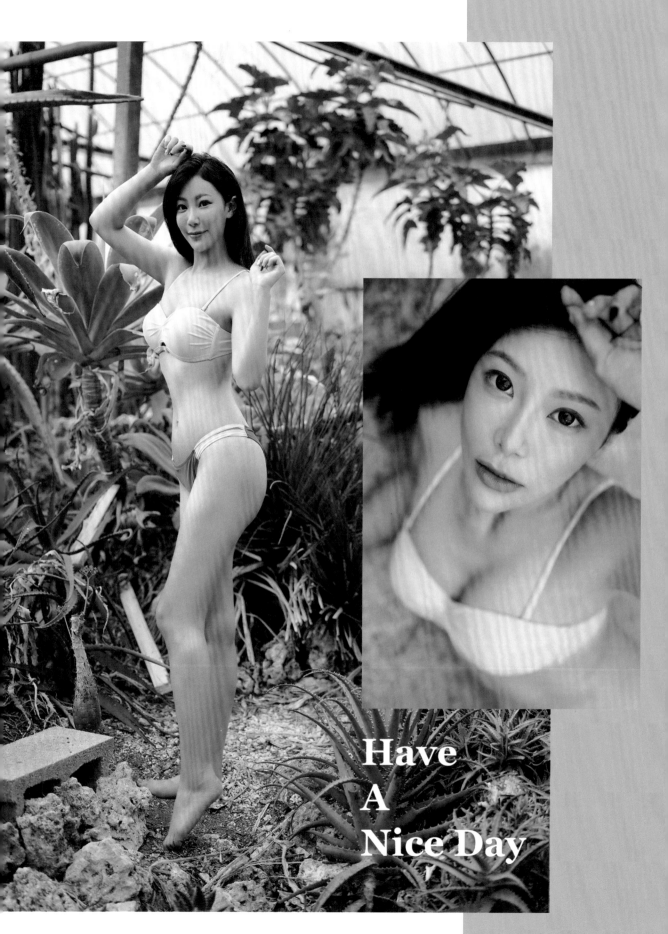

Have
A
Nice Day

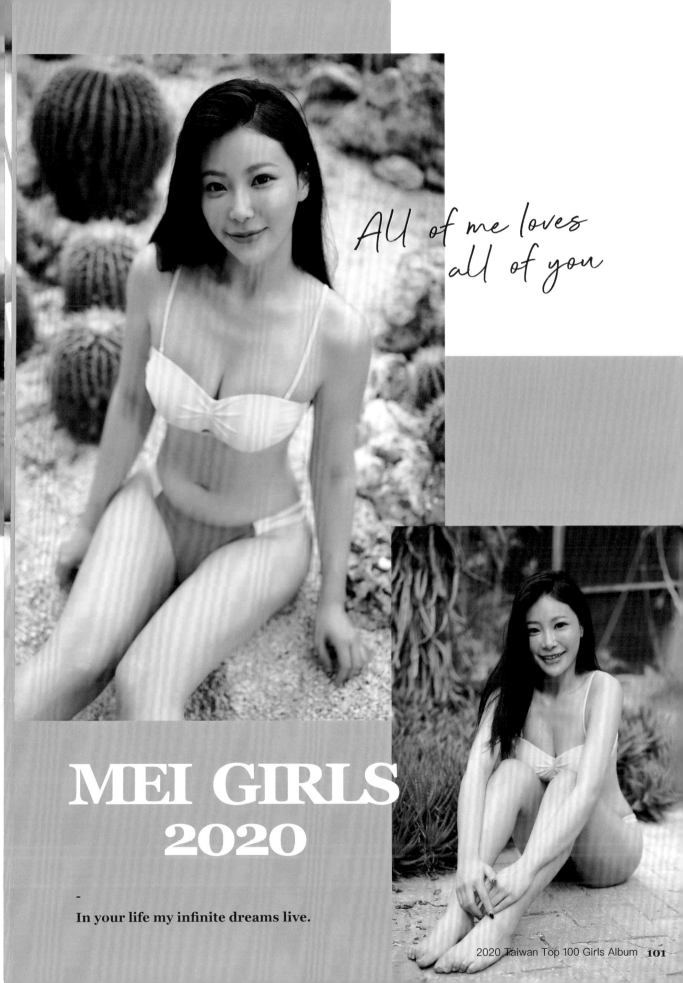

All of me loves
all of you

MEI GIRLS
2020

-

In your life my infinite dreams live.

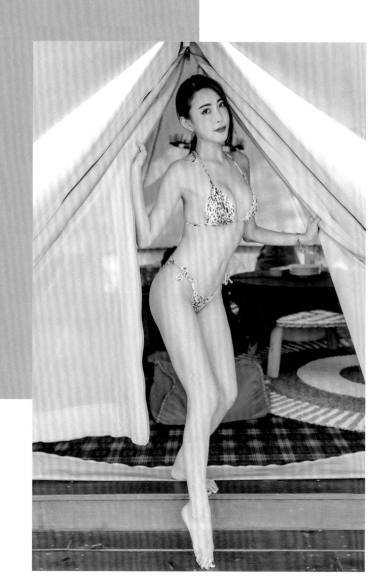

Summer
Vibes

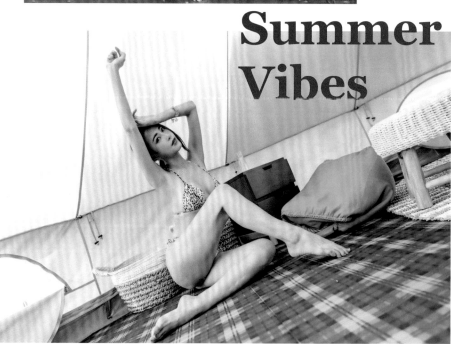

-
**Find joy
in the journey.**

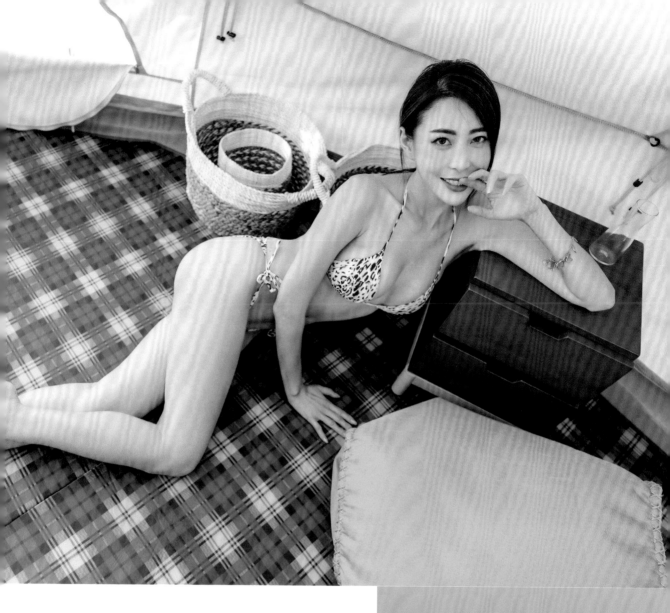

MEI
GIRLS
✕
2020
Abbie

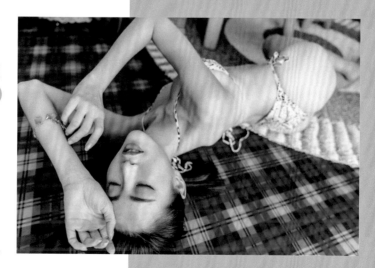

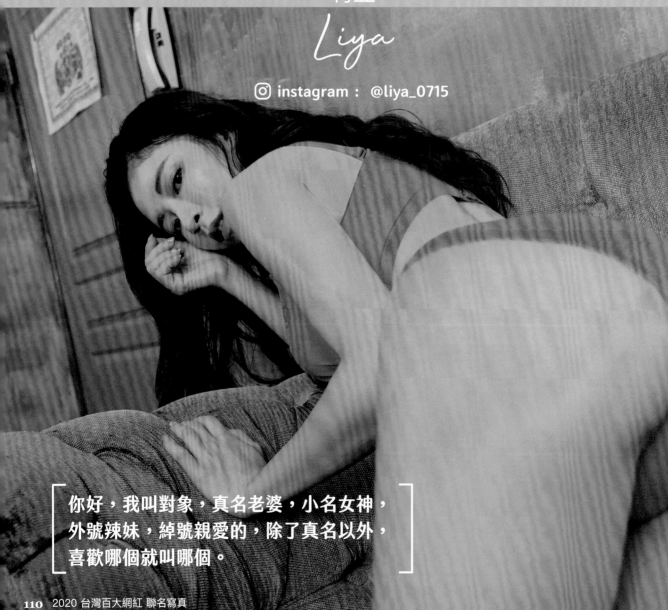

MEI GIRLS

✕

2020

莉亞

Liya

📷 instagram：@liya_0715

你好，我叫對象，真名老婆，小名女神，
外號辣妹，綽號親愛的，除了真名以外，
喜歡哪個就叫哪個。

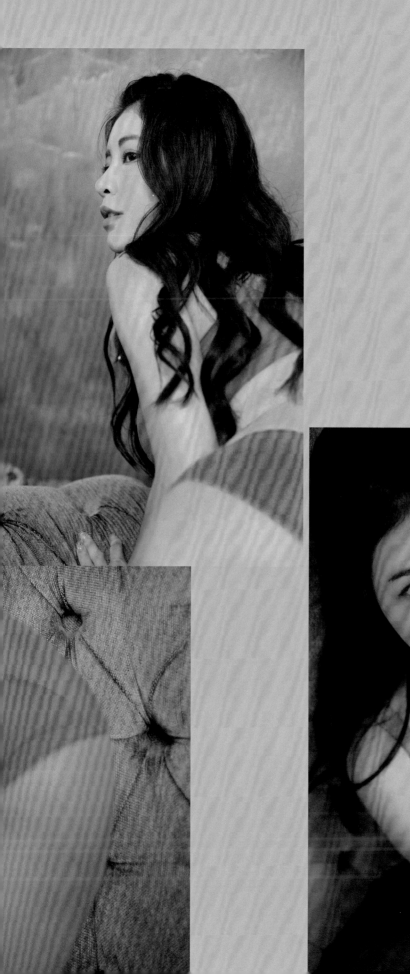
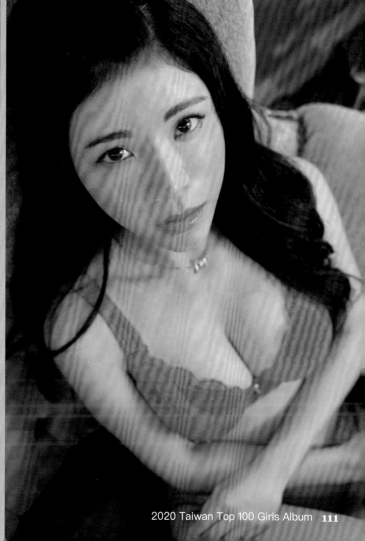

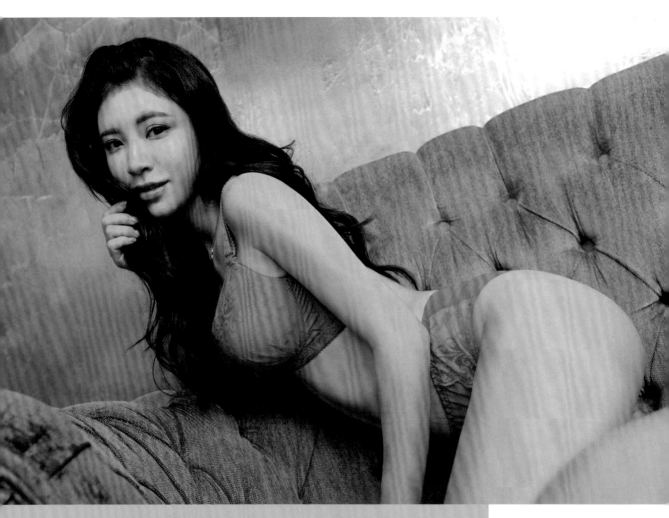

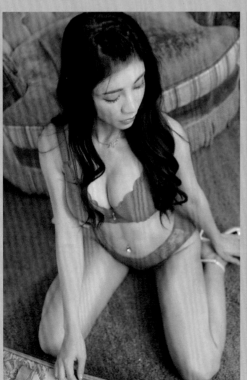

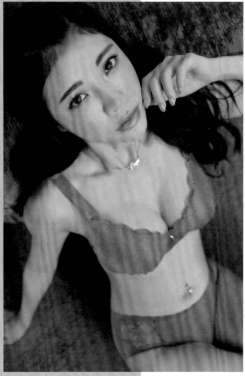

MEI
GIRLS
✕
2020

-
*I'm happy
when
I'm with you*

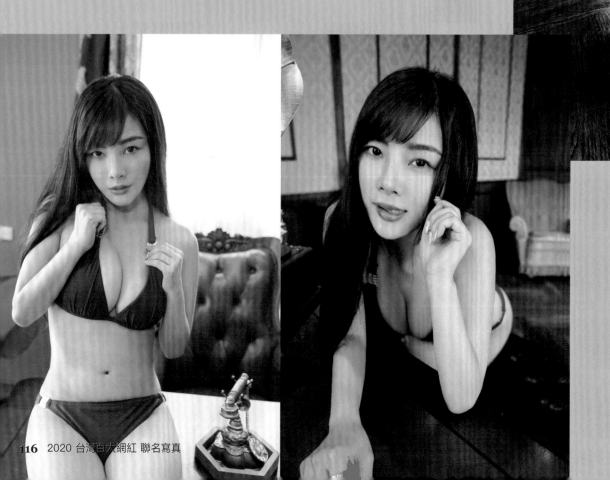

MEI GIRLS

×

2020

滷味妹 Q
小桃子

📷 instagram：@vivi02257

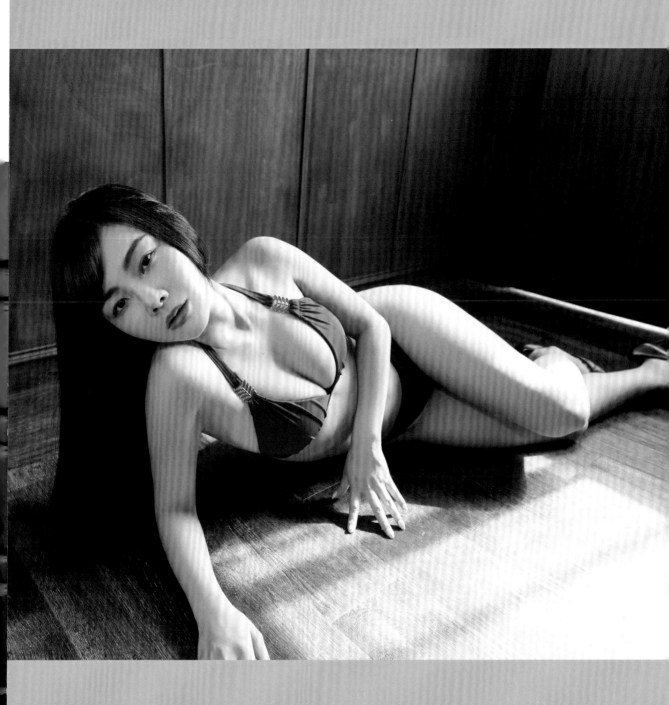

最動聽的不是我愛你，而是別擔心有我在。

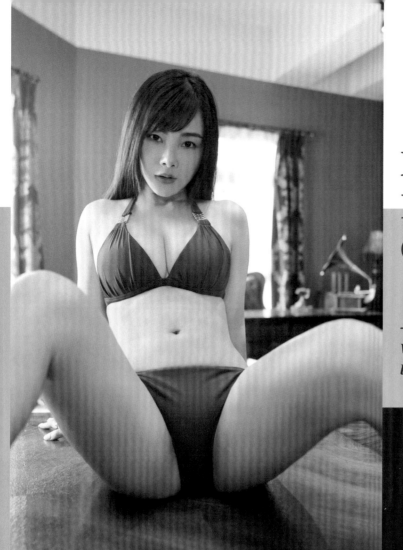

Make Dream Come True

-

Wish some days
lasted forever.

MEI
GIRLS
✕
2020

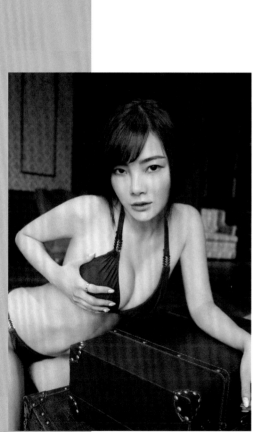

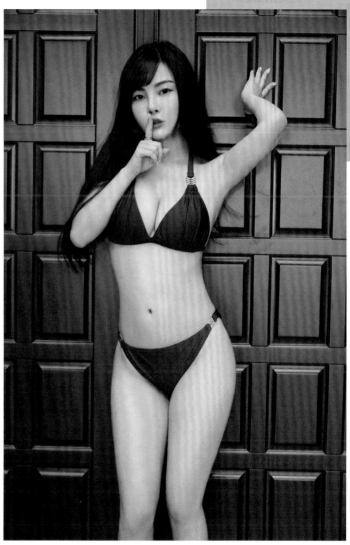

2020
Taiwan
Top 100 Girls Album

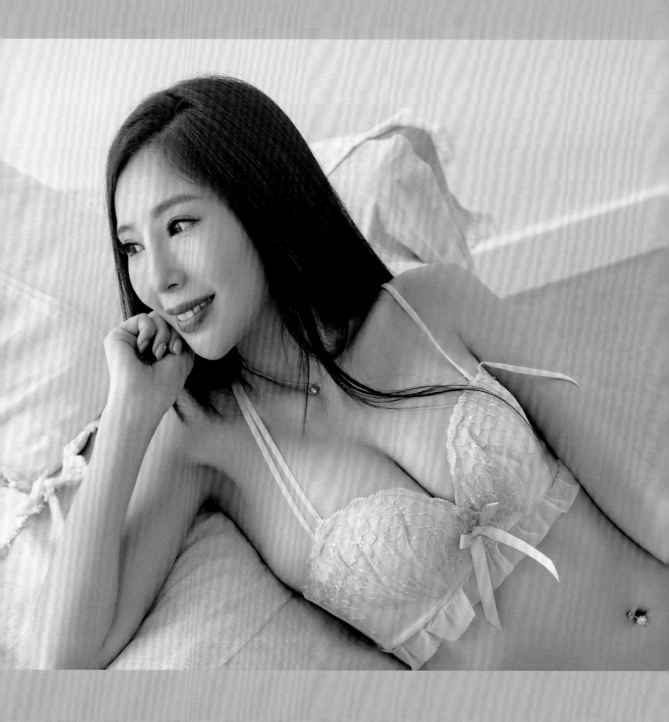

願你做人不缺愛，做愛不缺人。

MEI
GIRLS
✕
2020

甄馨

Tiffany

📷 instagram : @tiffanylin9000

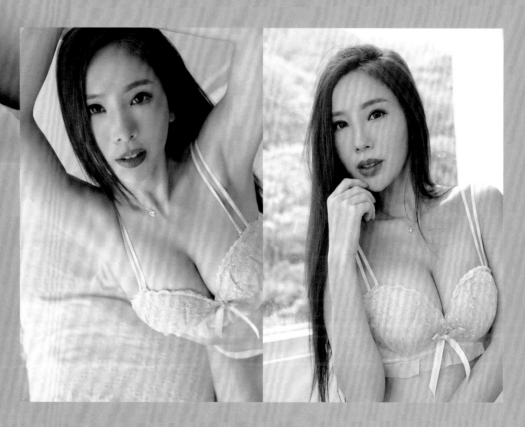

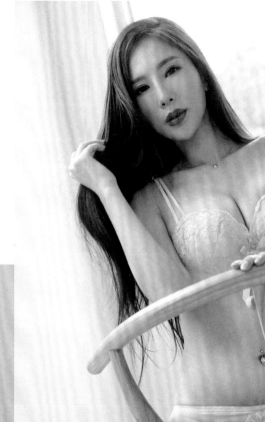

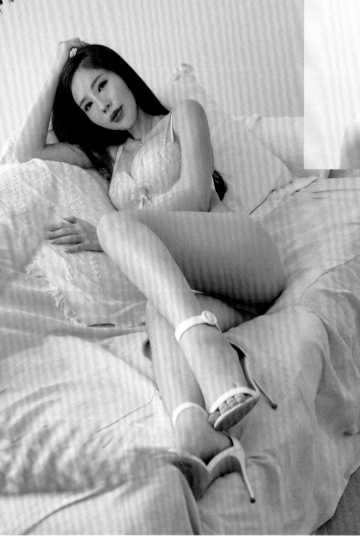

MEI
GIRLS
2020
Tiffany

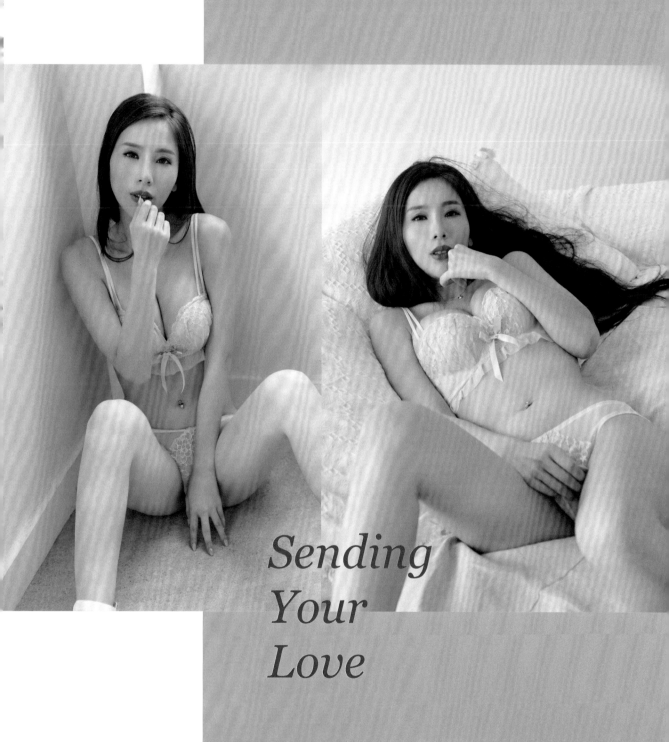

Sending Your Love

I'm happy when I'm with you

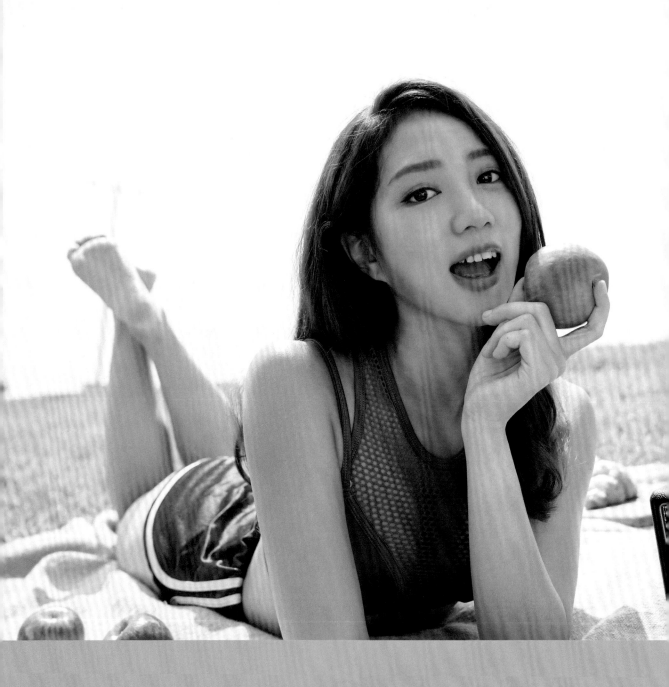

[今晚我想來點⋯⋯魚魚大餐～]

MEI GIRLS × 2020

魚魚
Fish

:camera: instagram：@fishhhh220

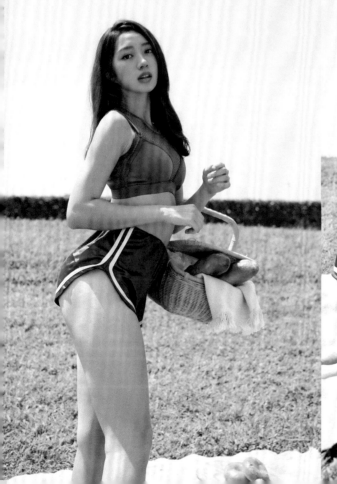

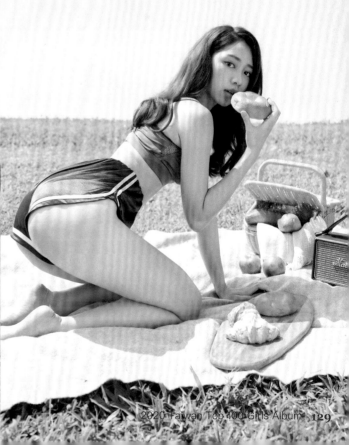

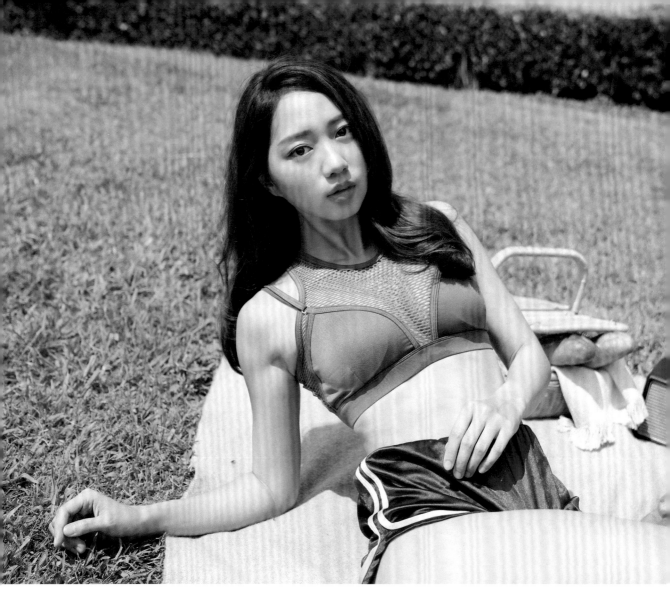

Summer
Picnic

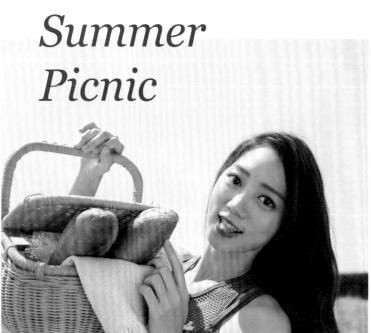

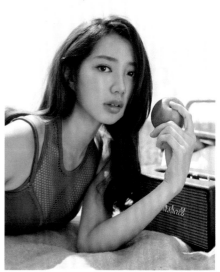

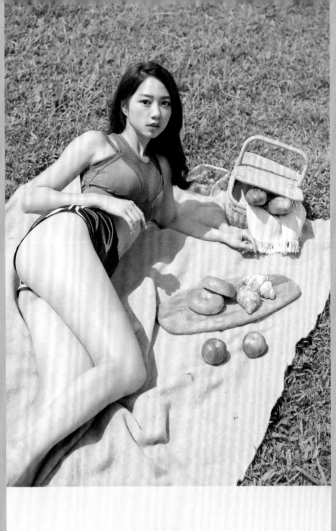
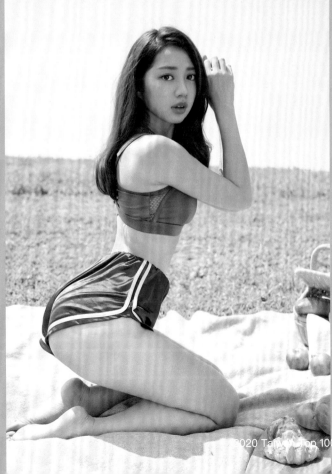

MEI GIRLS 2020

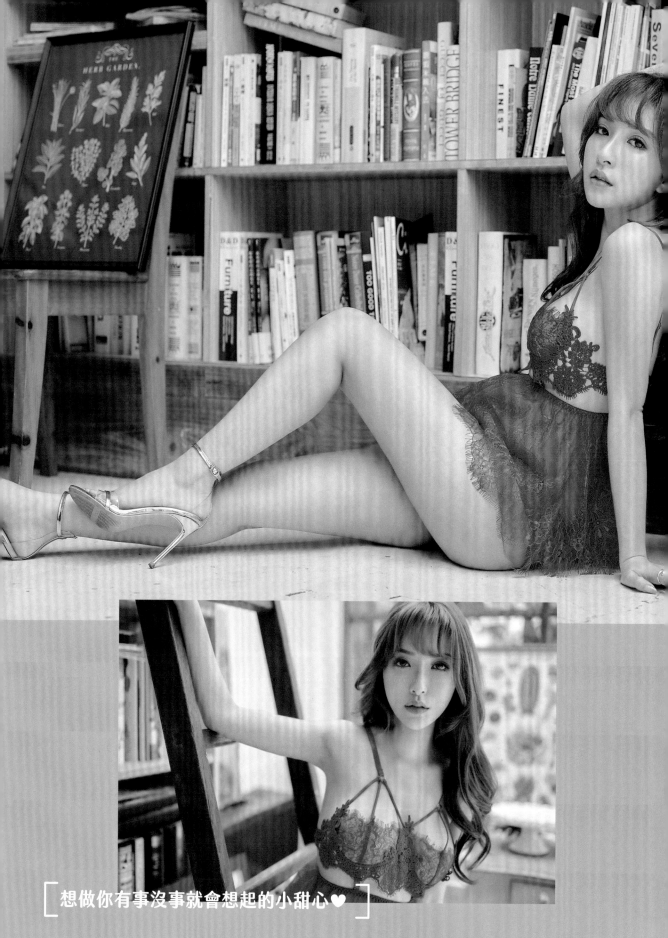

想做你有事沒事就會想起的小甜心♥

MEI GIRLS

×

2020

韓智恩

Nancy

instagram：@hanjren724

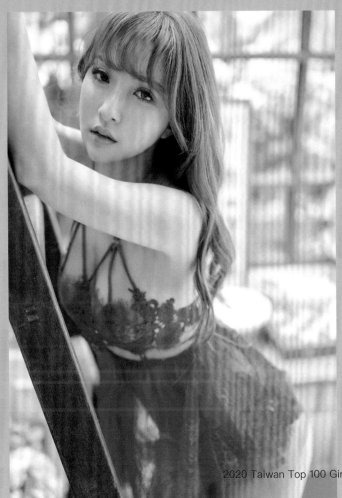

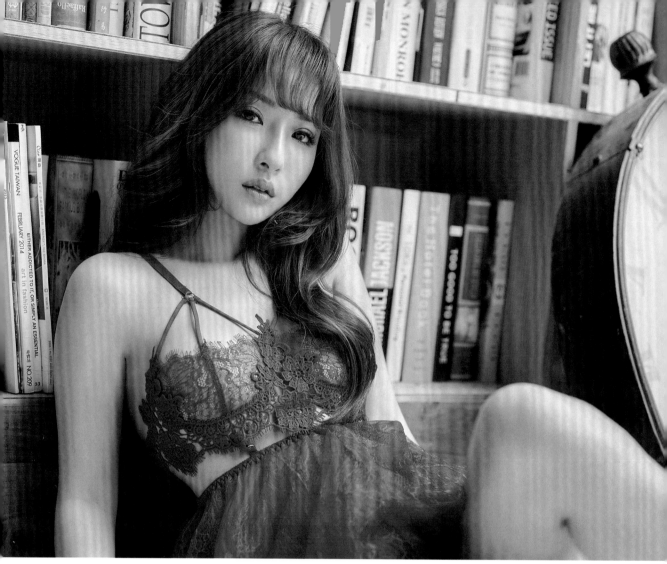

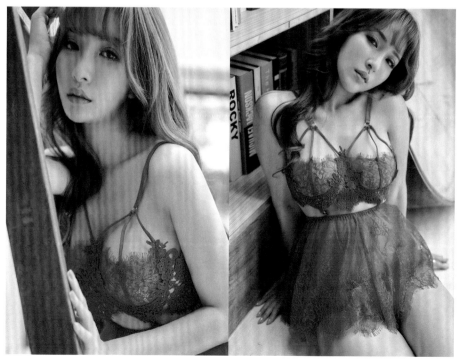

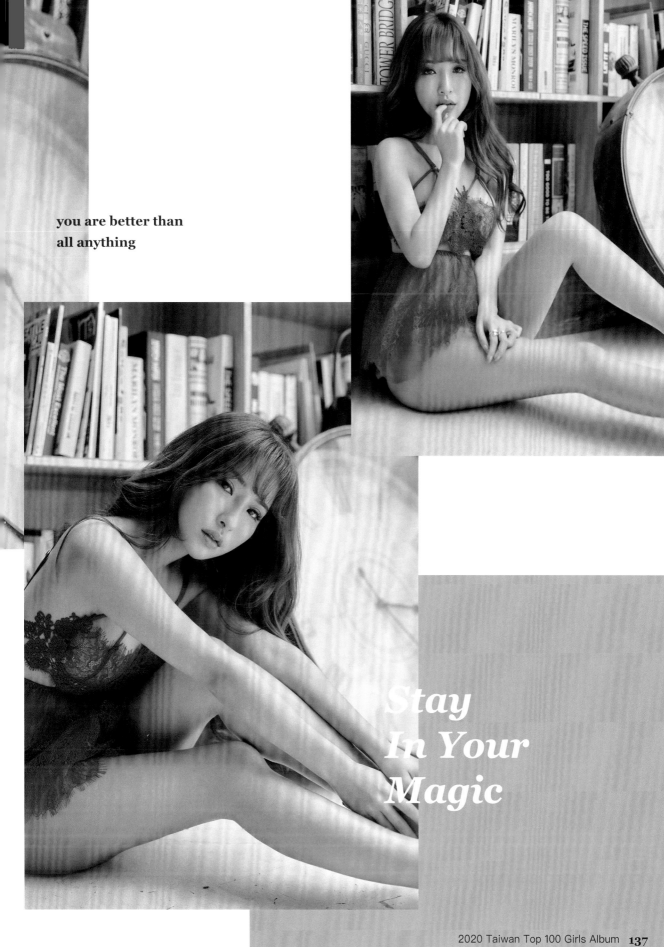

you are better than
all anything

*Stay
In Your
Magic*

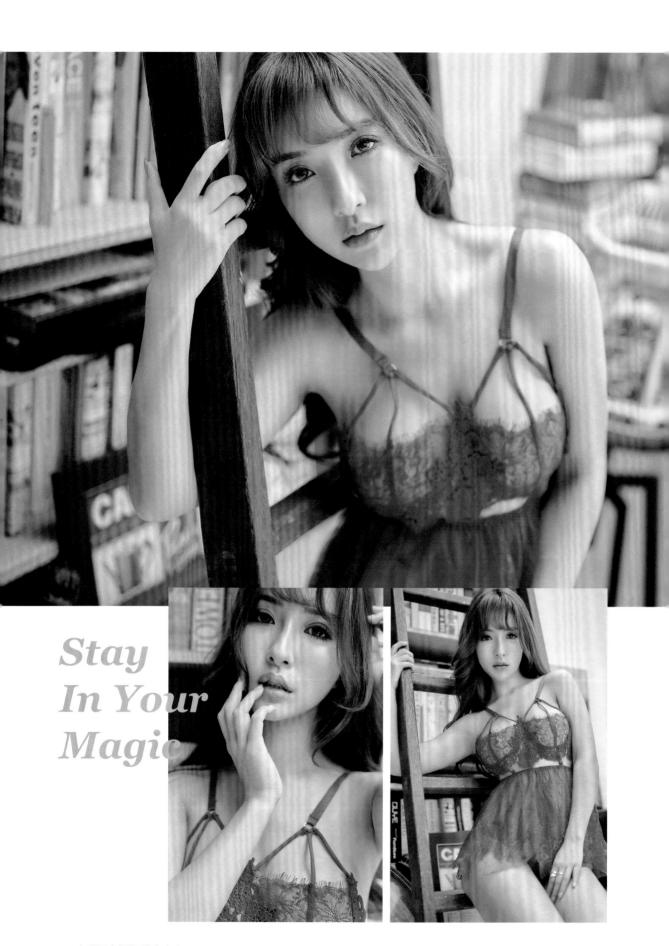

Stay
In Your
Magic

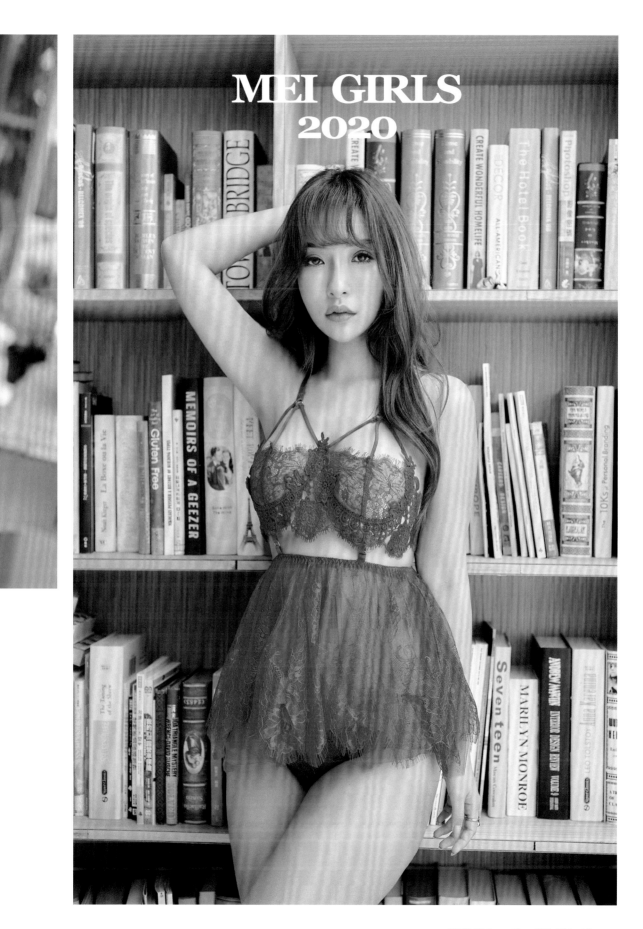

MEI GIRLS
2020

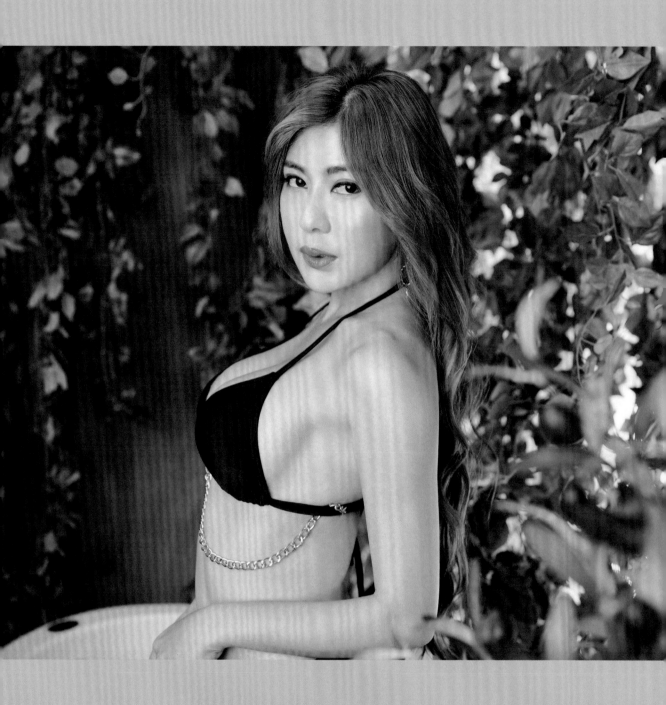

不知道怎麼動，我帶你一起做運動。

MEI
GIRLS
✕
2020

嘉嘉

Jo Jo

📷 instagram : @kity_qq

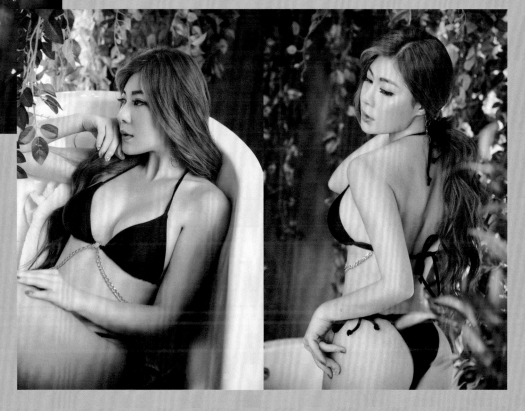

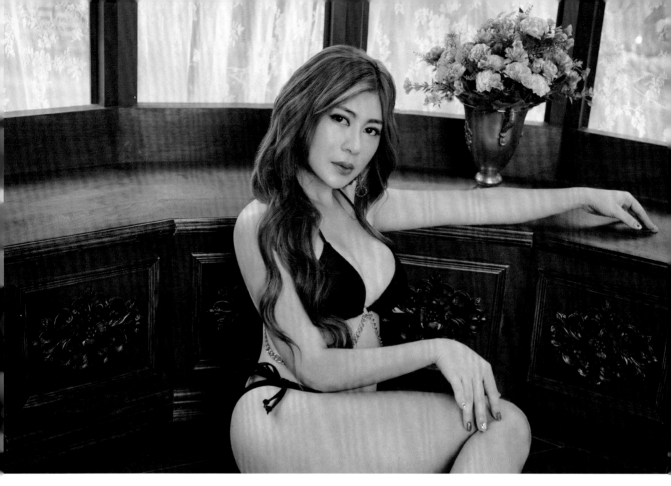

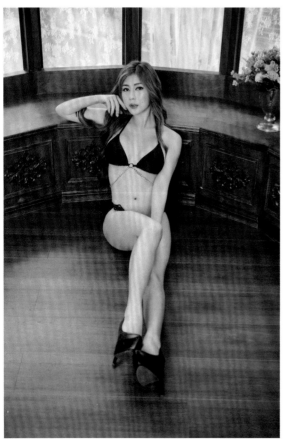

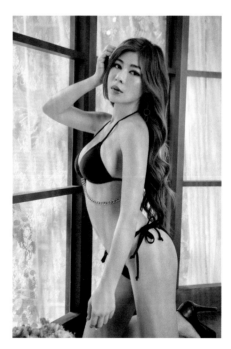

Fantasy.

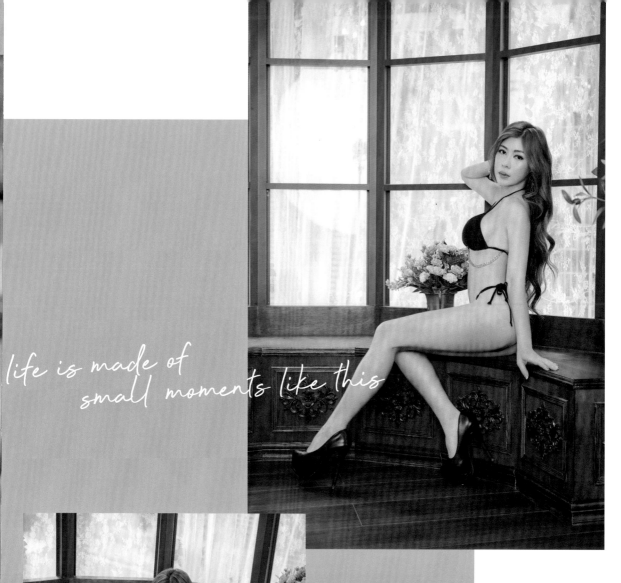

life is made of small moments like this

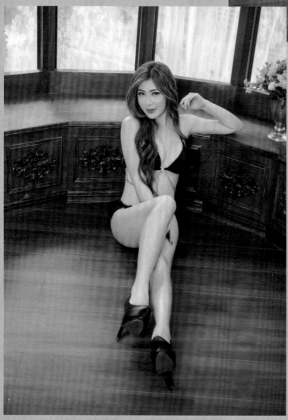

Angel Energy

-

*I'm happy when
I'm with you*

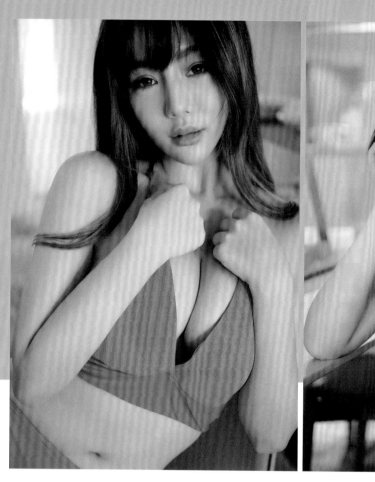
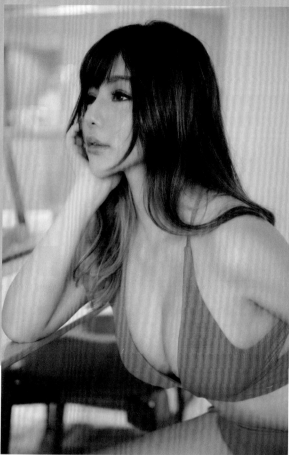

MEI GIRLS
2020
Dora

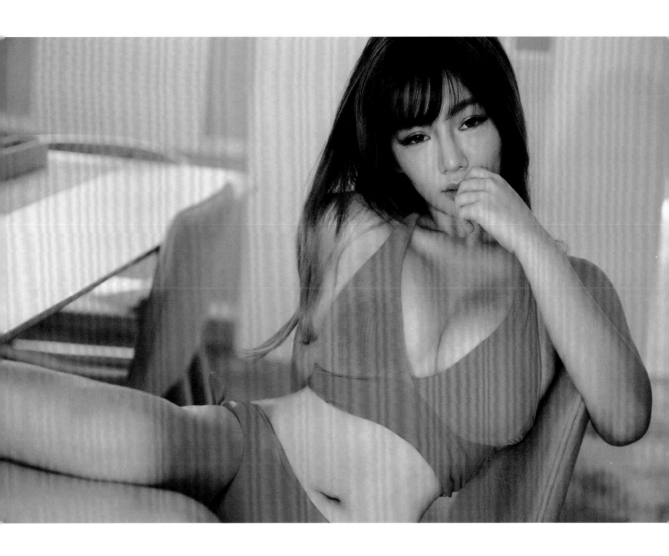

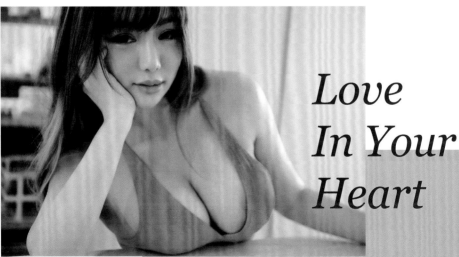

Love
In Your
Heart

-
The best thing
to hold onto
in life is each other.

MEI GIRLS

✕

2020

施菲亞

Feiya

📷 instagram：@feiya131

[我想你很忙，只要看前面三個字就好。]

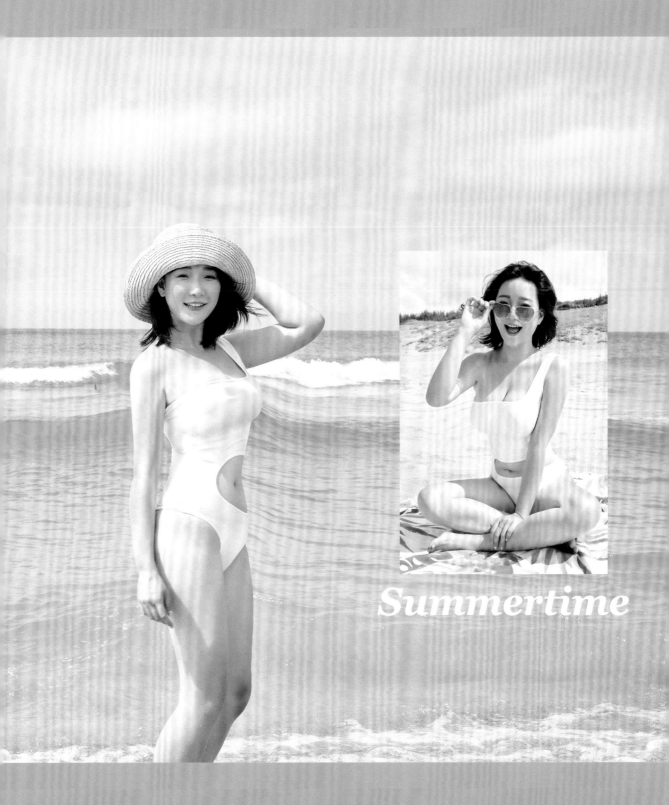

Summertime

MEI
GIRLS
2020

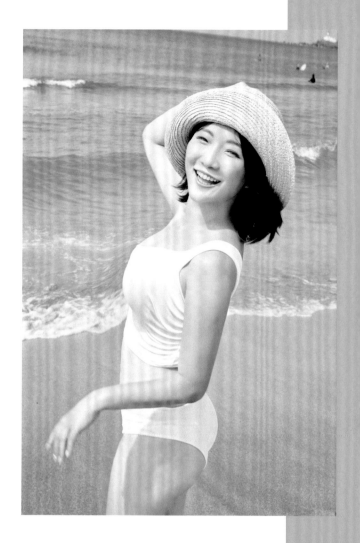

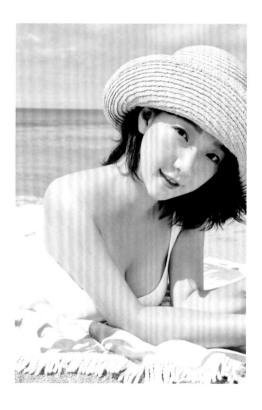

-
Closer to happiness
Than I've ever been.

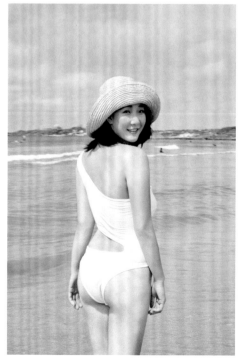

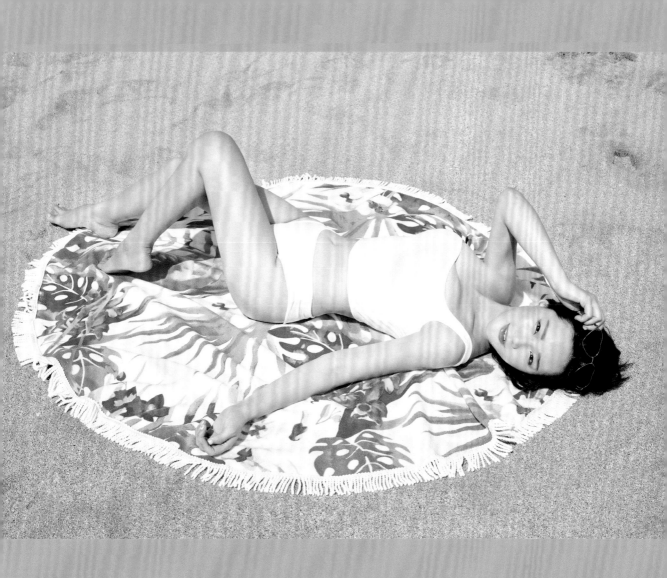

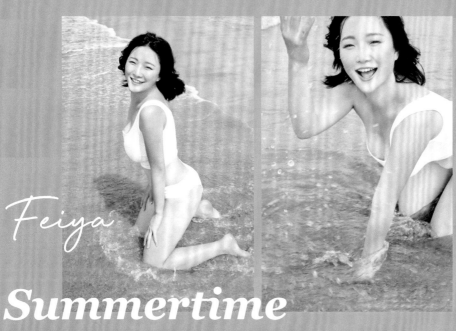

Feiya

Summertime

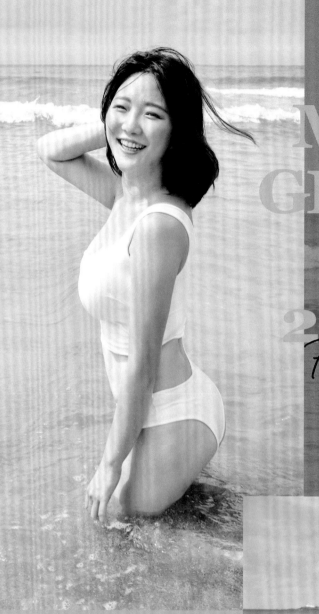

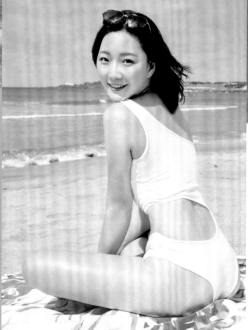

MEI
GIRLS
×
2020
Feiya

Summertime

-

Closer to happiness
Than I've ever been.

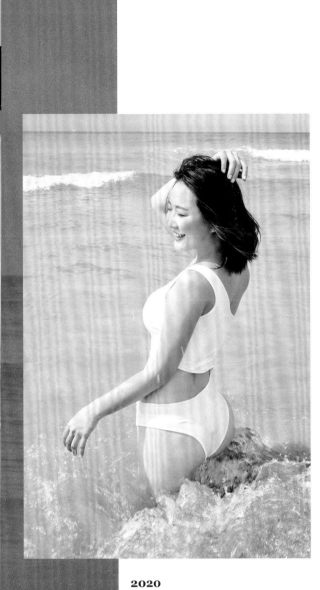

2020
Taiwan Top 100 Girls Album

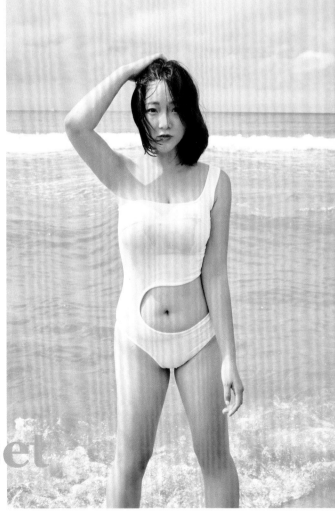

Sunset
Girl

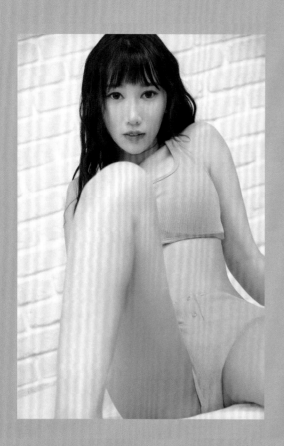

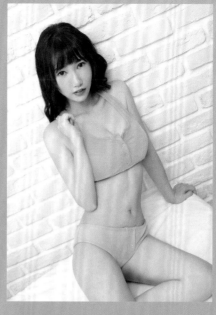

MEI GIRLS
2020

2020
Taiwan Top 100 Girls Album

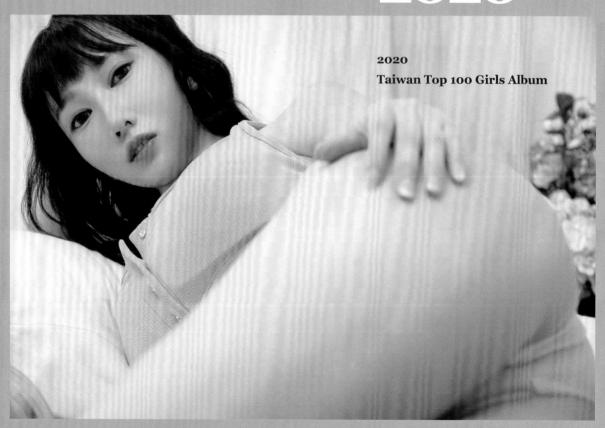

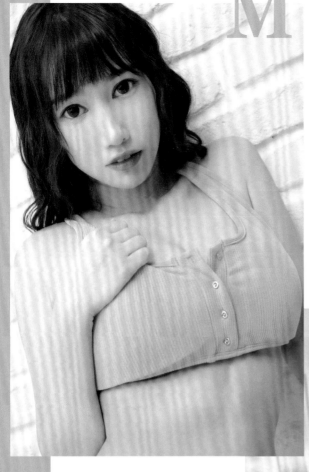

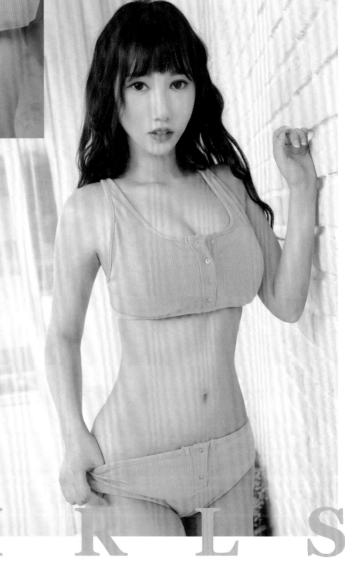

Sail
To
The Sun

love in
your eyes

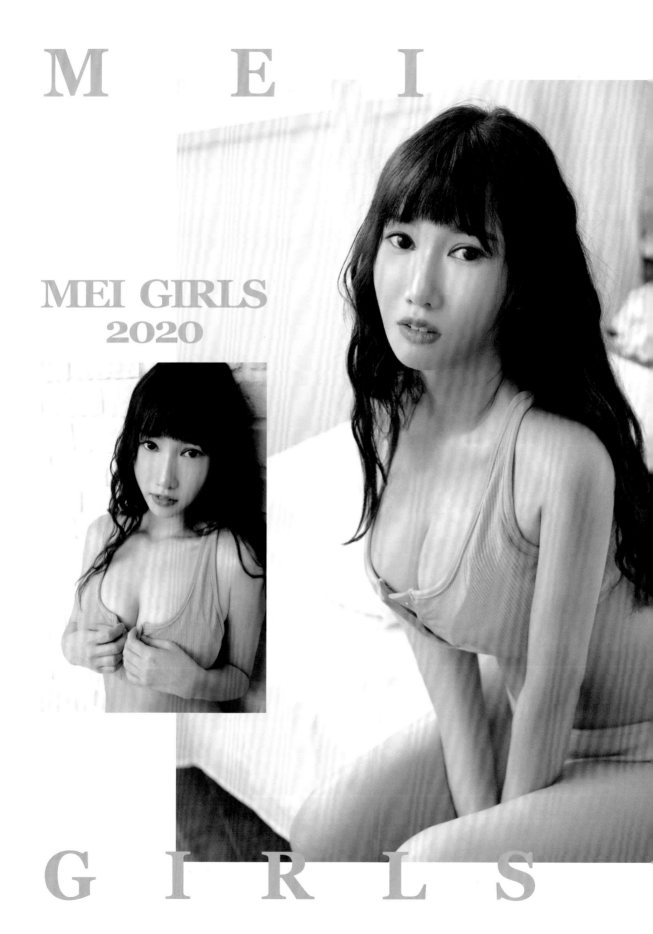

MEI

MEI GIRLS
2020

GIRLS

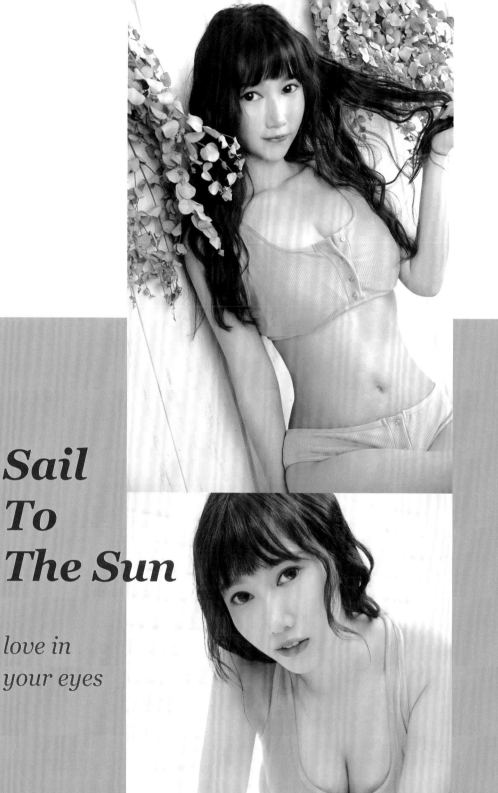

Sail
To
The Sun

*love in
your eyes*

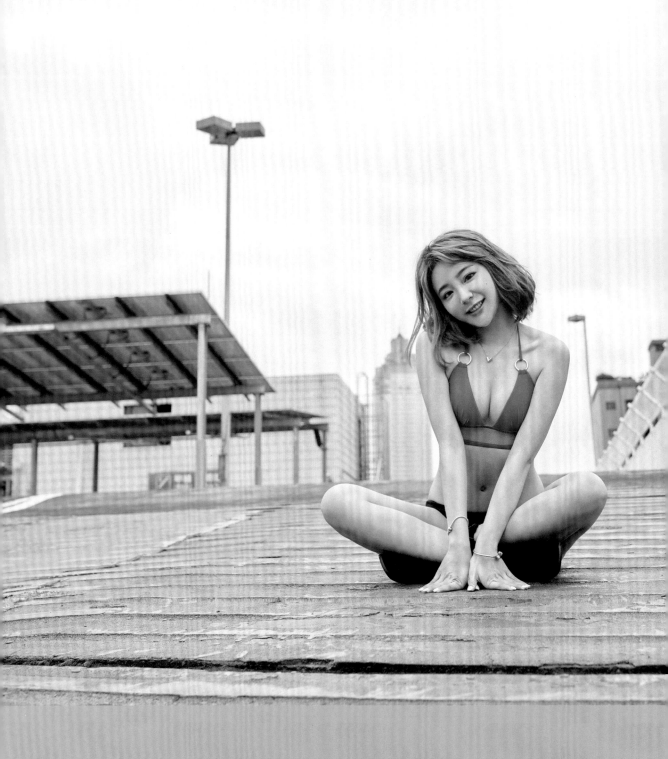

心情不好時，來看看我的照片，
你會笑的跟我一樣甜♥

MEI
GIRLS
\times
2020

瑤瑤
Nita

instagram：@yao_130

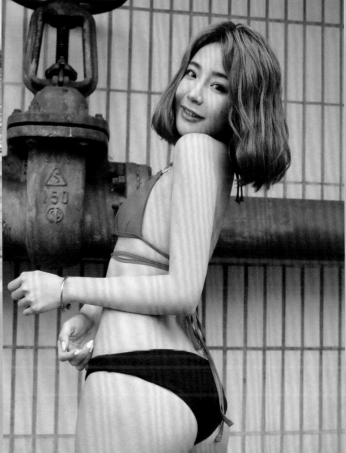

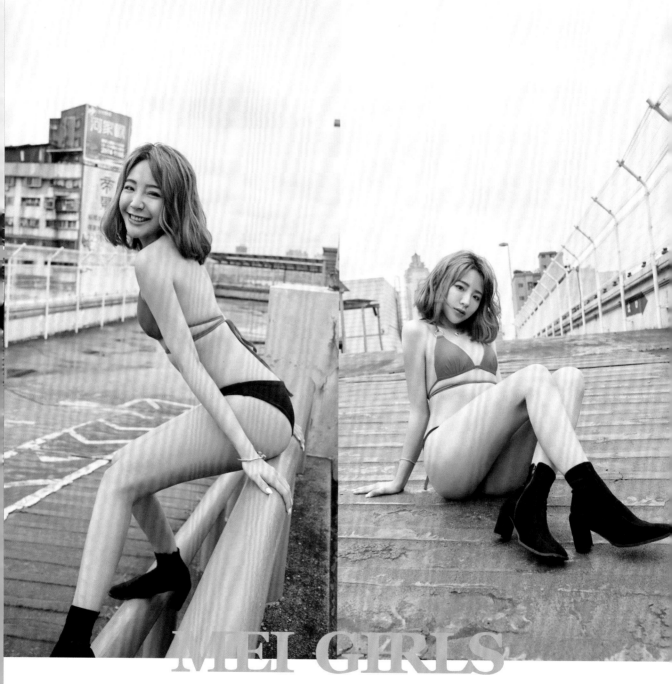

MEI GIRLS
2020
Nita

Taiwan
Top 100 Girls Album

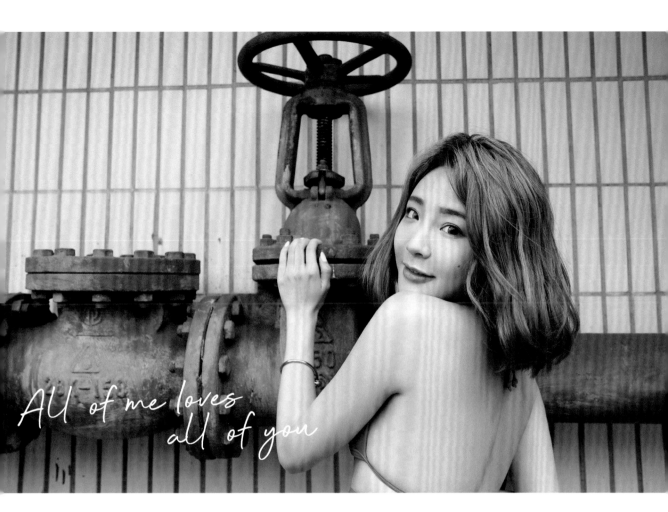

All of me loves
all of you

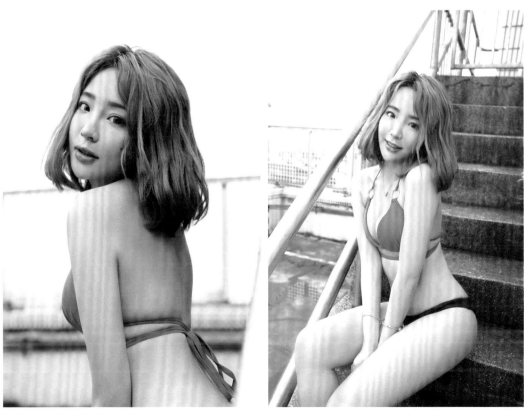

MEI
GIRLS
✕
2020

嵐芯語
糖果

instagram：@lanxinyu716

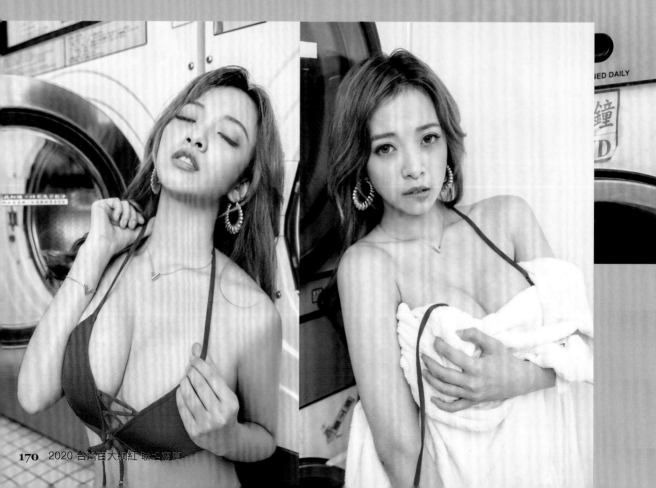

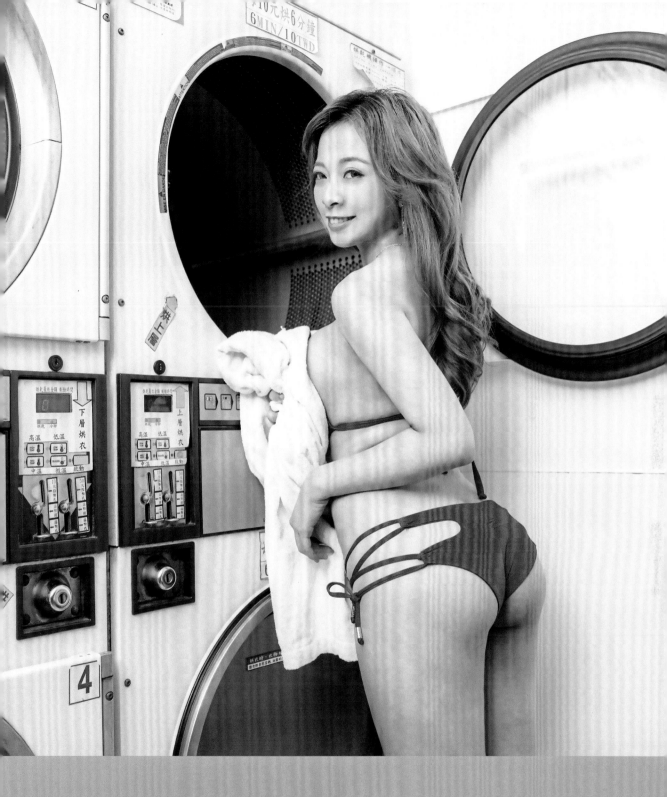

多希望壓著讓我喘不過氣的不是生活，
而是你♥

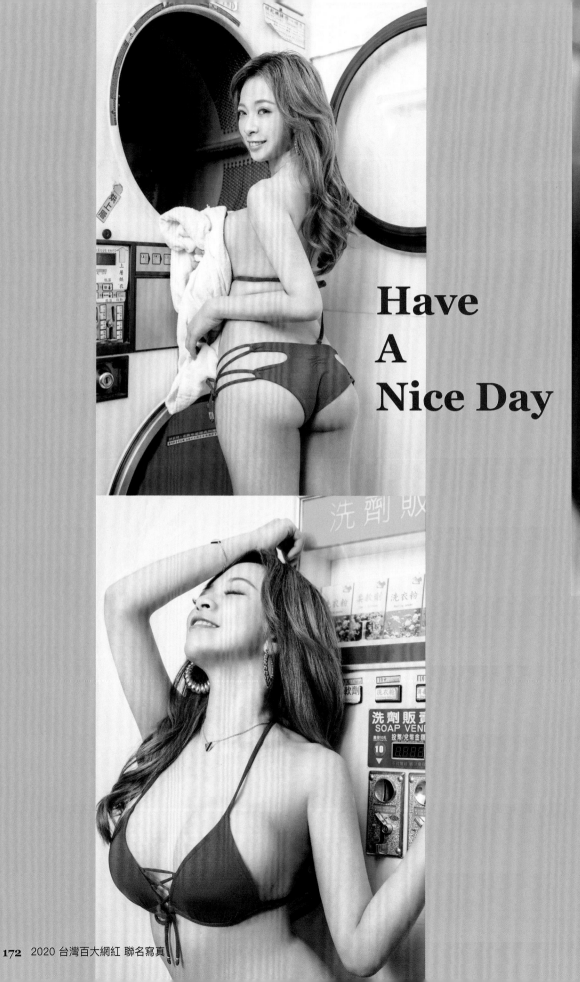

Have
A
Nice Day

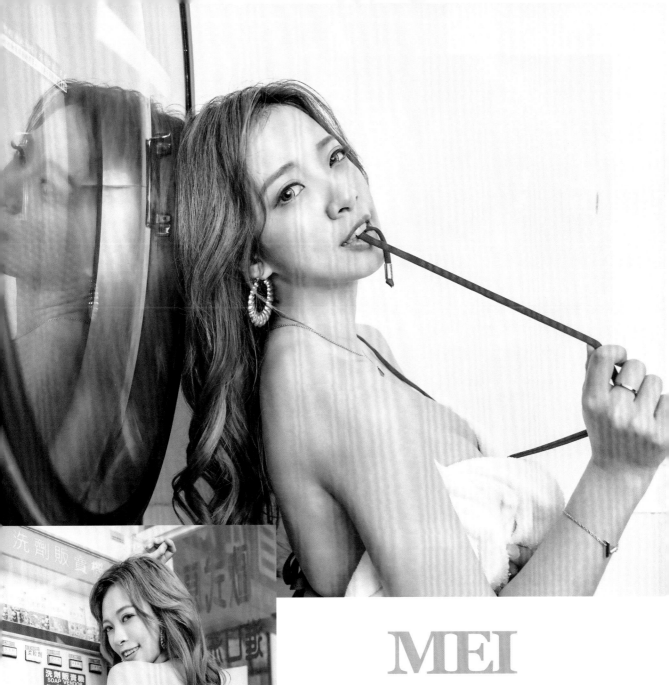

MEI
GIRLS
×
2020

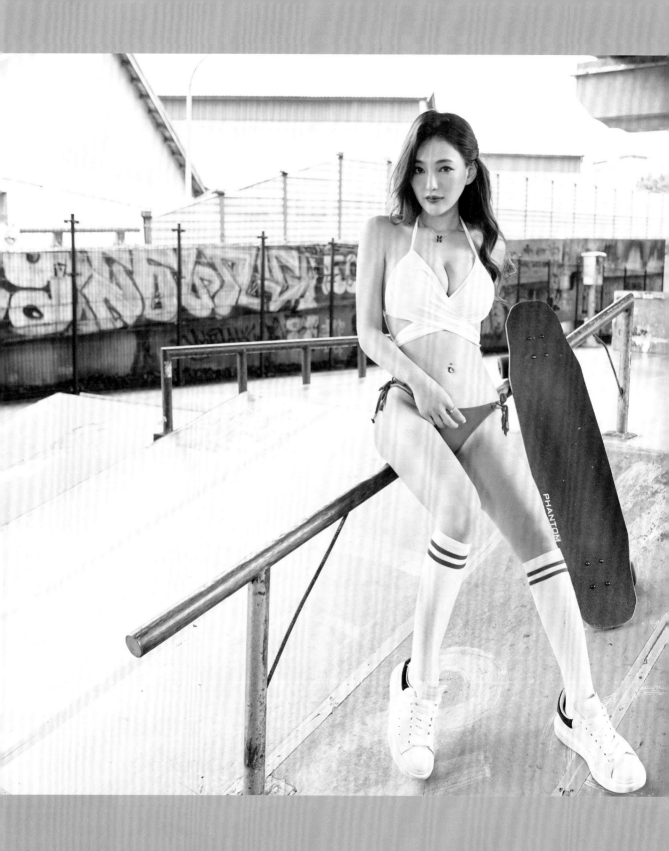

不要迷戀哥，嫂子會揍你。

MEI
GIRLS
✕
2020

奶妹
Donna

📷 instagram：@milk__2020

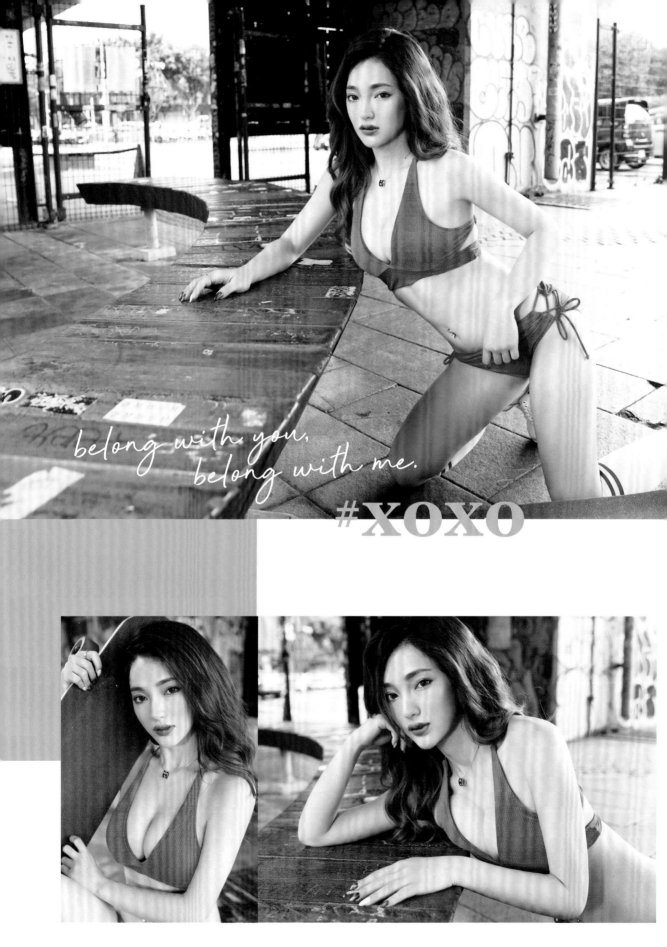

belong with you,
belong with me.

#XOXO

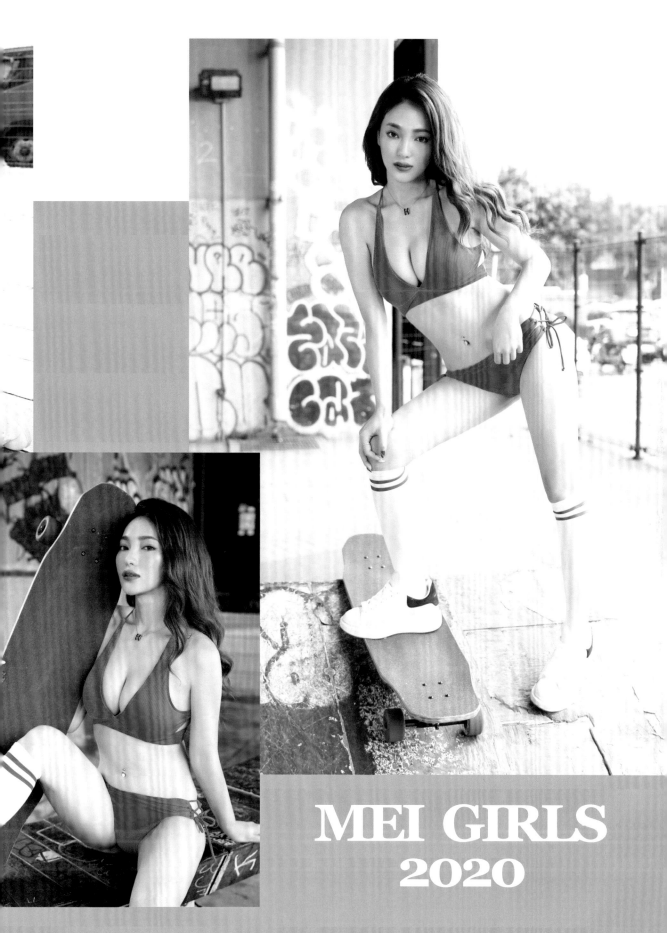

MEI GIRLS 2020

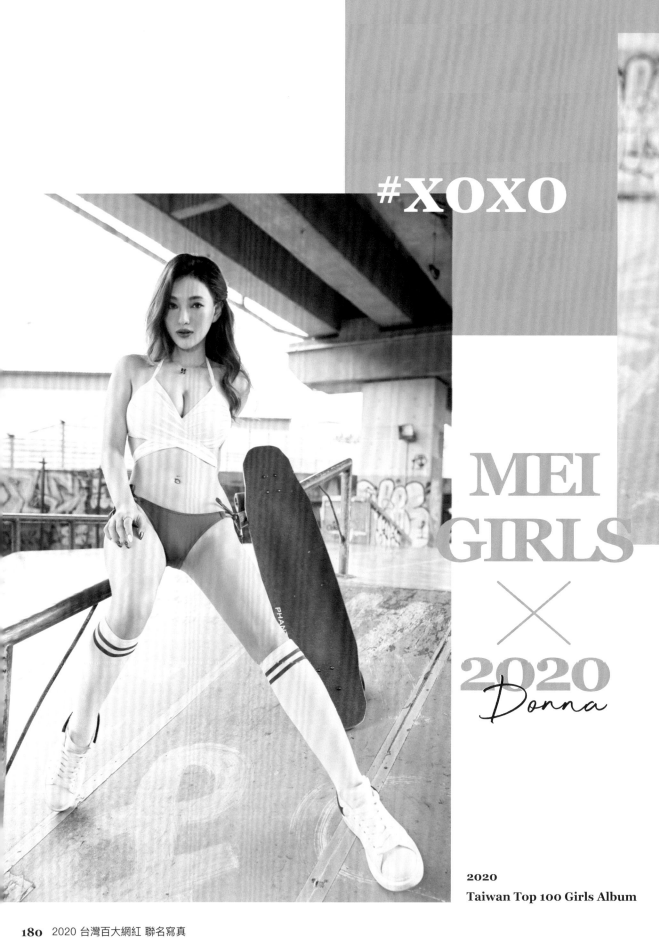

#XOXO

MEI
GIRLS
✕
2020
Donna

2020
Taiwan Top 100 Girls Album

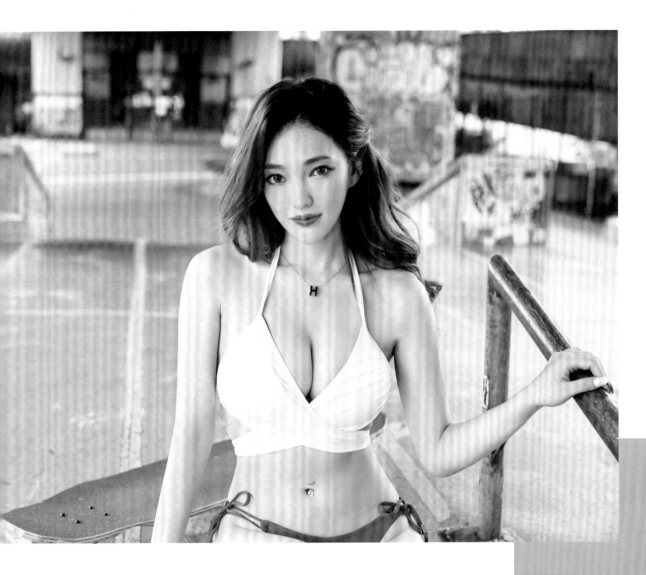

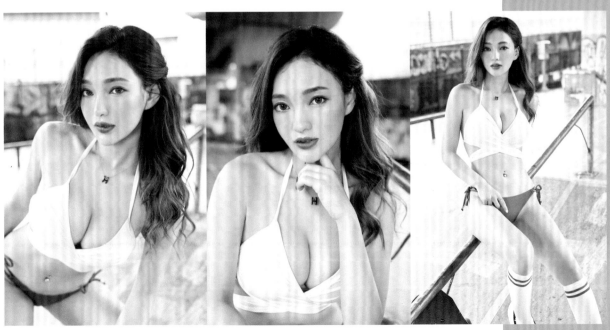

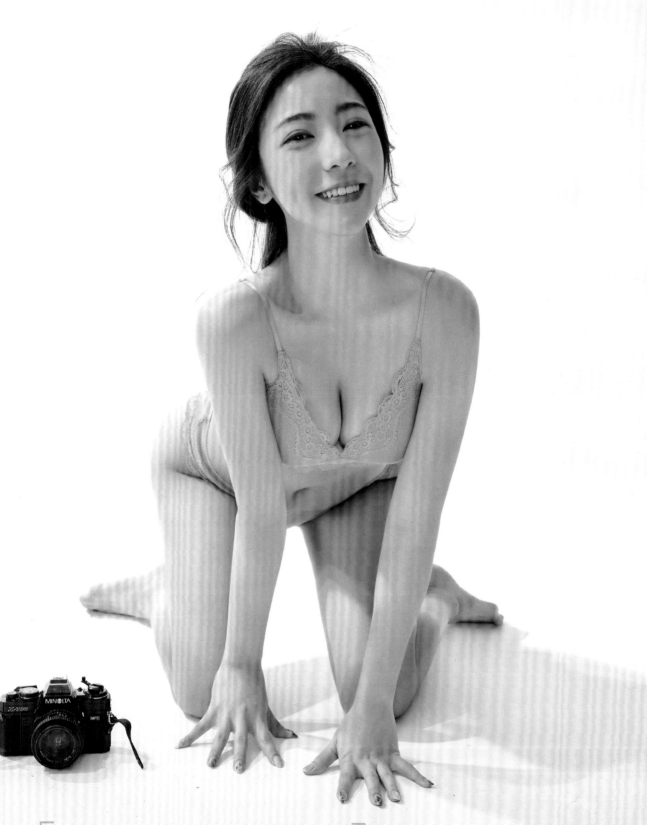

［ 我的心思很好猜，除了你就是發大財 ］

MEI
GIRLS
✕
2020

小曖
Aihsieh

instagram : @aihsieh

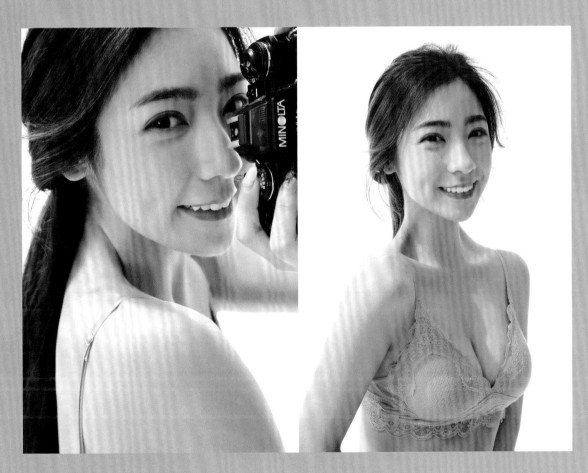

MEI
GIRLS
✕
2020

邱比特

Judy

📷 instagram：@judy_qqq

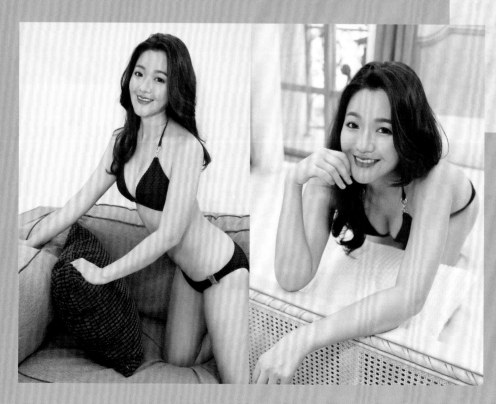

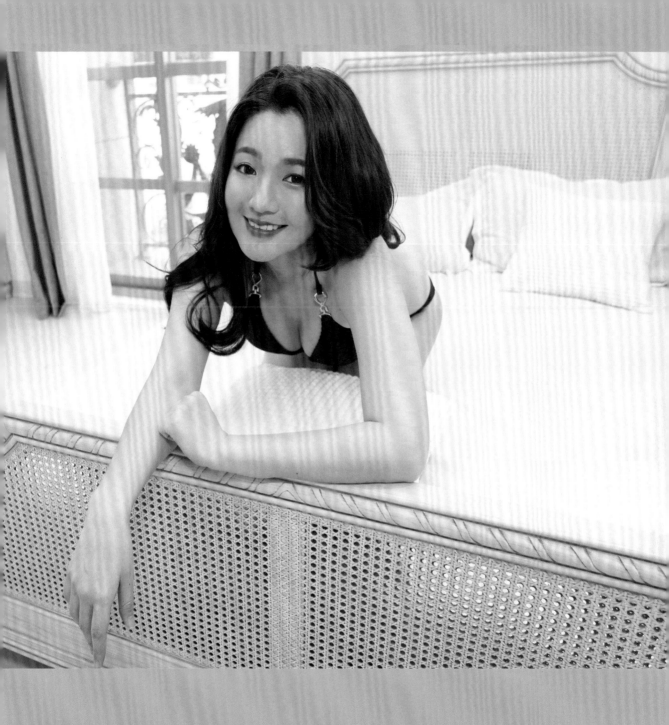

[我可能不完美，但我至少不虛偽。]

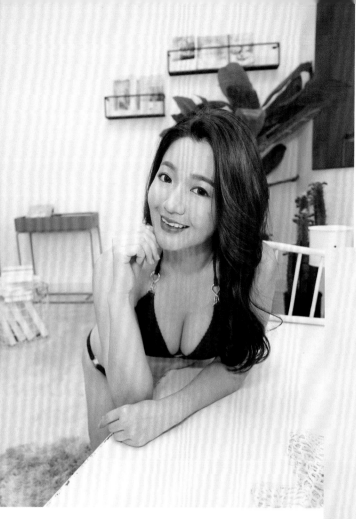

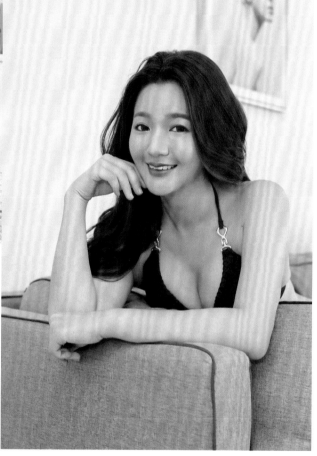

MEI
GIRLS
✕
2020
Judy

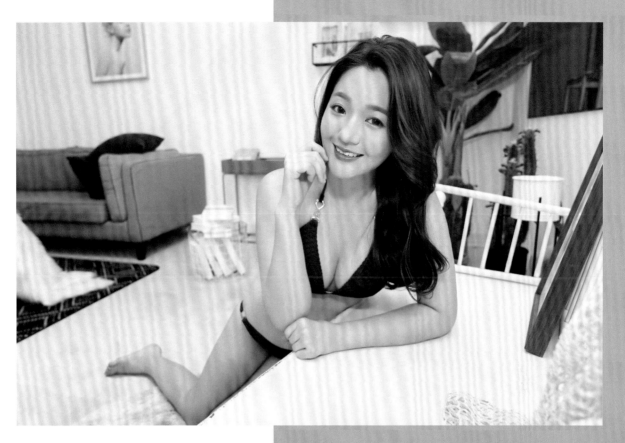

Love Your Self

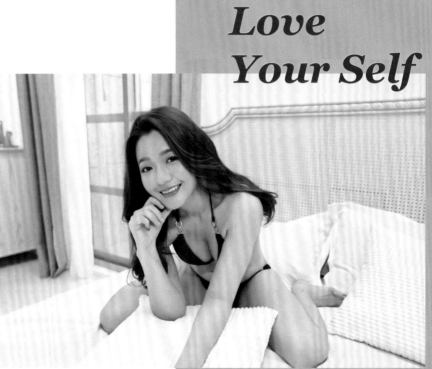

2020
Taiwan Top 100 Girls Album

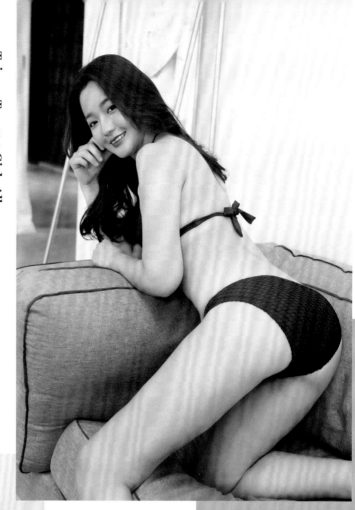

Relax

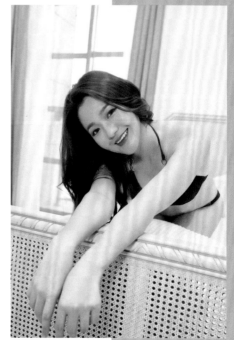

Love
Your Self

2020
Taiwan Top 100 Girls Album

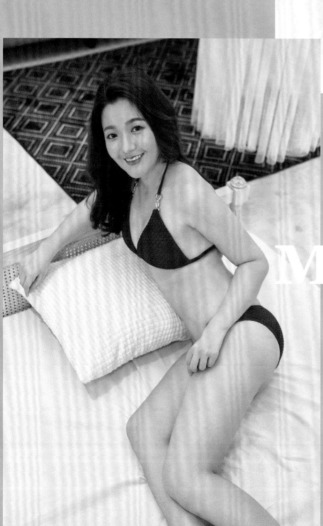

MEI GIRLS
2020
Judy

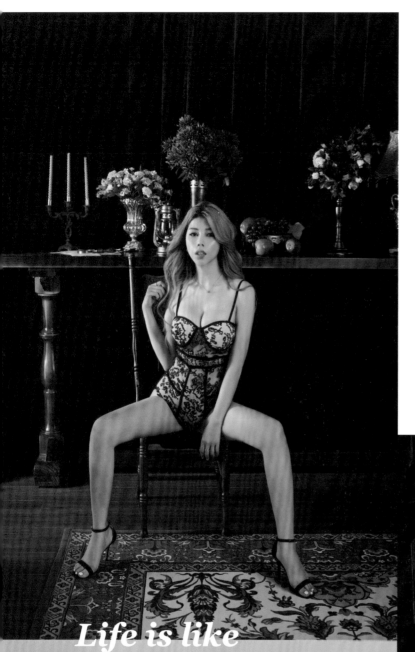

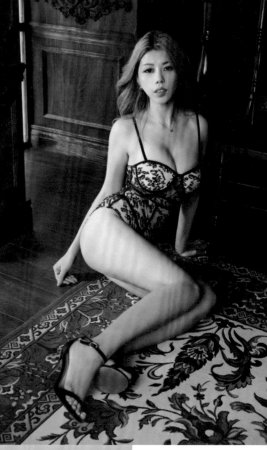

MEI
GIRLS
2020

Life is like
A box of
Chocolates

2020
Taiwan Top 100 Girls Album

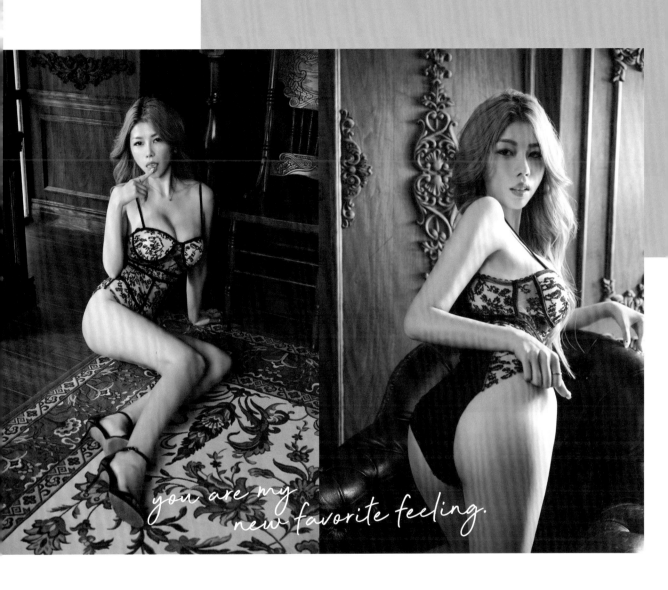

you are my new favorite feeling.

Take my hand and
My whole life too.
I can't help falling in love
With you

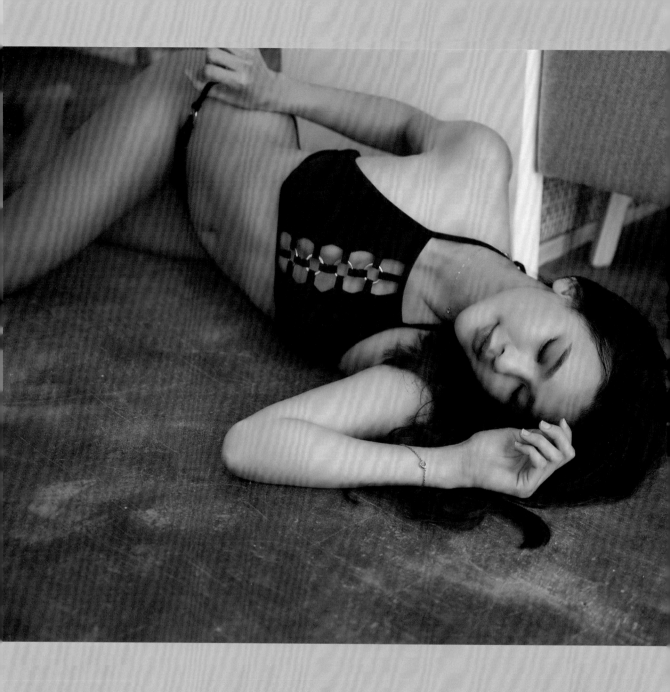

[我的心胸很狹小，但用來裝你剛剛好。]

MEI GIRLS

✕

2020

小蜥晰

⬡ instagram ： @yammy0720

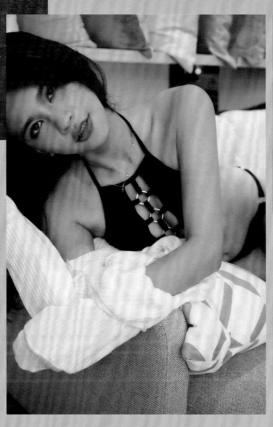

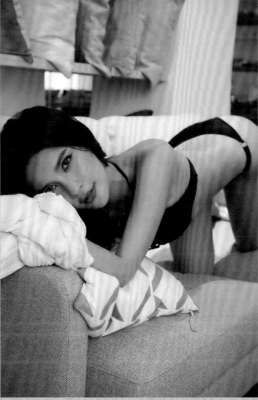

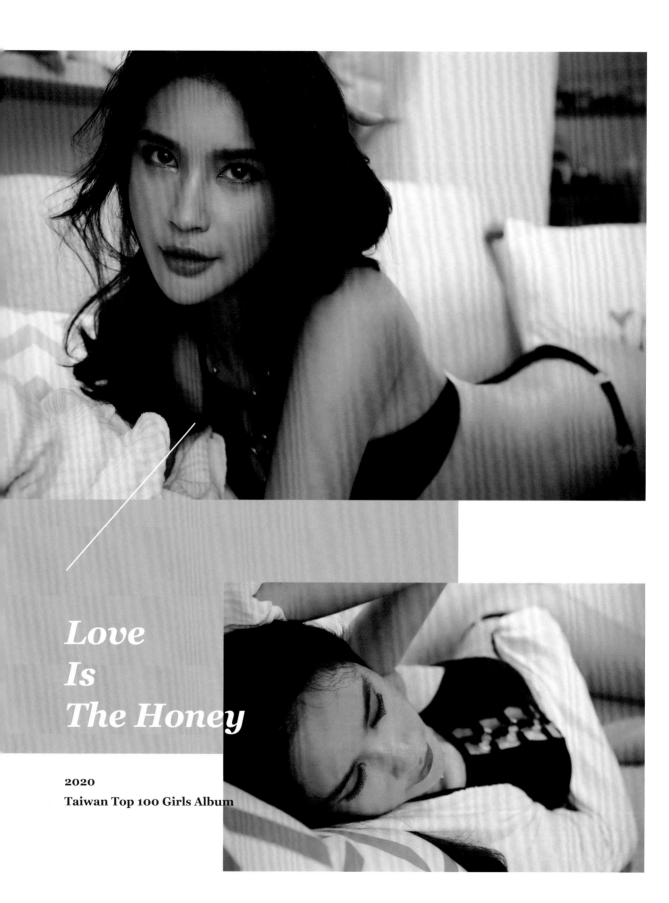

Love
Is
The Honey

2020
Taiwan Top 100 Girls Album

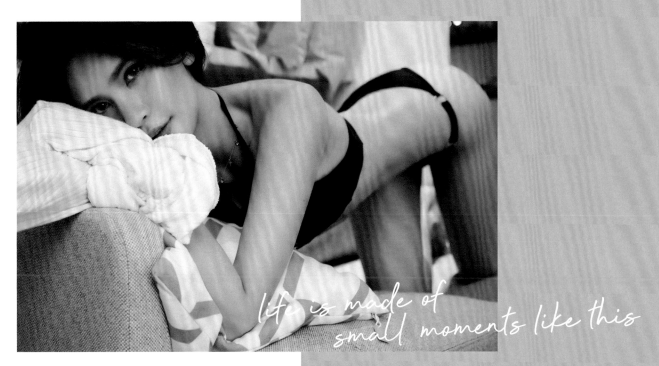

life is made of
small moments like this

Life is the flower
for which love is
the honey

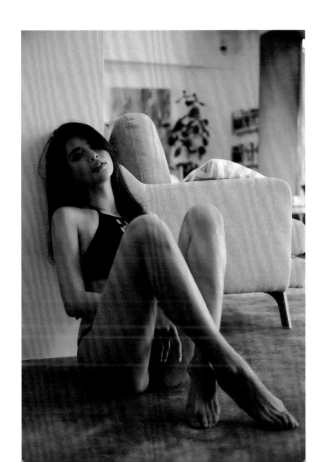

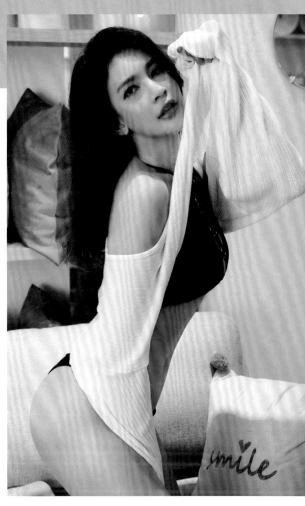

MEI
GIRLS
2020

2020
Taiwan Top 100 Girls Album

Life is the flower
for which love is
the honey

Love
Is
The Honey

**Life is the flower
for which love is
the honey**

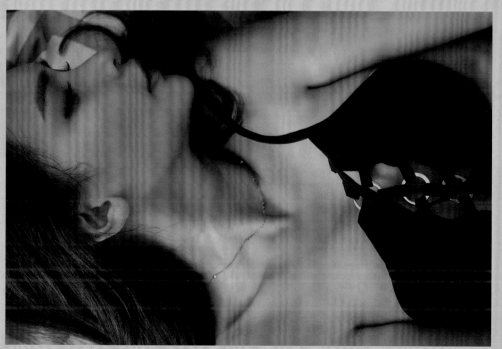

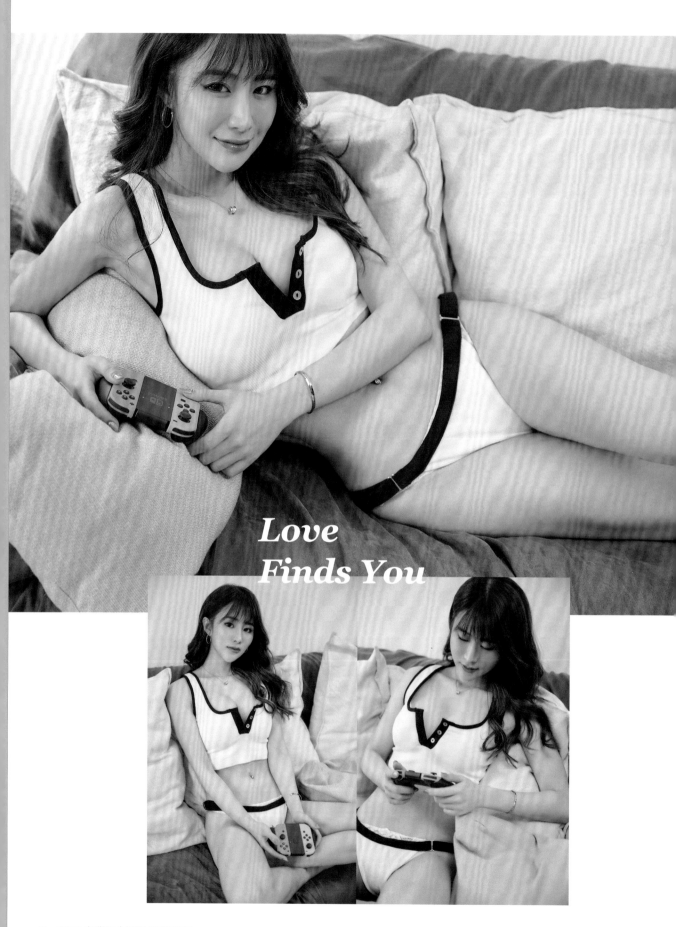

Love
Finds You

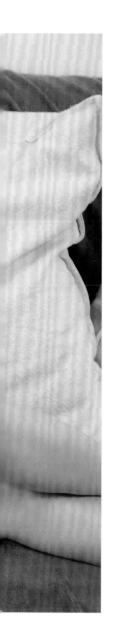

MEI GIRLS
2020
Shan

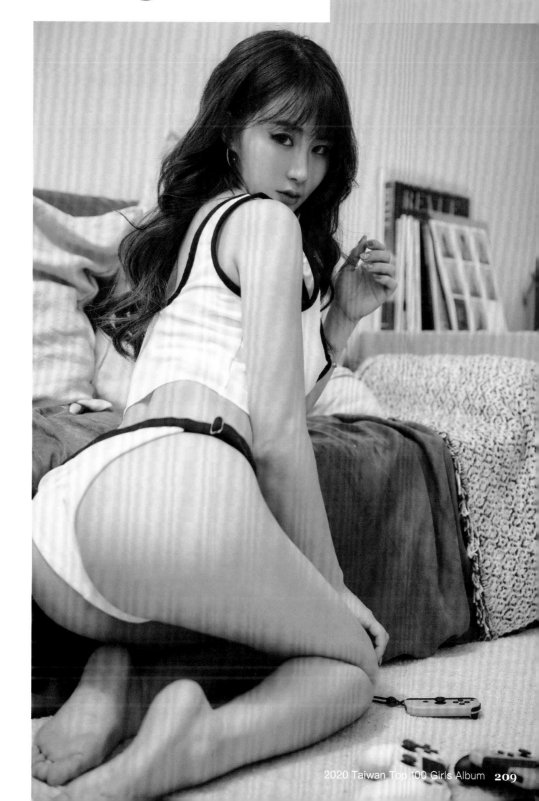

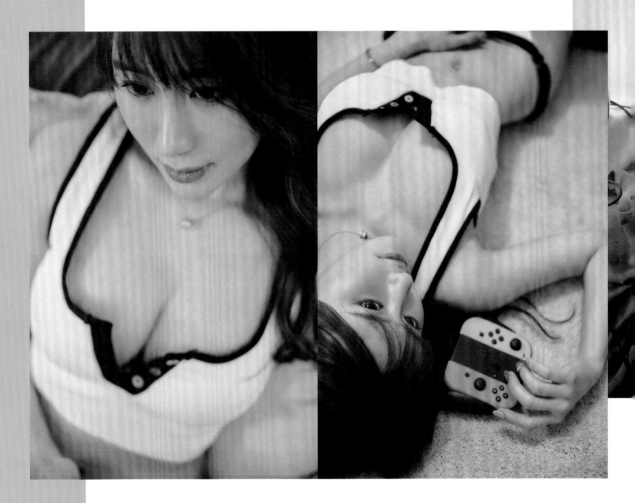

MEI GIRLS
2020
Shan

-

**life is made of
small moments like this.**

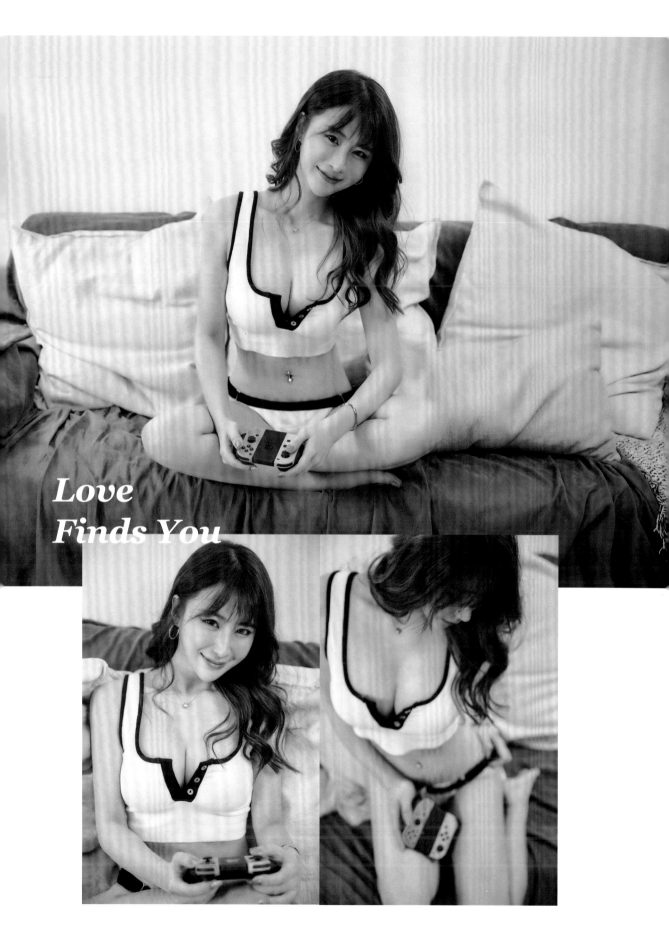

Love
Finds You

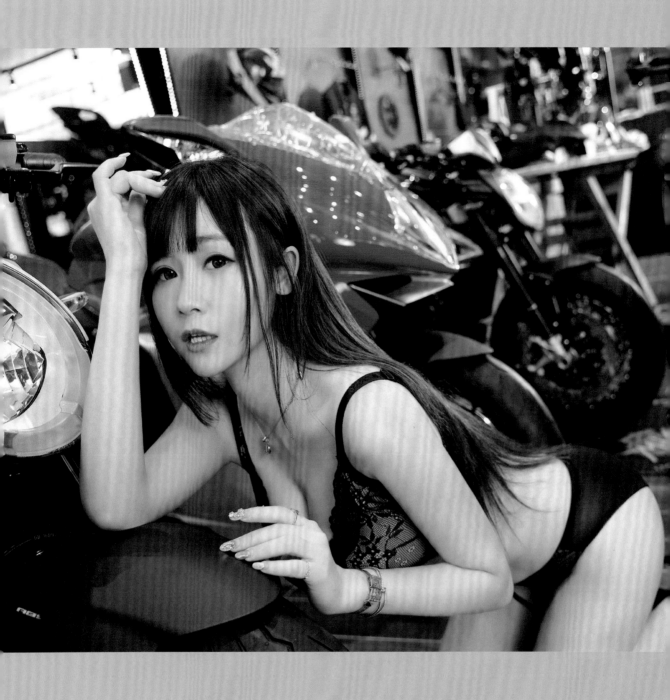

希望我的奇奇怪怪，能成為你眼裡的可可愛愛 ❤

MEI GIRLS

✕

2020

小林兒
Royi

:camera: instagram : @yiyibaby02

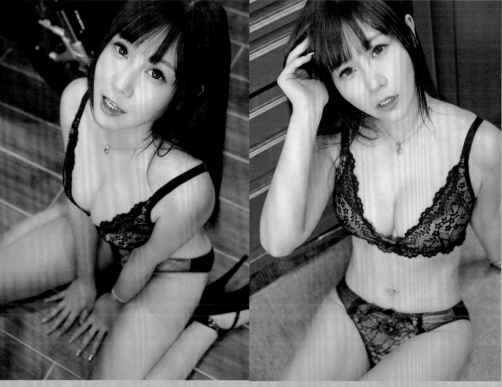

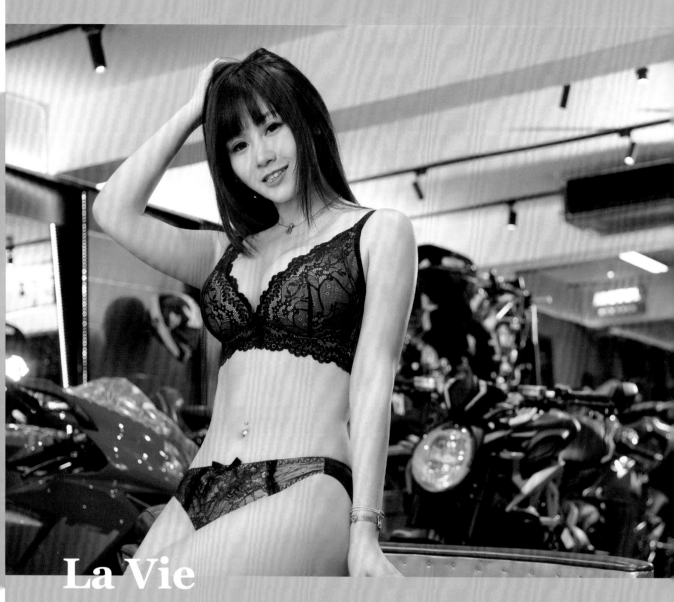

La Vie
Est Belle

Taiwan Top 100 Girls Album

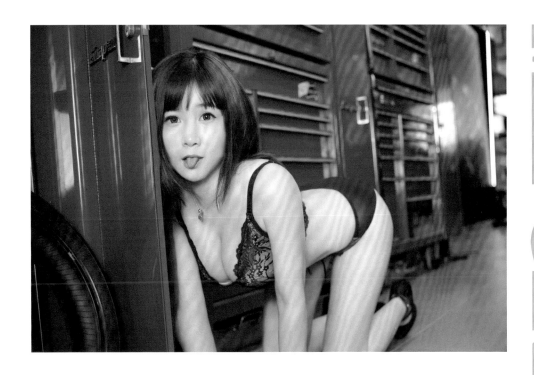

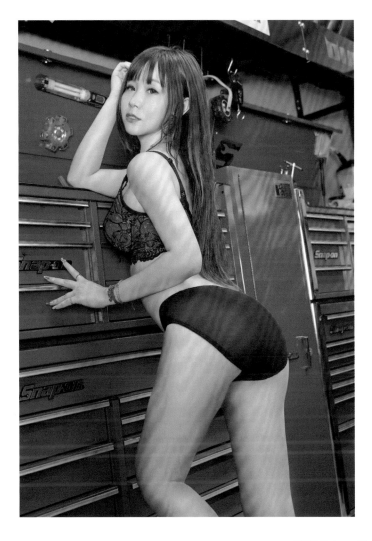

MEI GIRLS

\times

2020

甜甜寶
Kawayi

instagram : @audy8261300

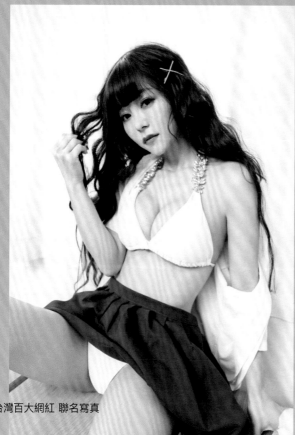

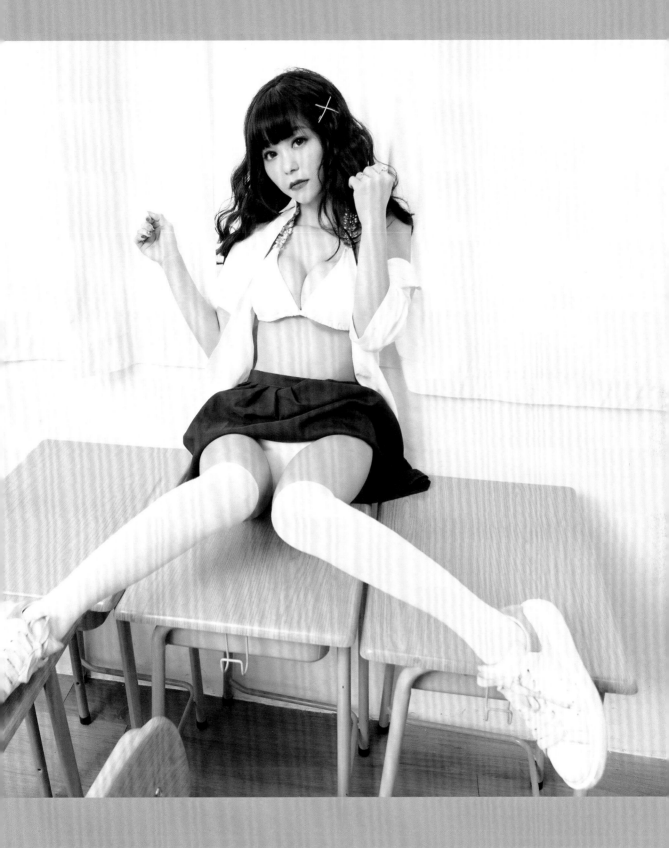

[我可以在淘宝上架嗎？因為我也想當你的宝貝]

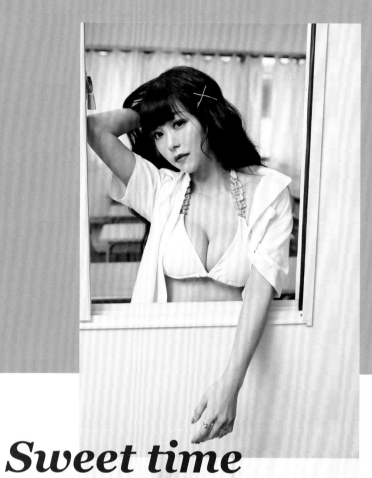

Sweet time

The best thing to hold onto
in life is each other.

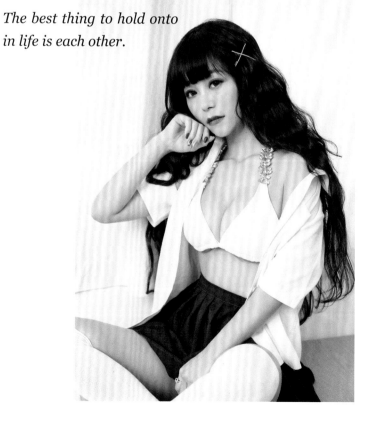

2020
Taiwan
Top 100 Girls Album

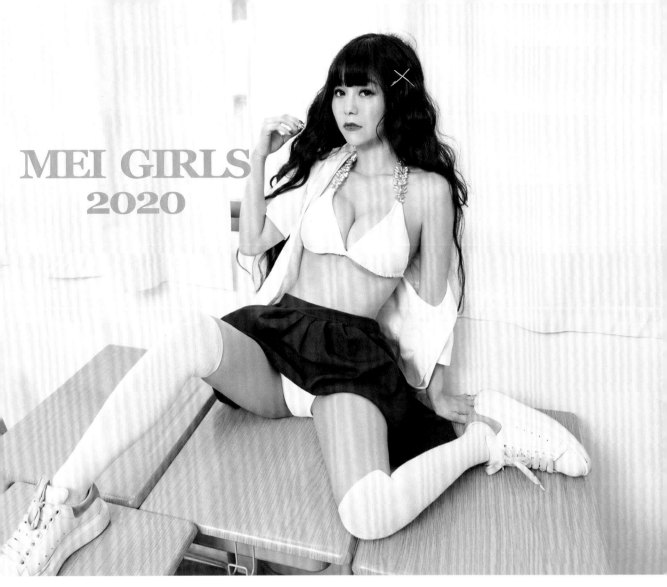

MEI GIRLS
2020

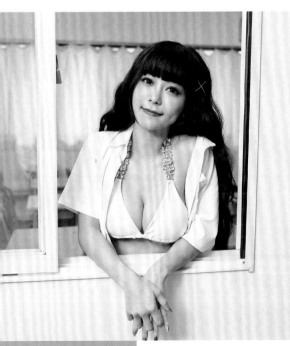

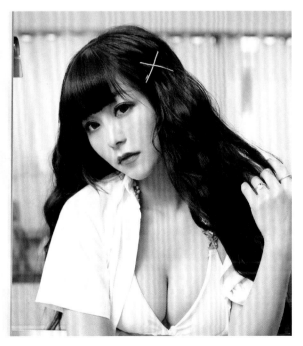

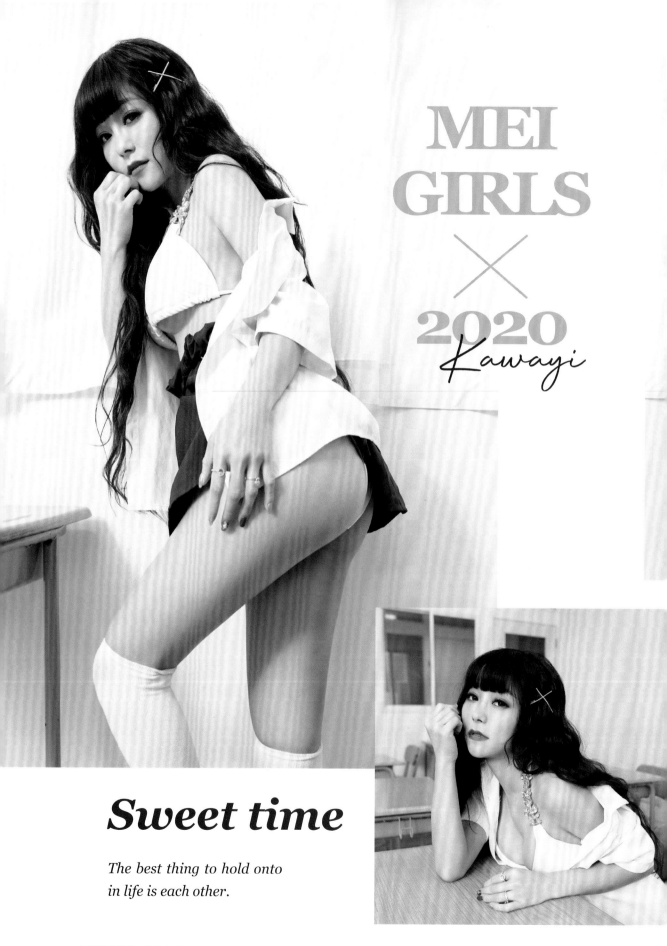

MEI
GIRLS
×
2020
Kawayi

Sweet time

*The best thing to hold onto
in life is each other.*

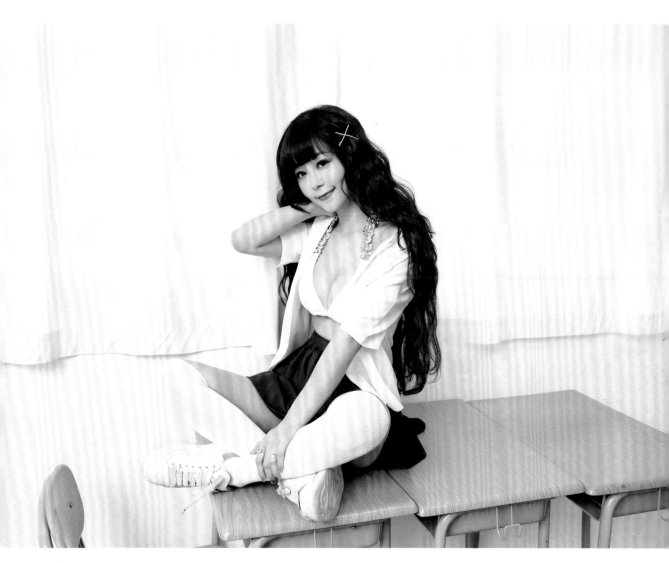

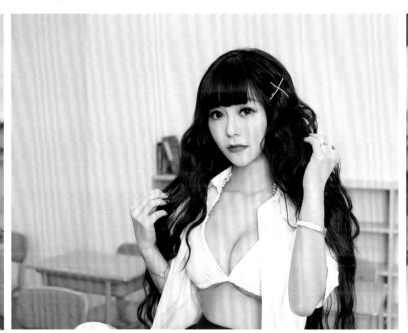

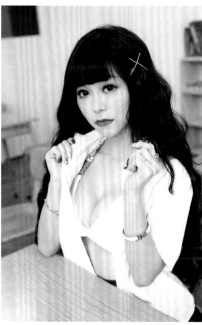

MEI
GIRLS
✕
2020

阿乃

Sinni

⃝ instagram : @sinni_yaya

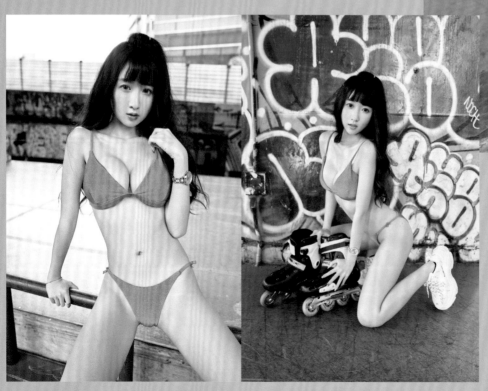

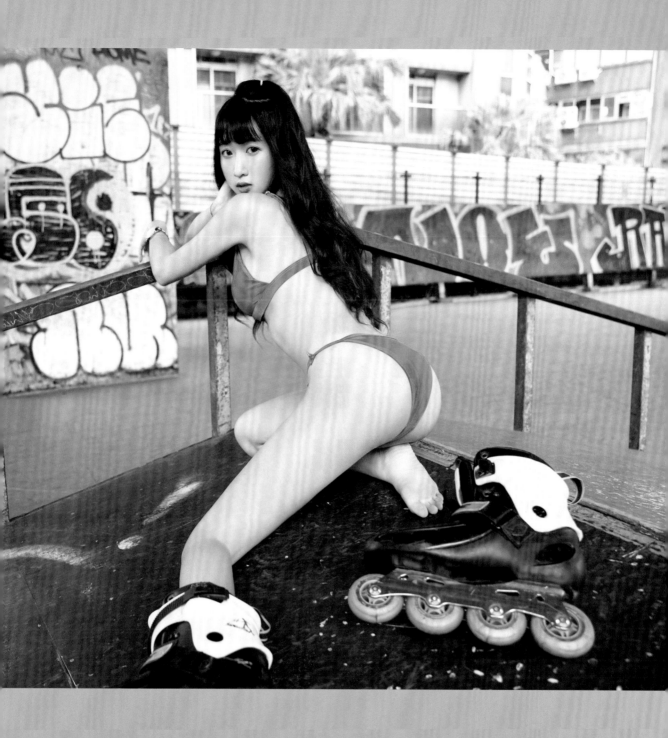

他們都很迷人，我不一樣我磨人。

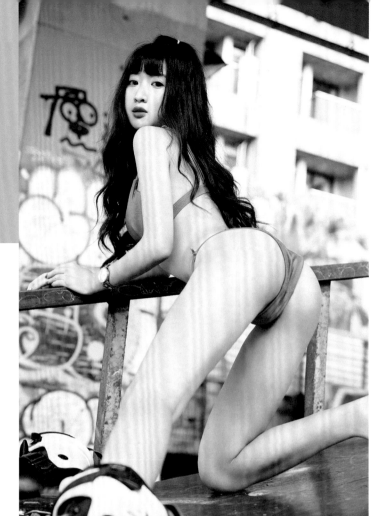

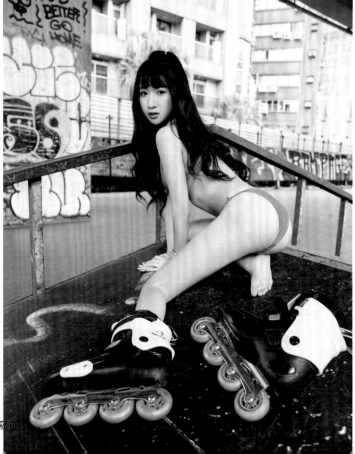

MEI GIRLS 2020

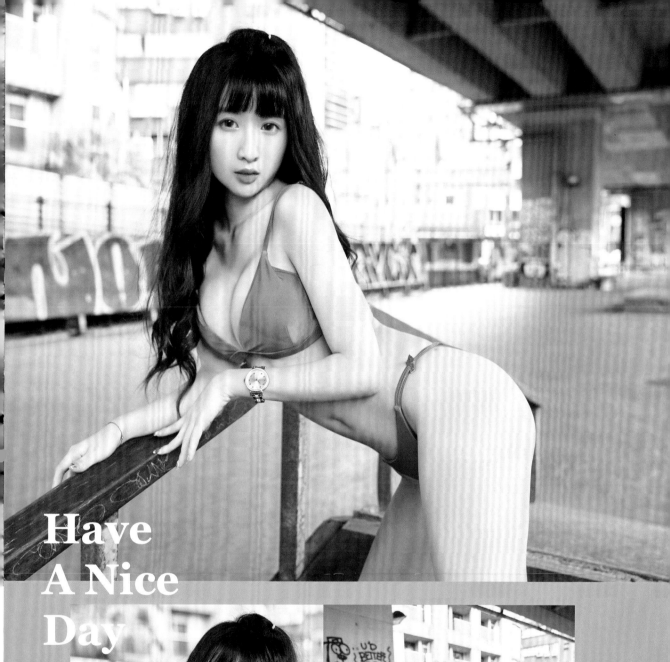

Have
A Nice
Day

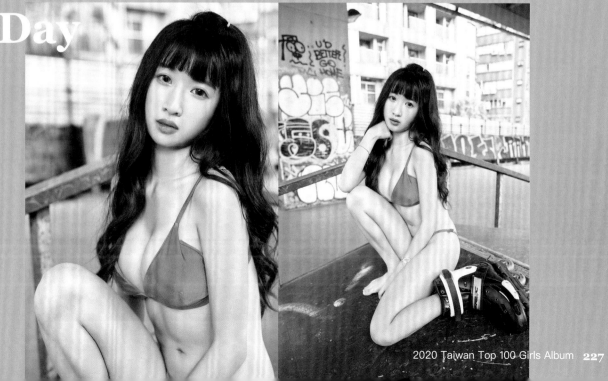

MEI
GIRLS
×
2020

圓圓

Cynthia

📷 instagram : @ccynthia1996

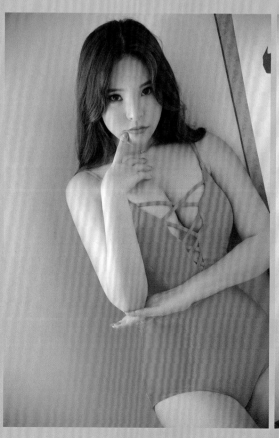

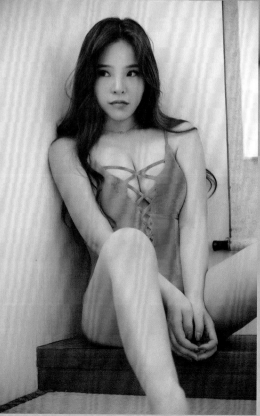

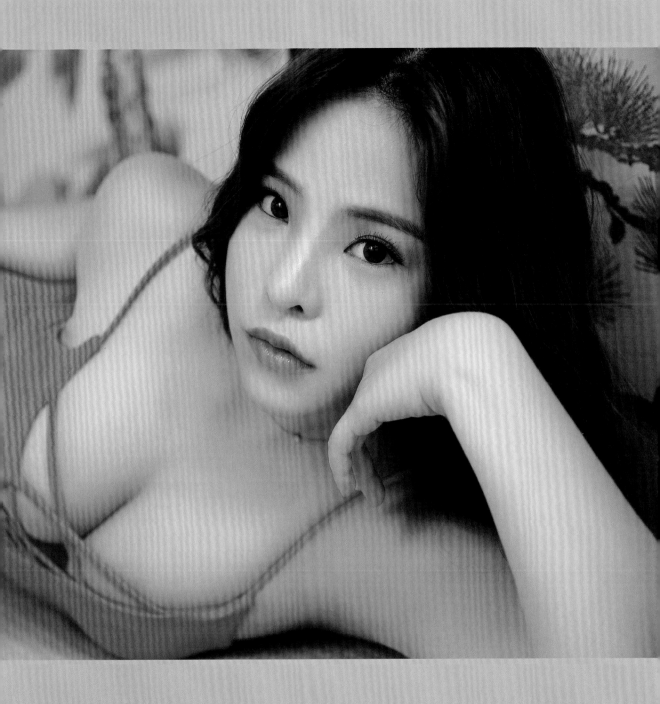

只要對象換得快，沒有悲傷只有❤

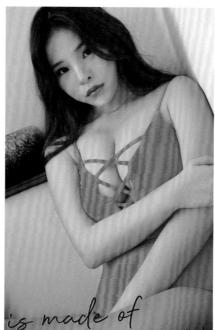

life is made of small moments like this

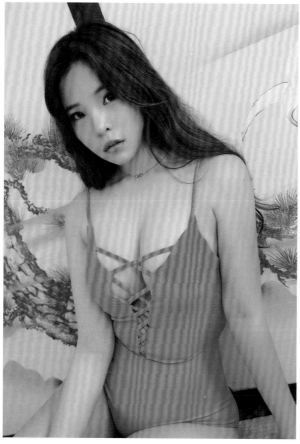

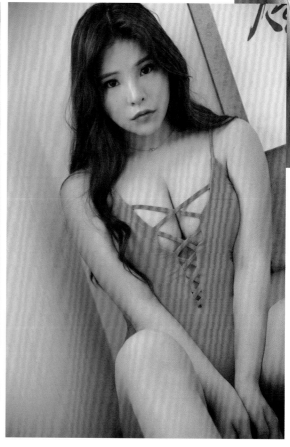

MEI GIRLS 2020

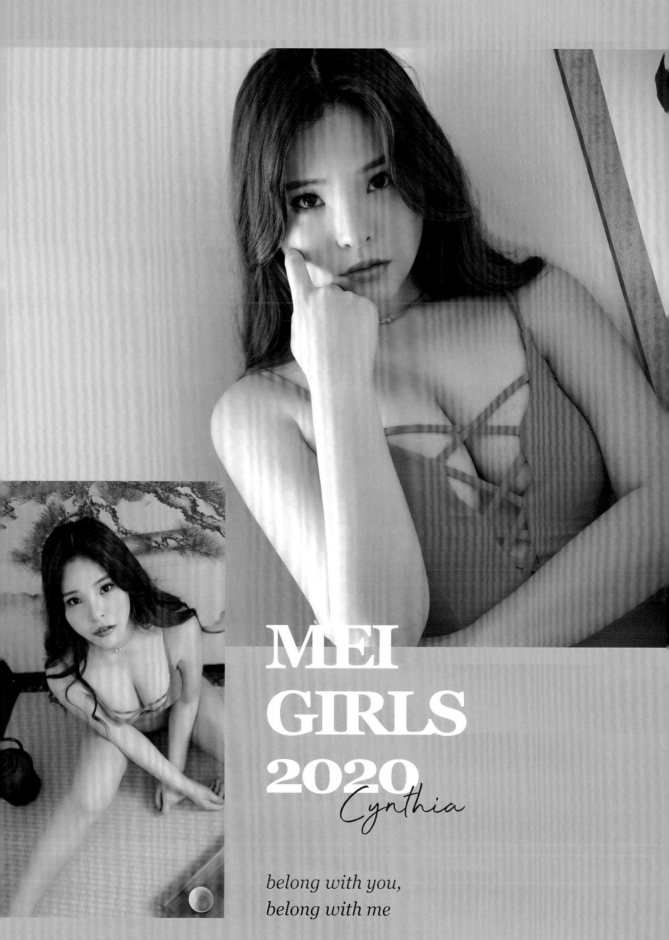

MEI
GIRLS
2020
Cynthia

belong with you,
belong with me

MEI
GIRLS
2020
Cynthia

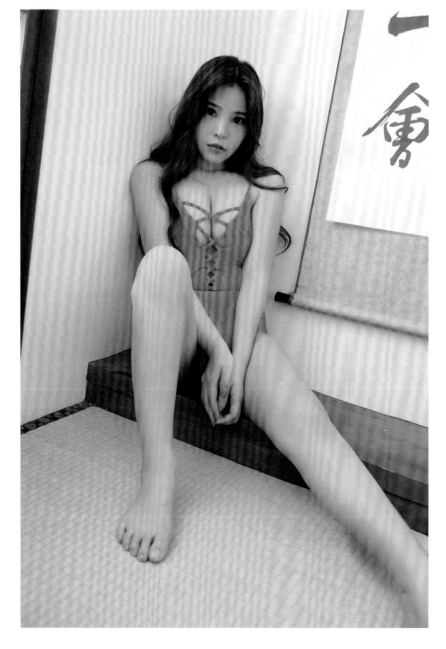

**2020 Taiwan
Top 100 Girls Album**

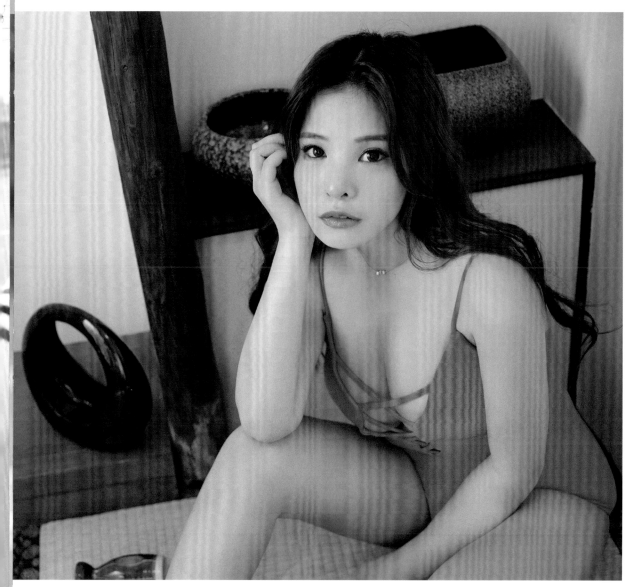

Summer
Breeze

belong with you,
belong with me

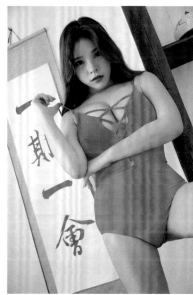

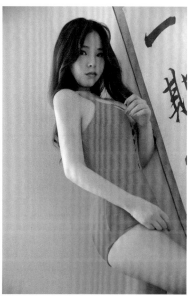

2020

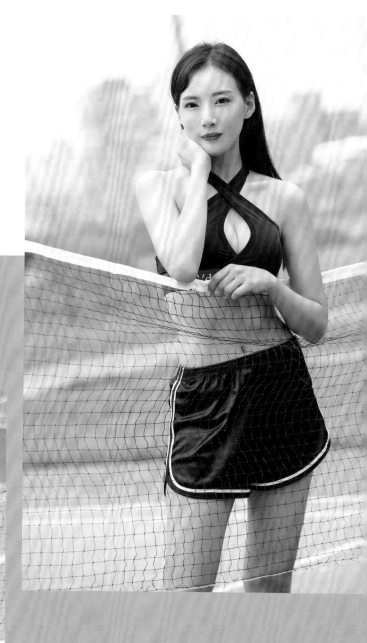

*I'm happy
when I'm with you*

-

**You are better
than
all anything**

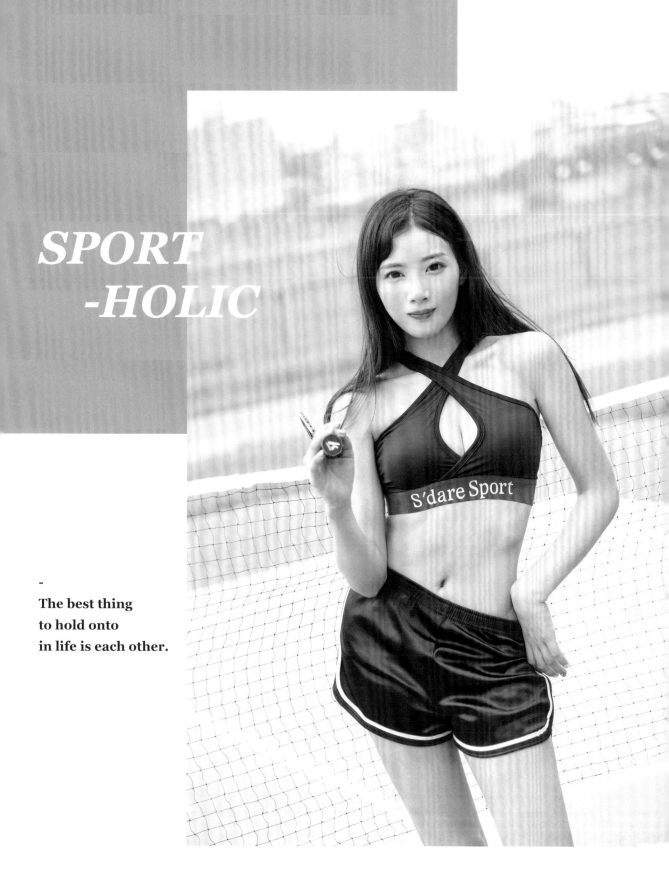

SPORT -HOLIC

-
**The best thing
to hold onto
in life is each other.**

MEI
GIRLS
×
2020

米娜

instagram ： @mw00526

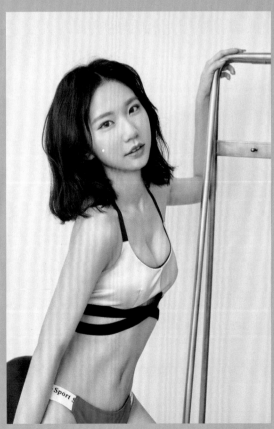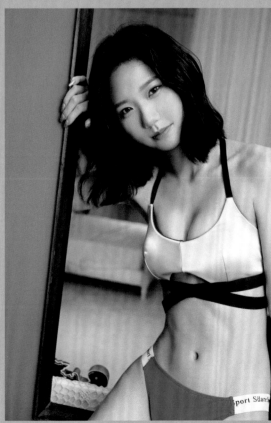

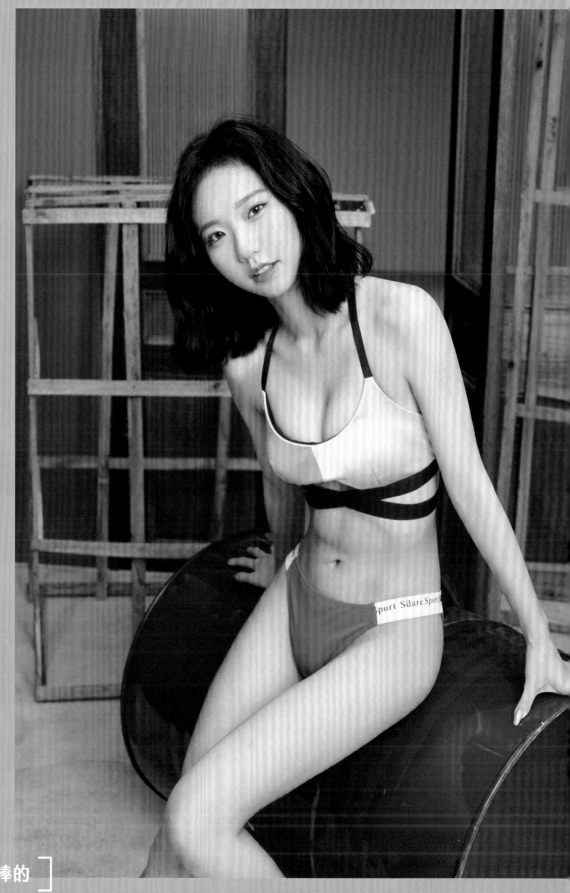

[我是最棒的]

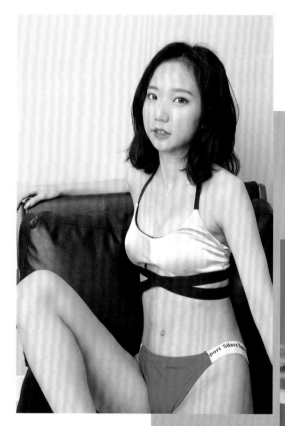

Love
Is An
Adventure

2020
Taiwan
Top 100 Girls Album

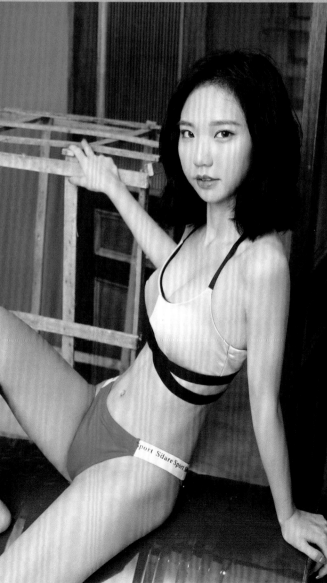

s u m m e r t i m e

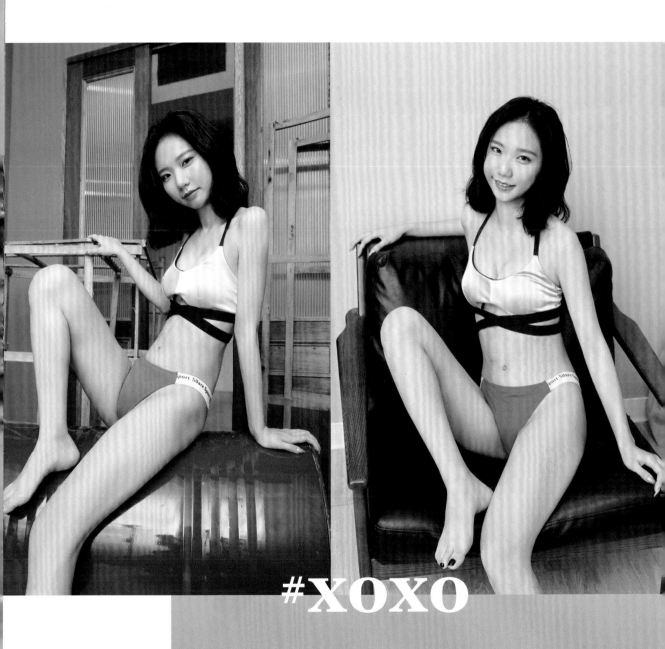

#XOXO

Staying
Here

*Find joy in the
Journey*

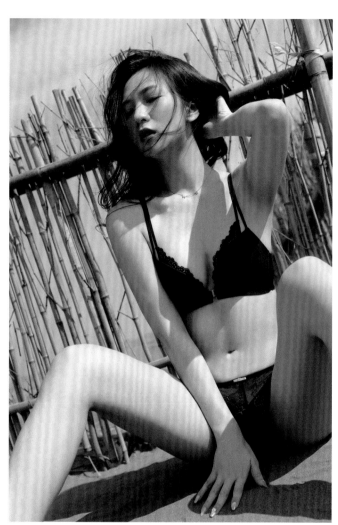

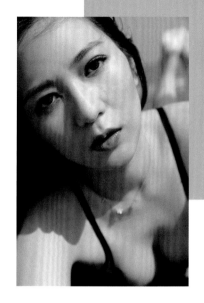

MEI
GIRLS
2020
Hannah

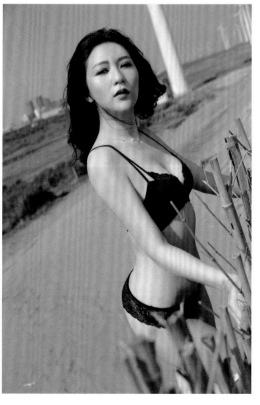

Your smile
Is a blessing

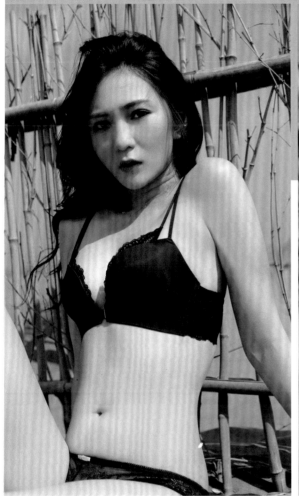
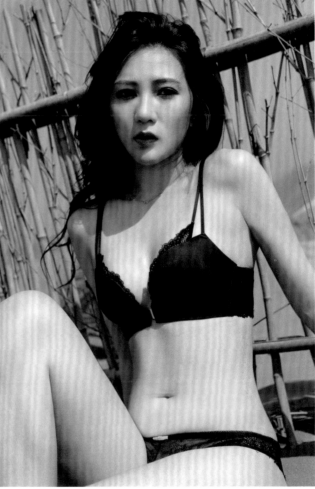

Summer
Afternoon

2
0
2
0

2020
Taiwan Top 100 Girls Album

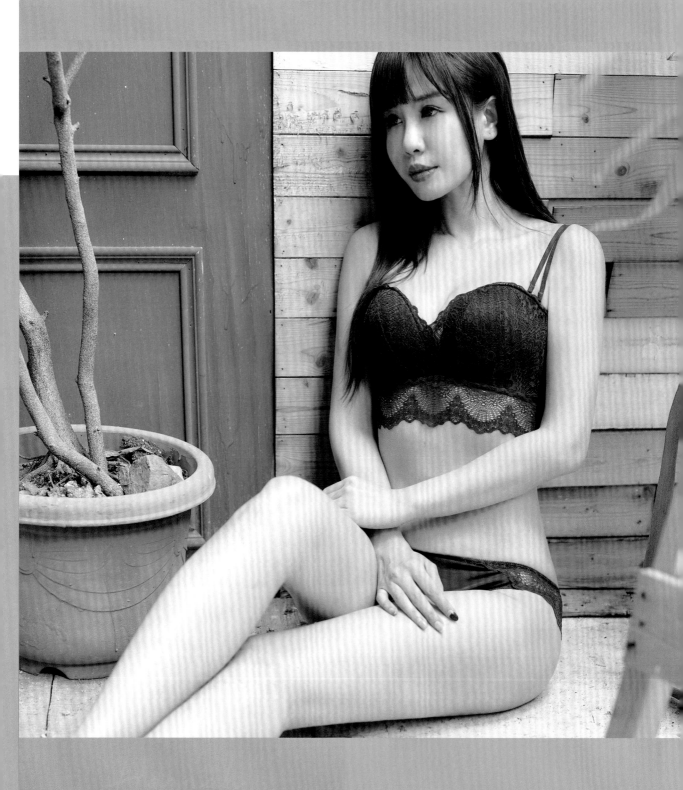

如果你的世界對你不友善，歡迎來我的世界。

MEI
GIRLS
✕
2020

雲雲
Rachel

⑃ instagram ： @rachel0531520

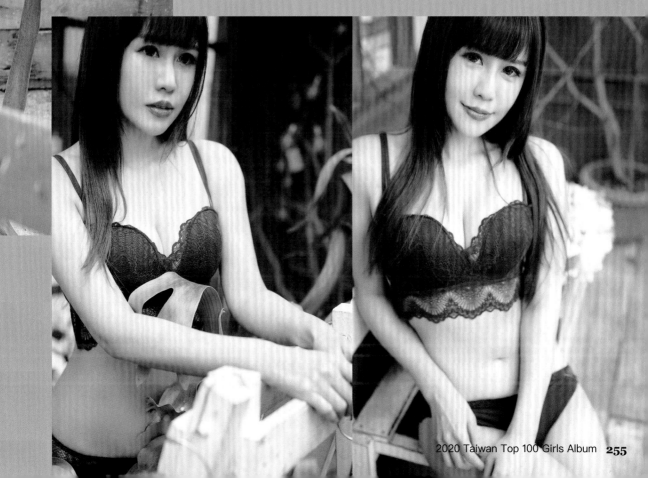

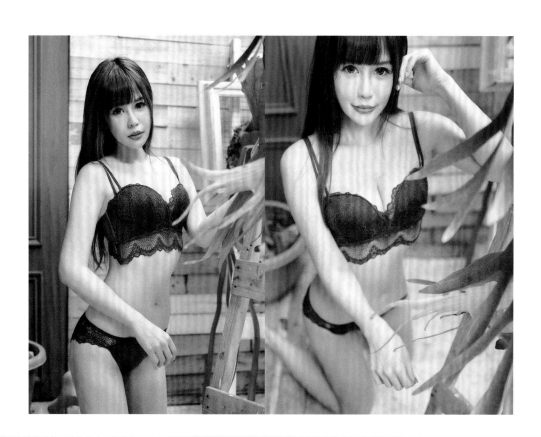

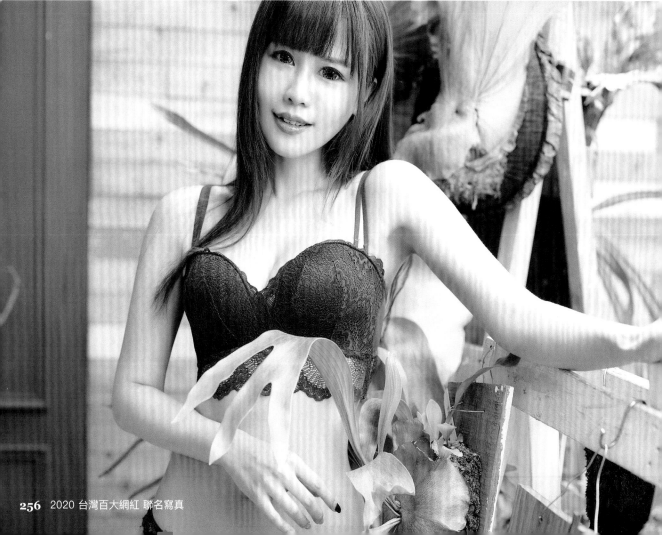

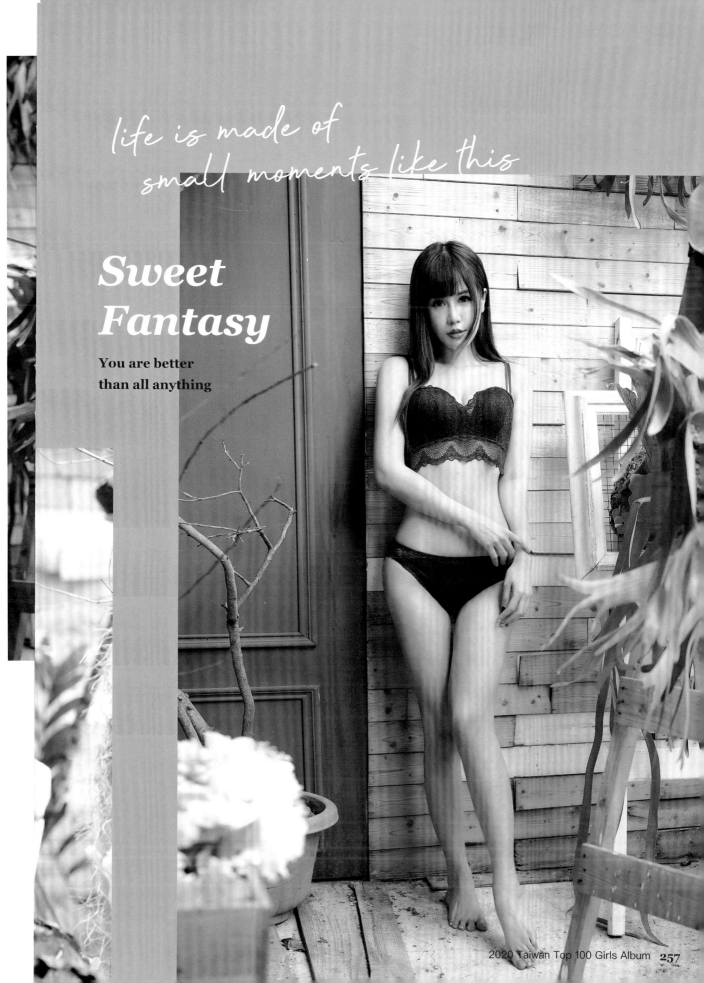

life is made of
small moments like this

Sweet
Fantasy

**You are better
than all anything**

MEI
GIRLS
✕
2020

吉寶

Keppel

📷 **instagram：@x334567002**

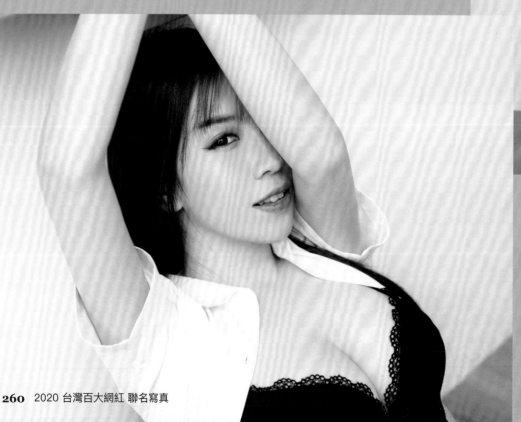

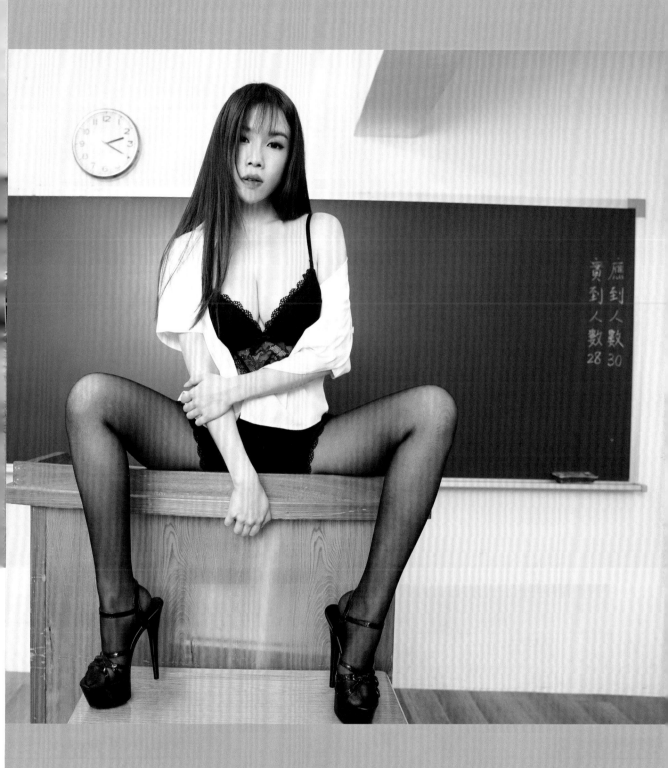

無聊的時候多想想我！ 不要浪費時間，知道嗎？

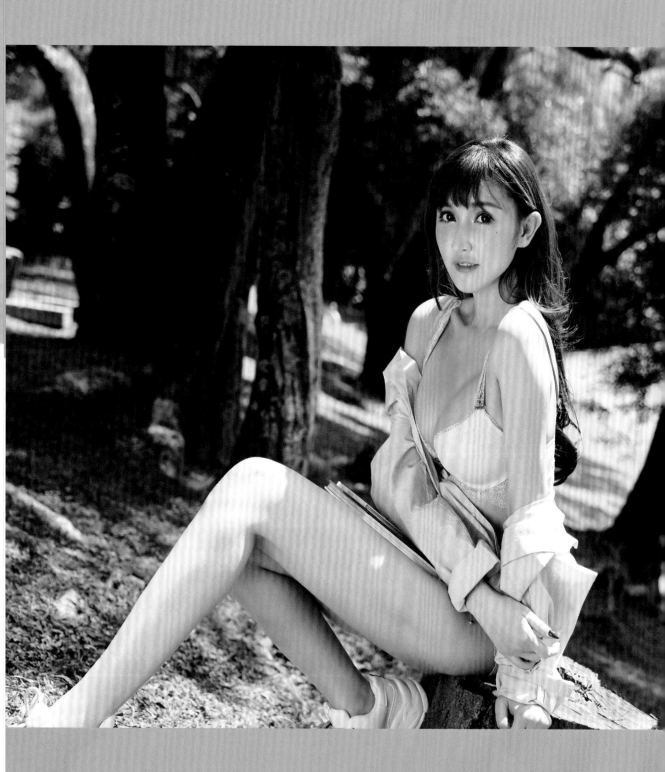

願我的微笑可以帶給你快樂

MEI
GIRLS
✕
2020

陸上美人魚
哈霓萱

📷 instagram：@gomyurnew

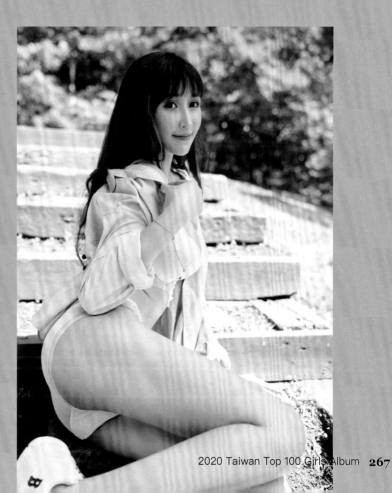

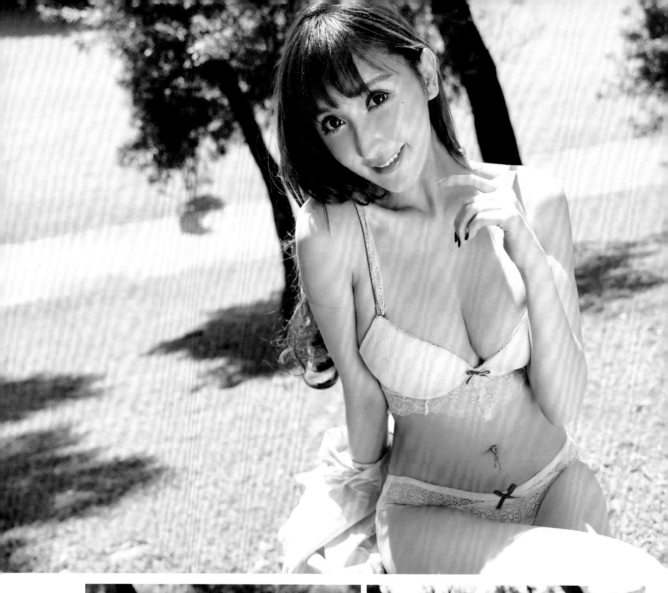

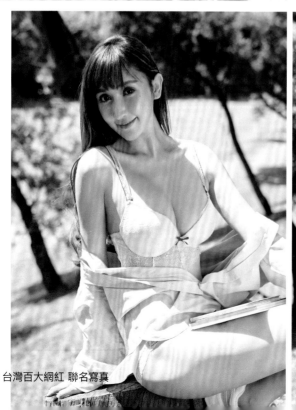

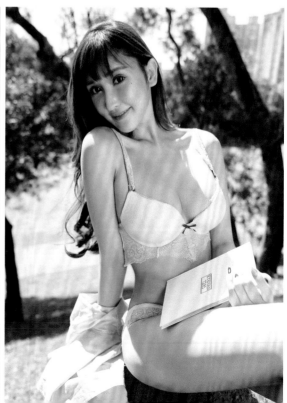

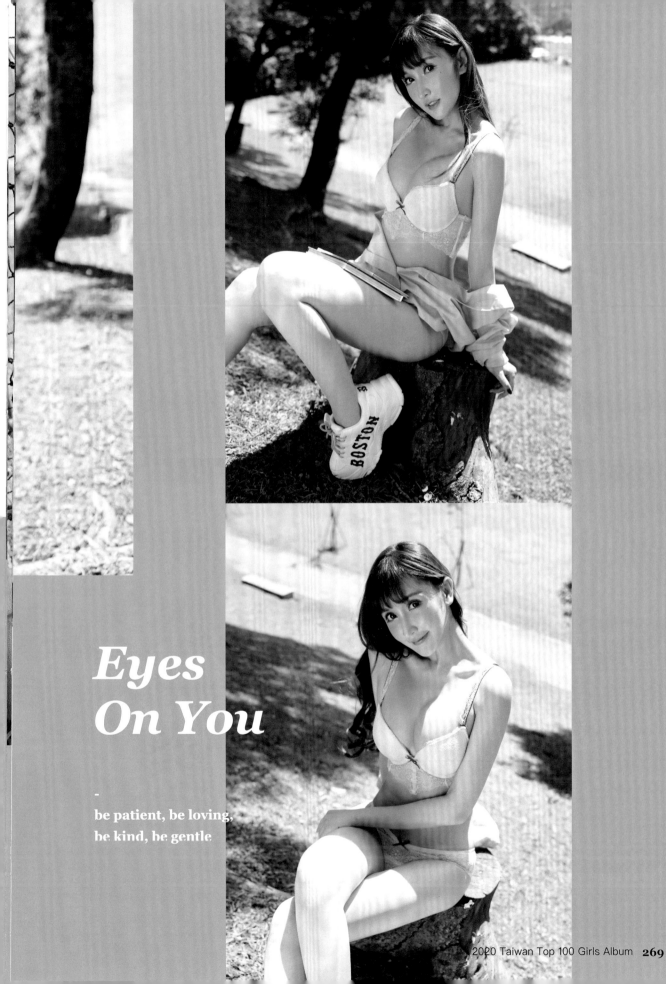

Eyes
On You

-

be patient, be loving,
be kind, be gentle

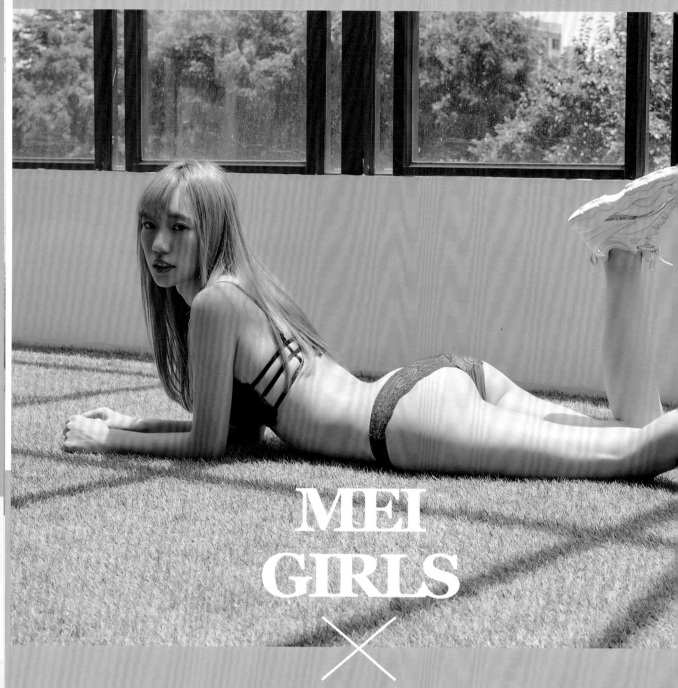

MEI
GIRLS

✕

2020

芷涵

Han

instagram：@han48oxs

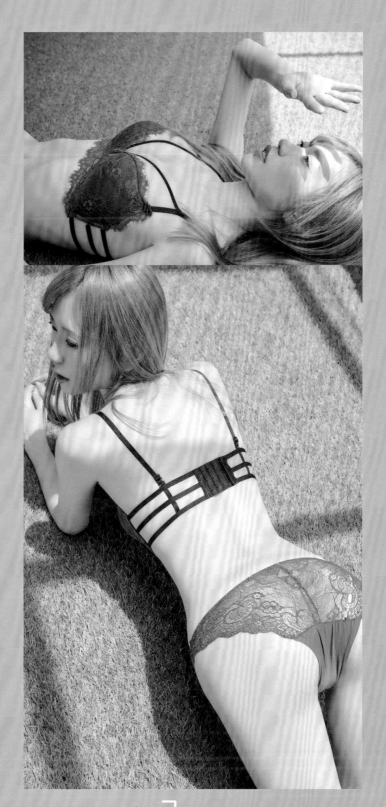

無論這個世界多麼苛刻，希望你都能偏愛我

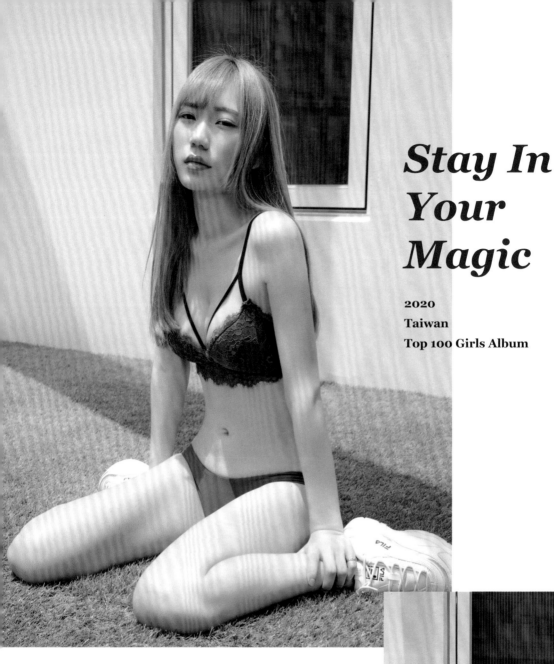

Stay In Your Magic

2020
Taiwan
Top 100 Girls Album

MEI GIRLS 2020
Han

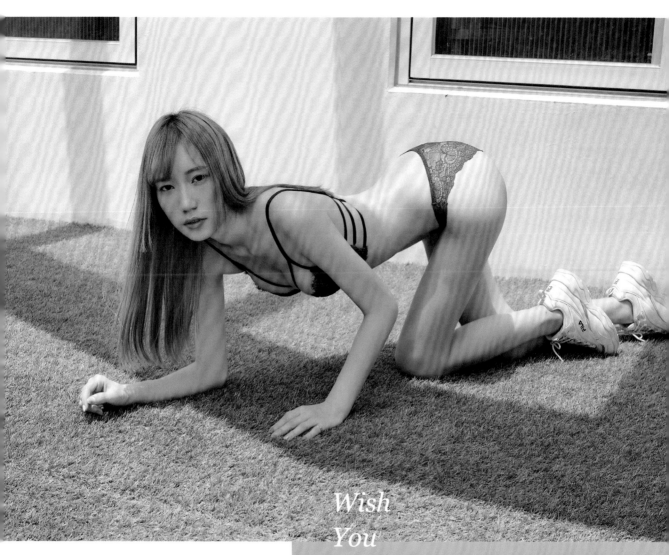

Wish
You
Were Here

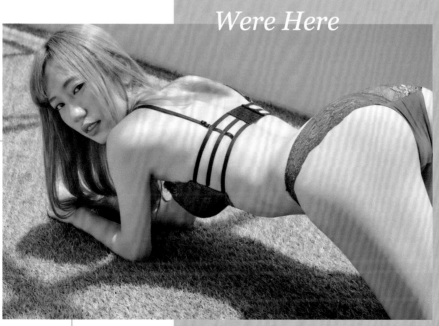

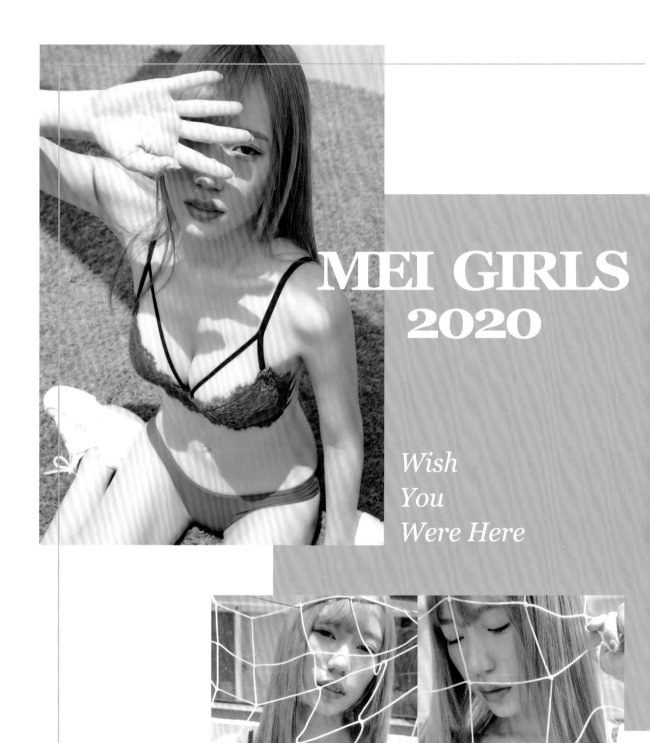

MEI GIRLS
2020

Wish
You
Were Here

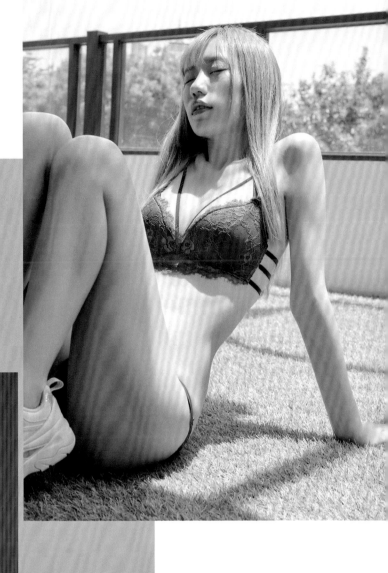

2 0 2 0

Stay In Your Magic

2020
Taiwan
Top 100 Girls Album

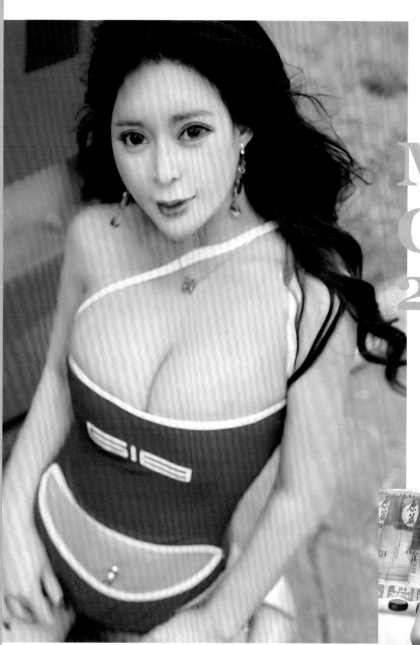

MEI
GIRLS
2020
Gina

Make
Today
Magical

2020
Taiwan
Top 100 Girls Album

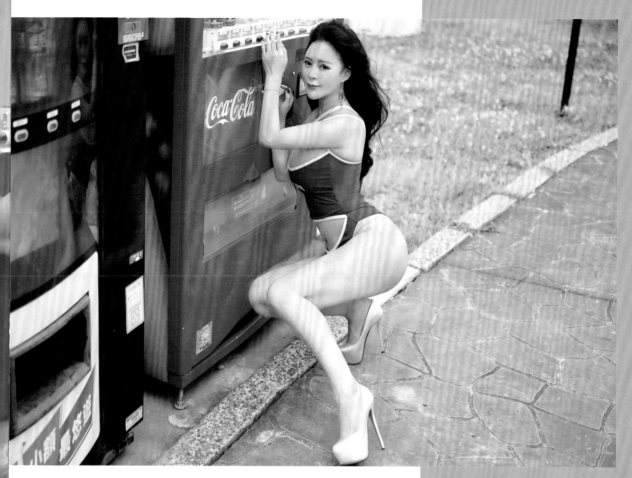

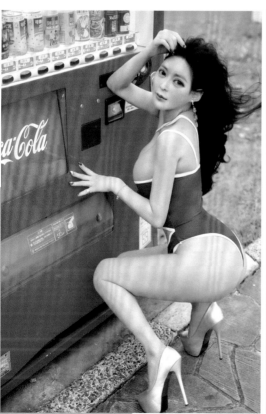

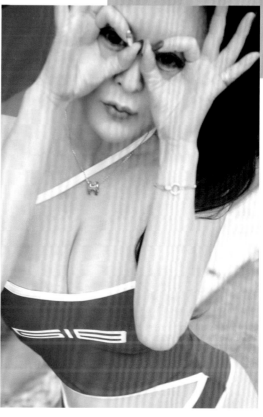

MEI GIRLS ✕ 2020

莉娜

Lena

📷 instagram：@lena12_31

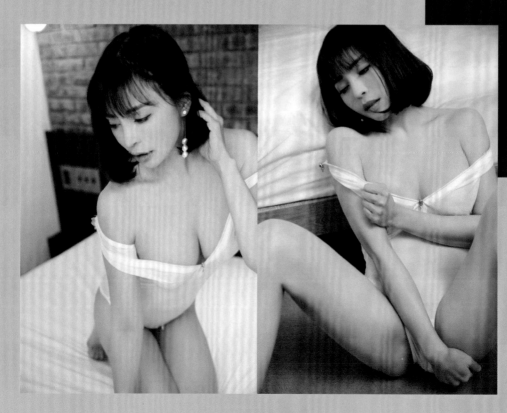

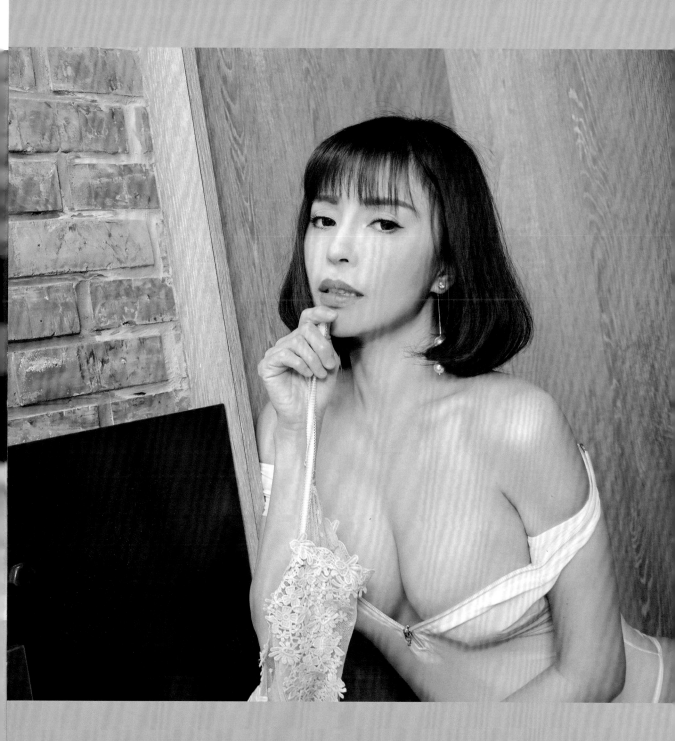

[相信自己的目標 (o^^o)
努力．努力．再努力～♥]

Wish You
Were Here

Your smile is
A blessing

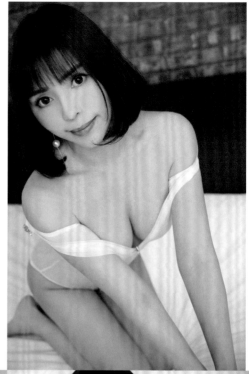

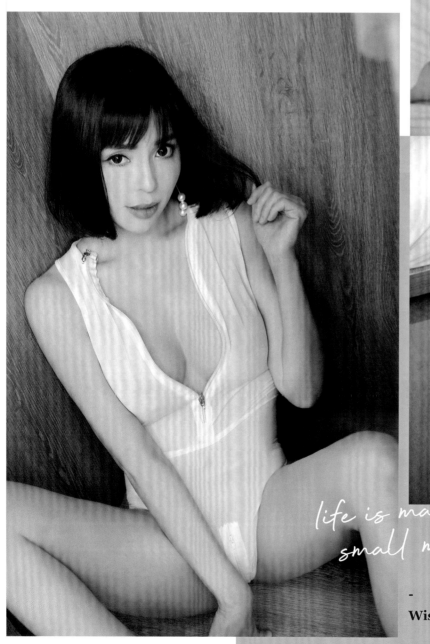

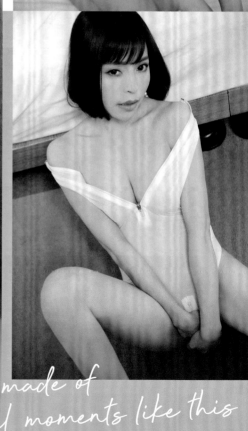

life is made of
small moments like this

-

Wish some days lasted forever.

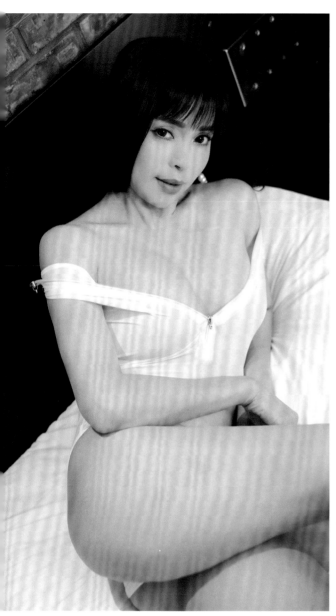

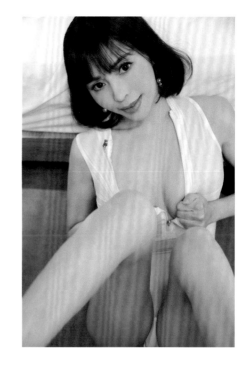

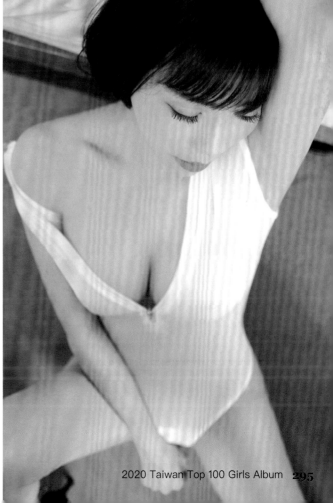

MEI
GIRLS
2020
Lena

MEI
GIRLS
✕
2020

妳米兒

Mishonna

📷 instagram : @a1793555

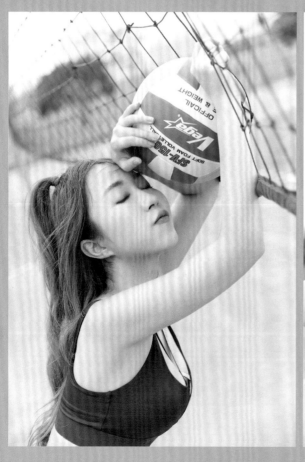
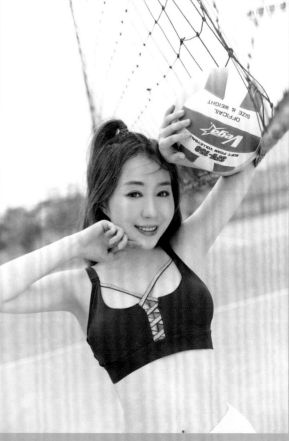

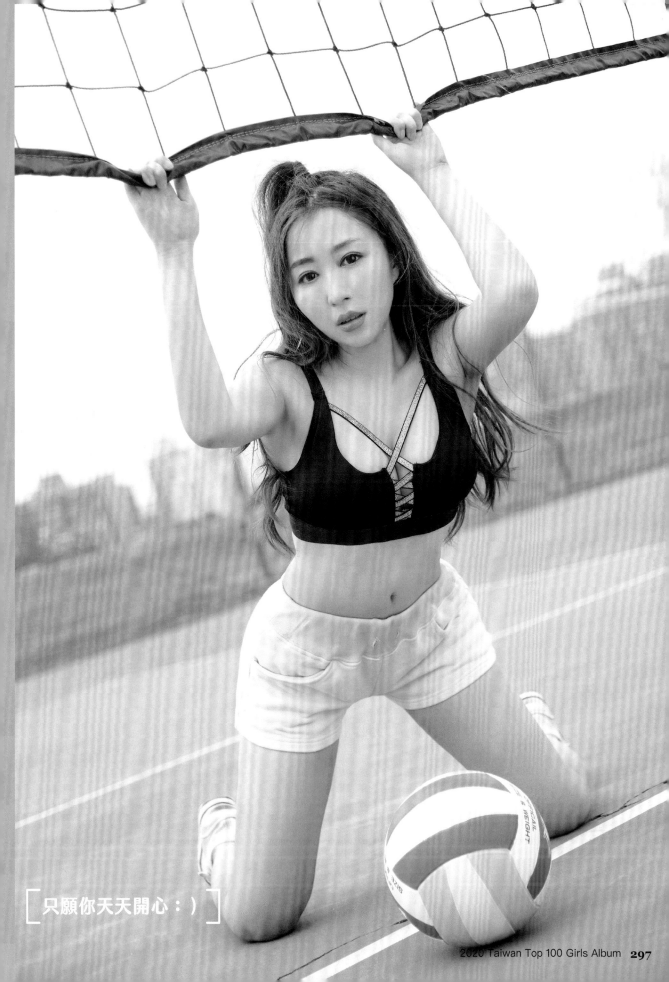

[只願你天天開心：)]

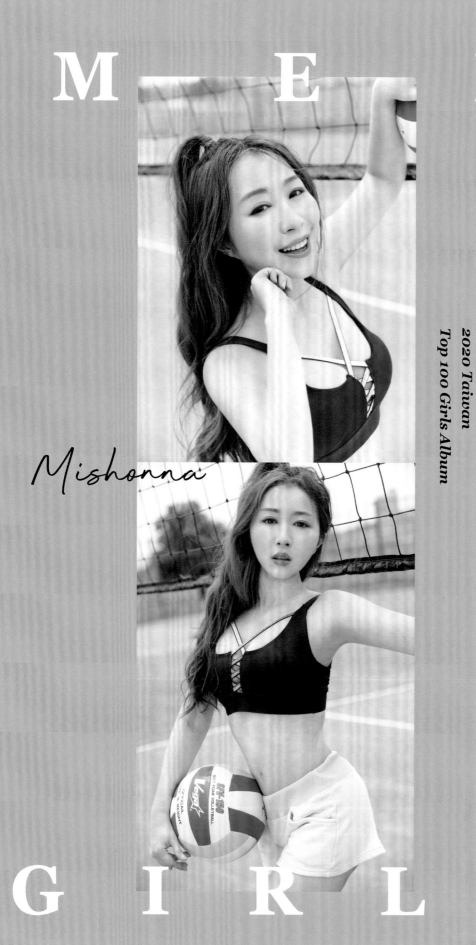

M E I S

GIRLS

Mishonna

2020 Taiwan
Top 100 Girls Album

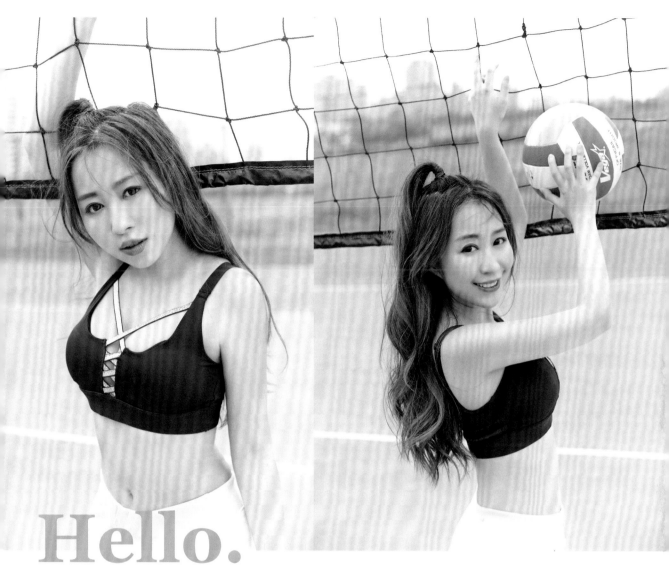

Hello.

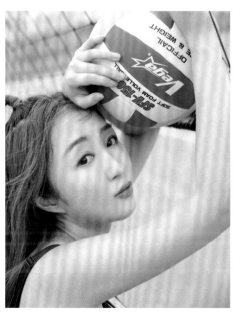

Believe
In
Yourself

Be happy
always

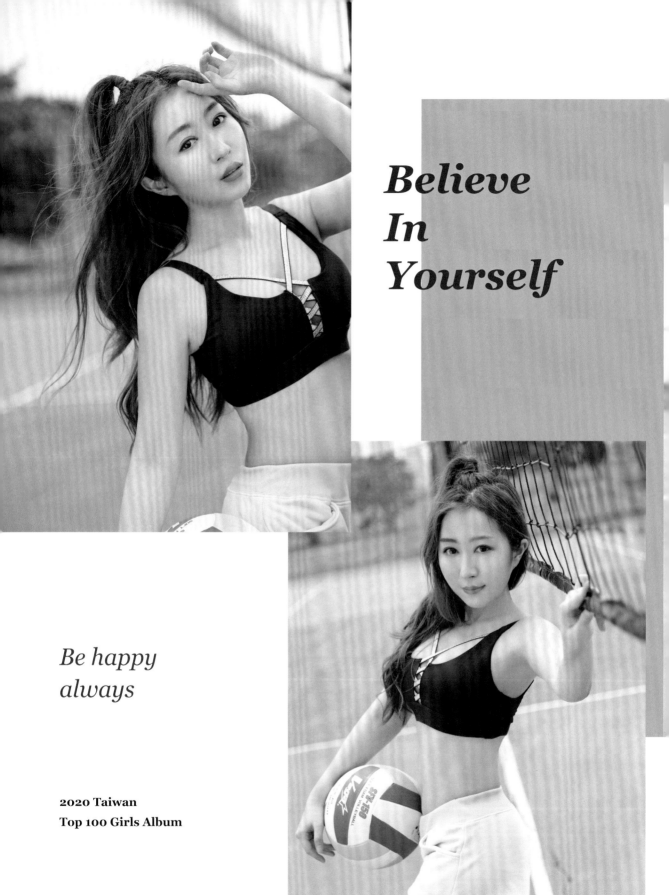

Believe
In
Yourself

Be happy
always

2020 Taiwan
Top 100 Girls Album

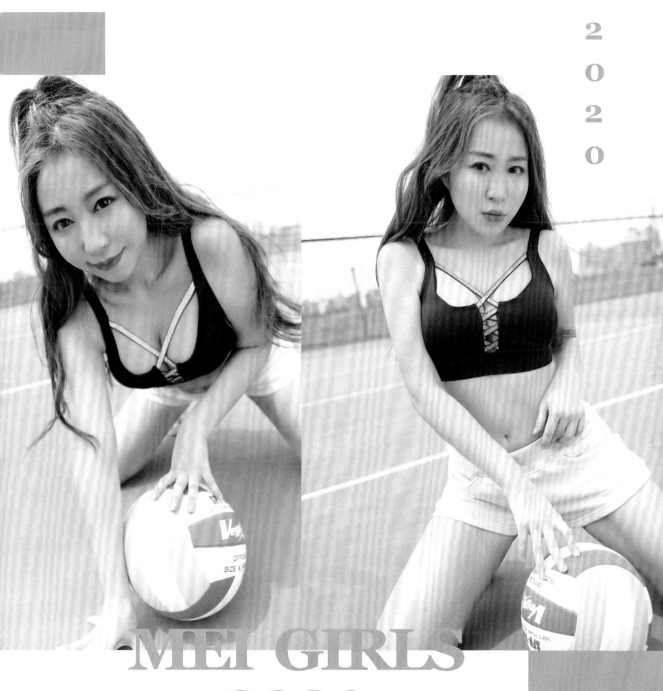

MEI GIRLS
2020
Mishonna

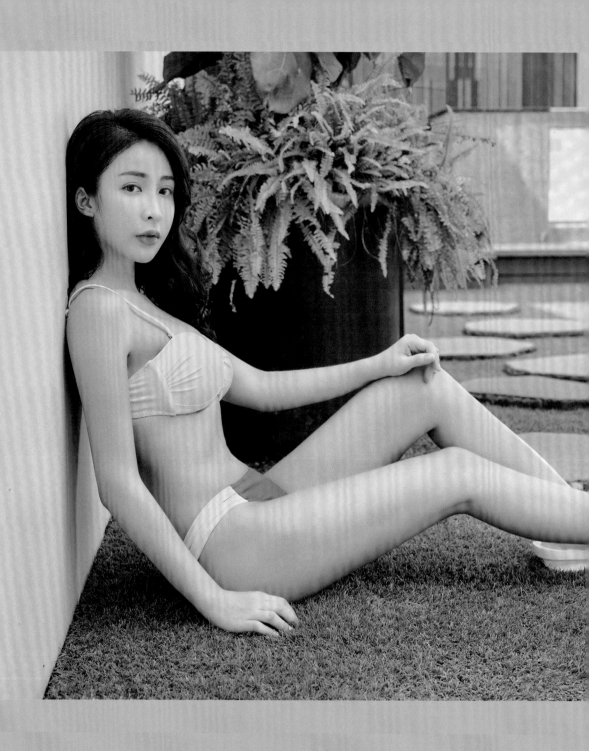

人不完美，也不需要假裝，但每天都應該盡力
做到最好，讓我們成為最好的自己。

MEI
GIRLS
✕
2020

Pony

📷 instagram : @p_on_y

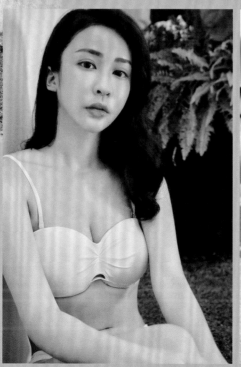

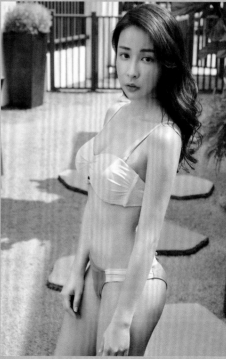

Summer
Breeze

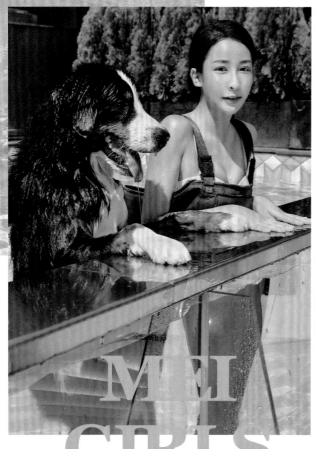

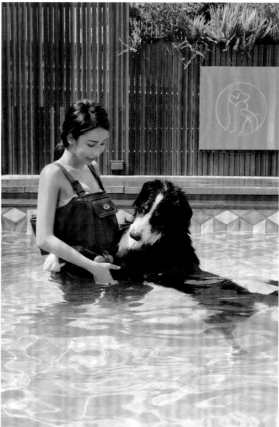

MEI
GIRLS
×
2020
Pony

2020 Taiwan
Top 100 Girls Album

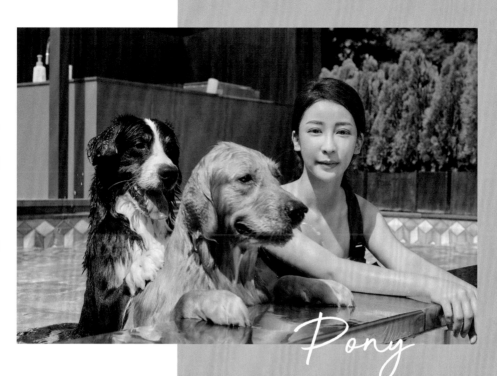

Pony

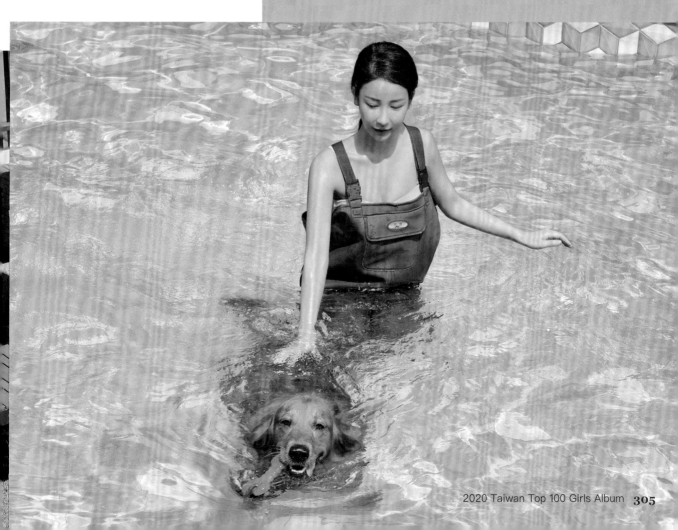

MEI
GIRLS
✕
2020

優菈
Yola

📷 instagram : @yola0703

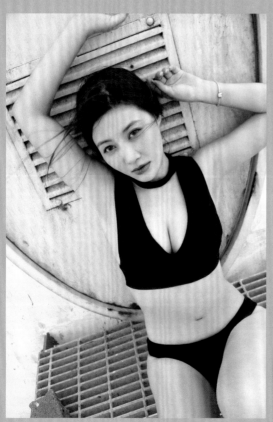
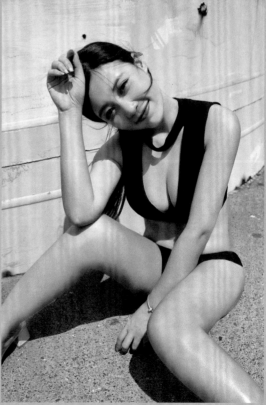

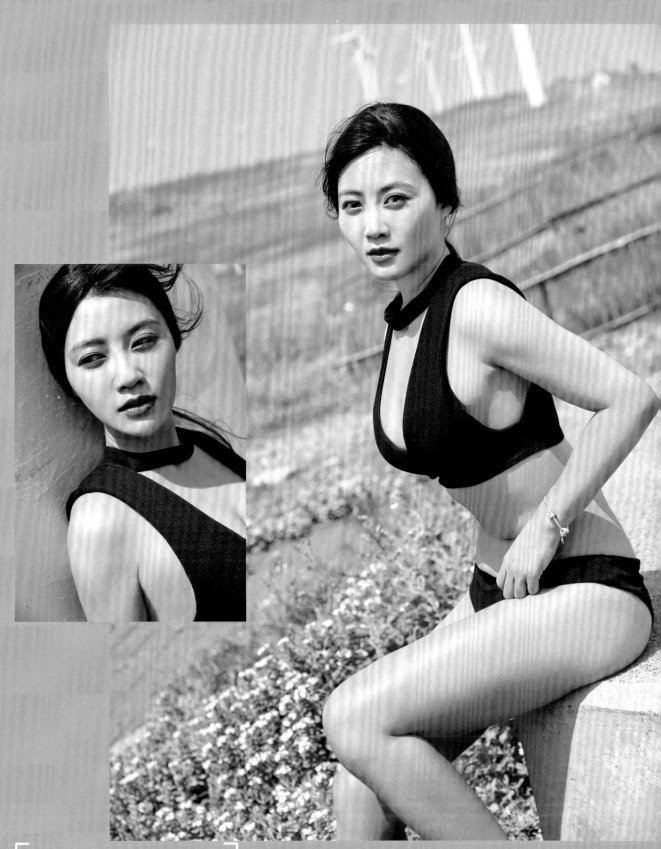

沒有你們沒有現在的我

Breezy
Summer
Day

-

**In your life my infinite
dreams live.**

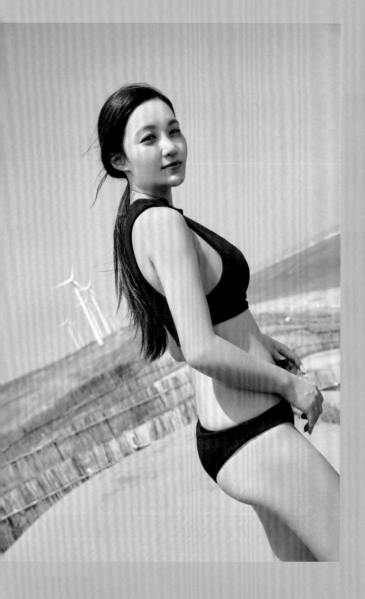

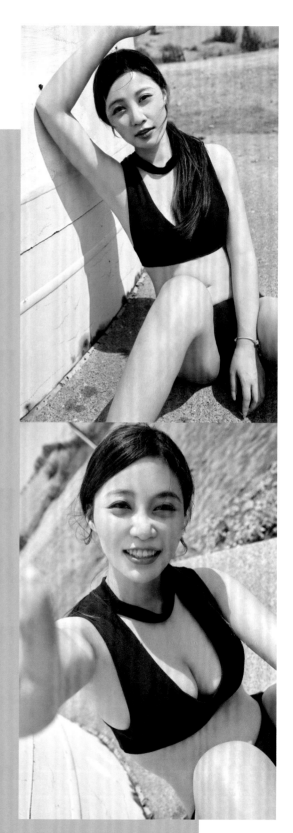

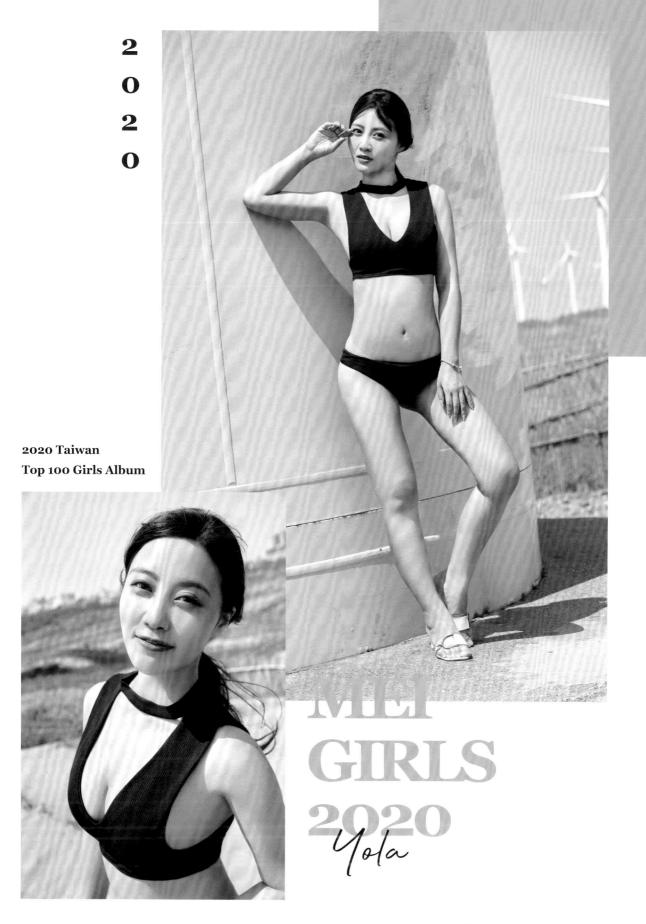

2020

2020 Taiwan
Top 100 Girls Album

MEI
GIRLS
2020
Yola

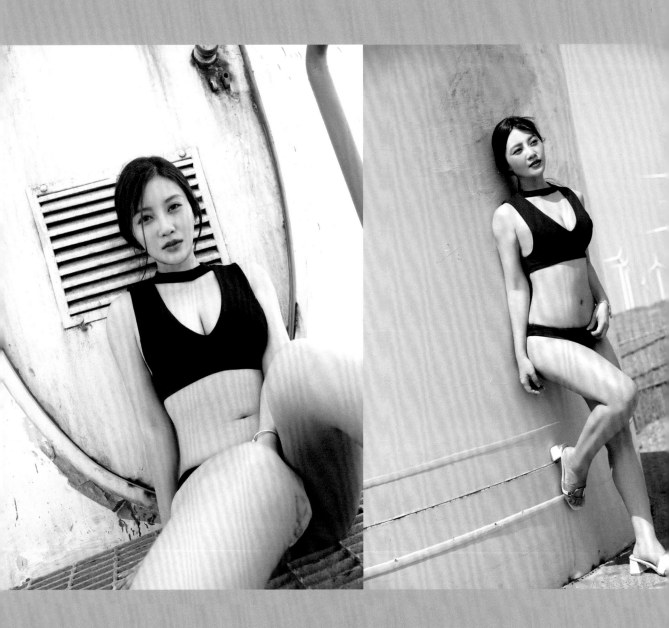

MEI GIRLS
2020
Yola

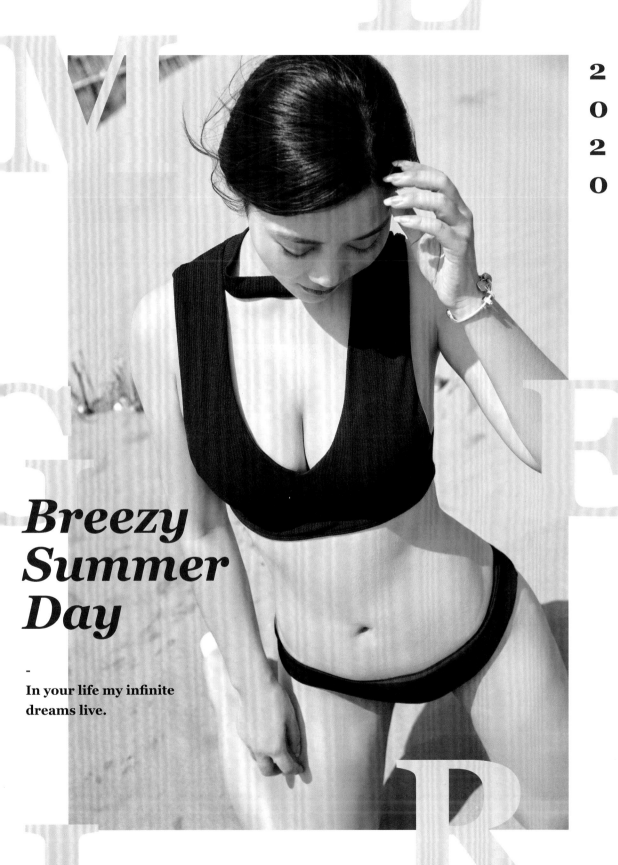

**Breezy
Summer
Day**

-

In your life my infinite
dreams live.

MEI GIRLS × 2020

Mi

instagram : @jtes4440

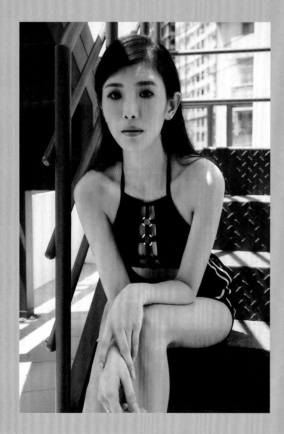

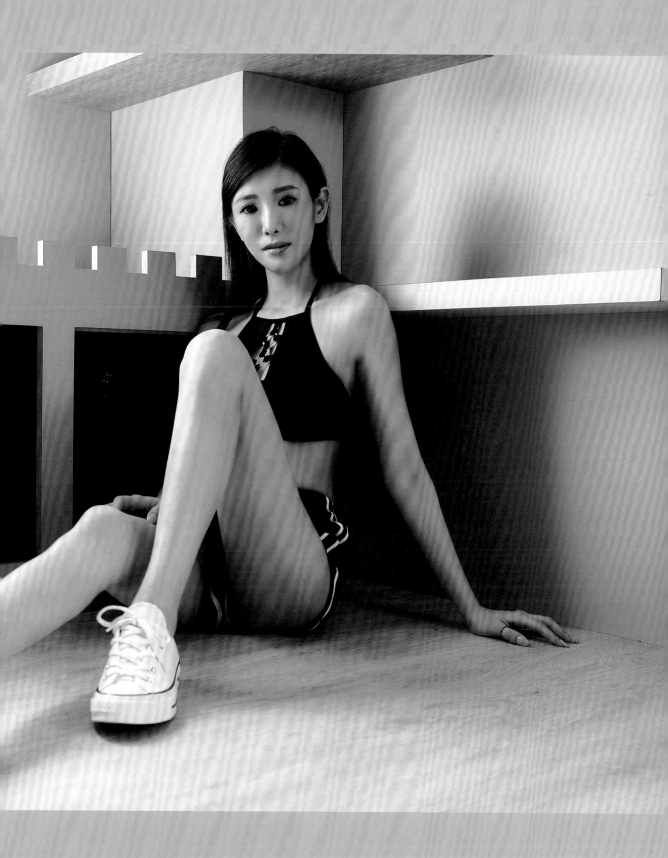

時光溫柔，需要你懂生活可愛，也要你寵。

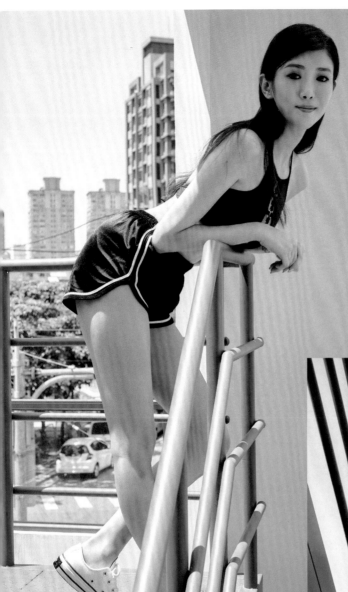

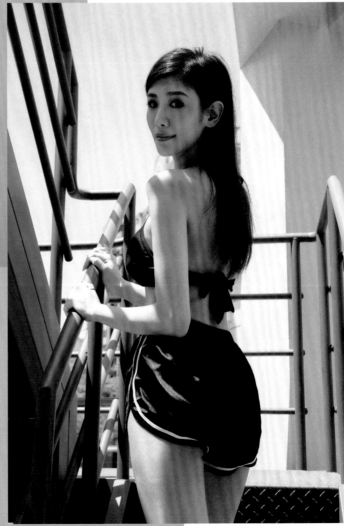

Summer

-
**You are better than
all anything**

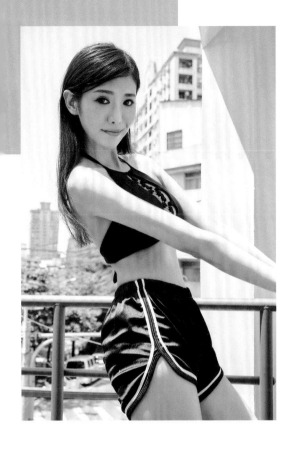

Mei Girl

Summer
Mood
For
Everyone

Mi

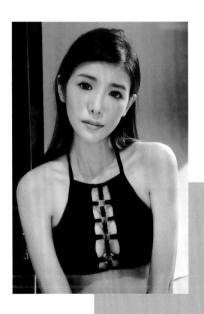

2 0 2 0

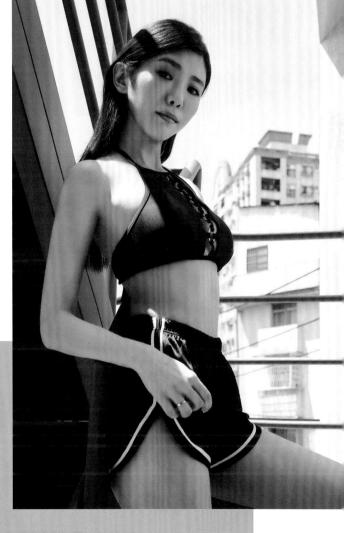

Mei Girl

Summer
Mood
For
Everyone

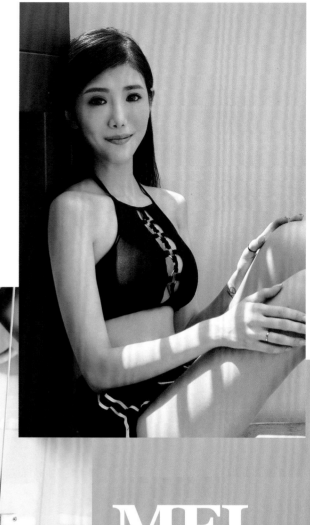

MEI
GIRLS
✕
2020
Mi

**Taiwan
Top 100 Girls Album**

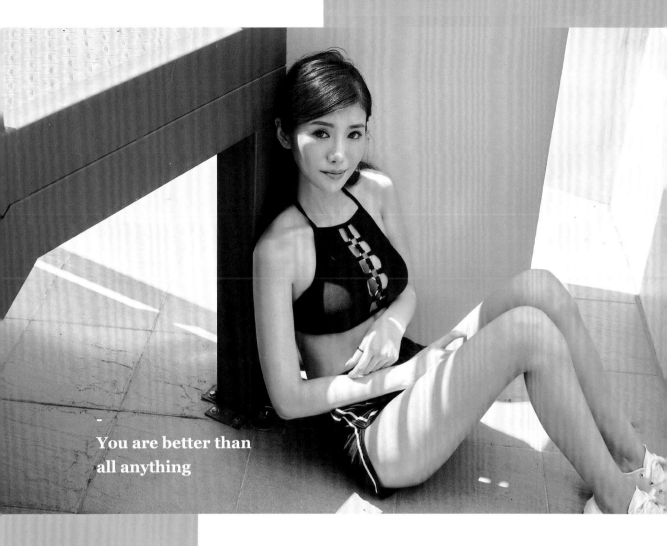

You are better than
all anything

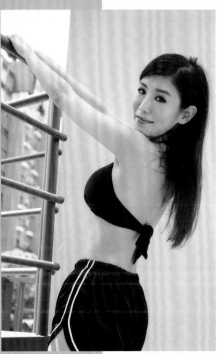

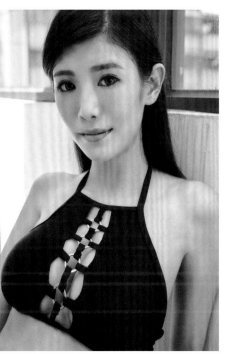

Summer

MEI
GIRLS
✕
2020

喵嗚

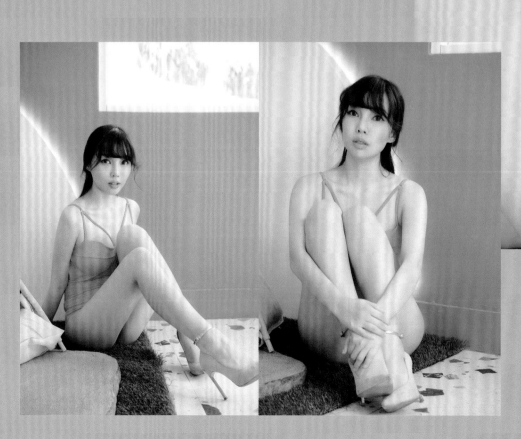

instagram：@miao.1027

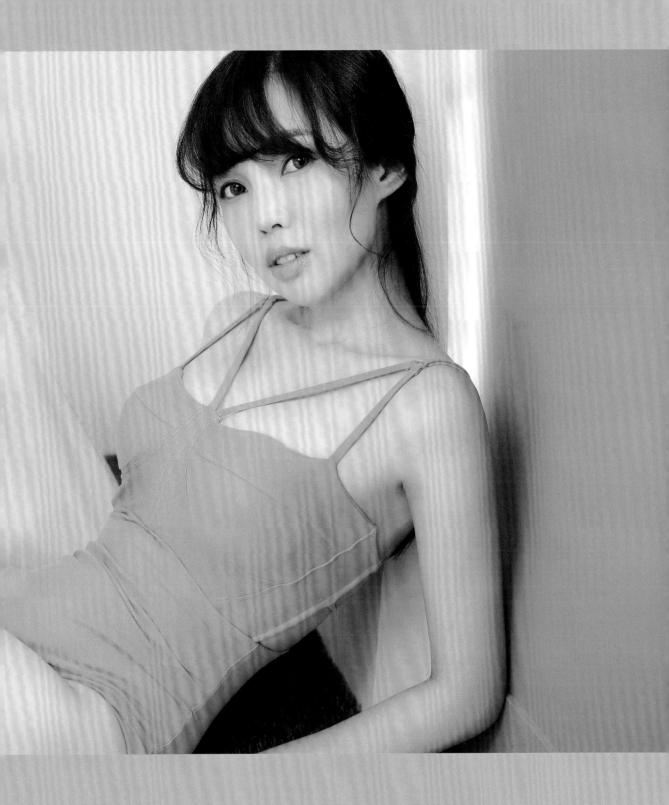

生活很苦，來看看我，我全糖的♥

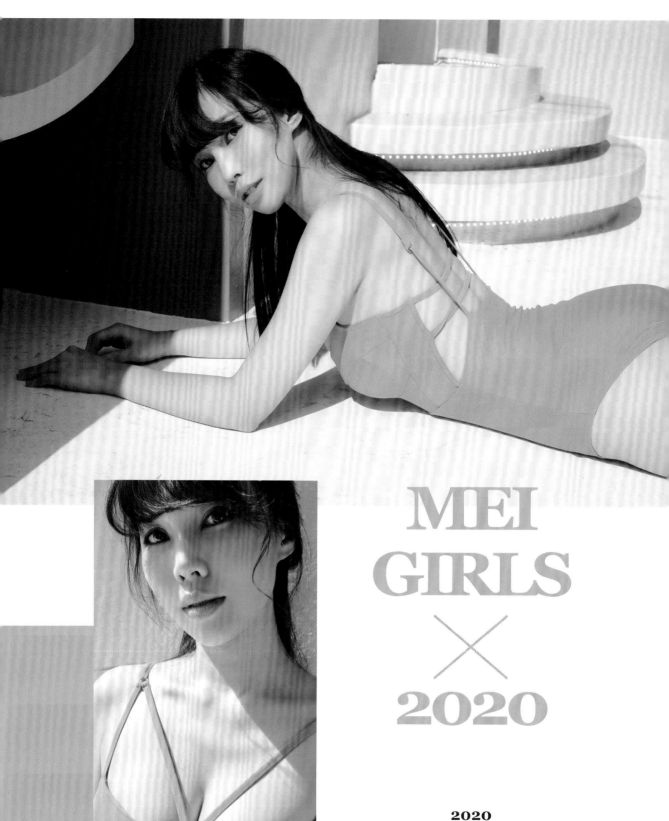

MEI
GIRLS
✕
2020

**2020
Taiwan
Top 100 Girls Album**

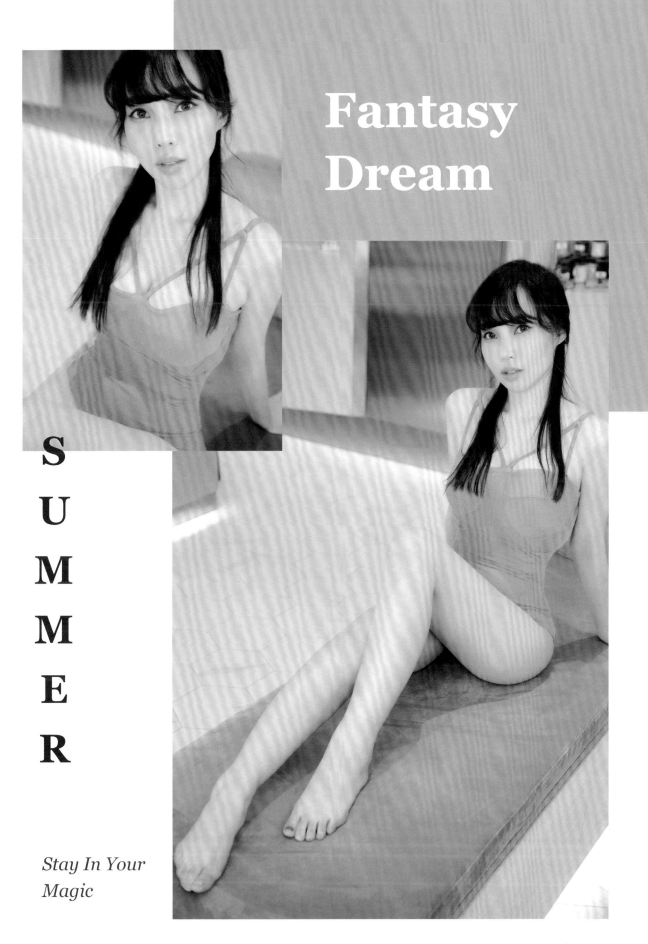

Fantasy
Dreawm

SUMMER

Stay In Your
Magic

MEI GIRLS
2020

Stay In Your
Magic

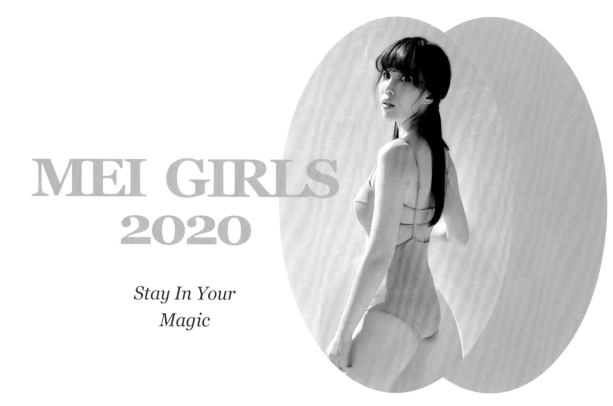

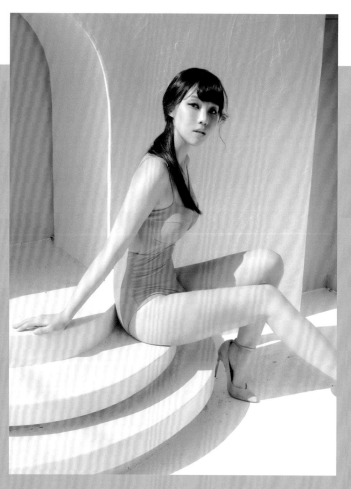

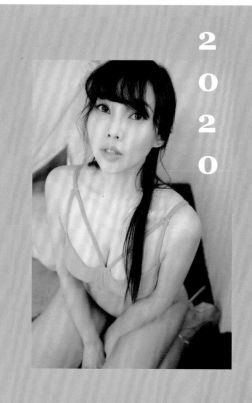

2020

Fantasy
Dream

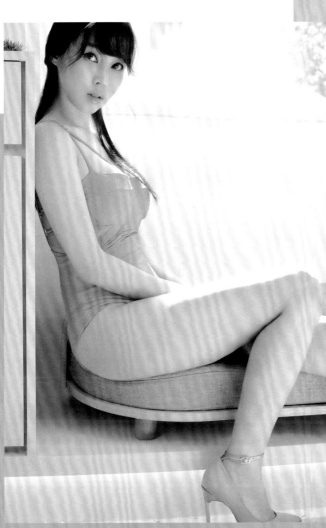

Taiwan
Top 100
Girls
Album

S
U
M
M
E
R

MEI GIRLS

✕

2020

糖小果

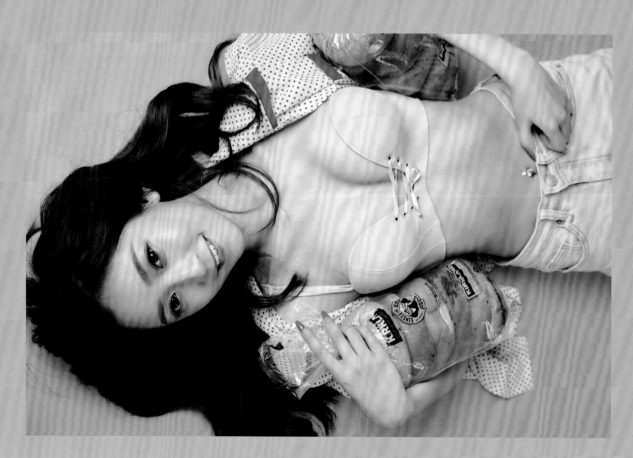

instagram：@candy_09_23

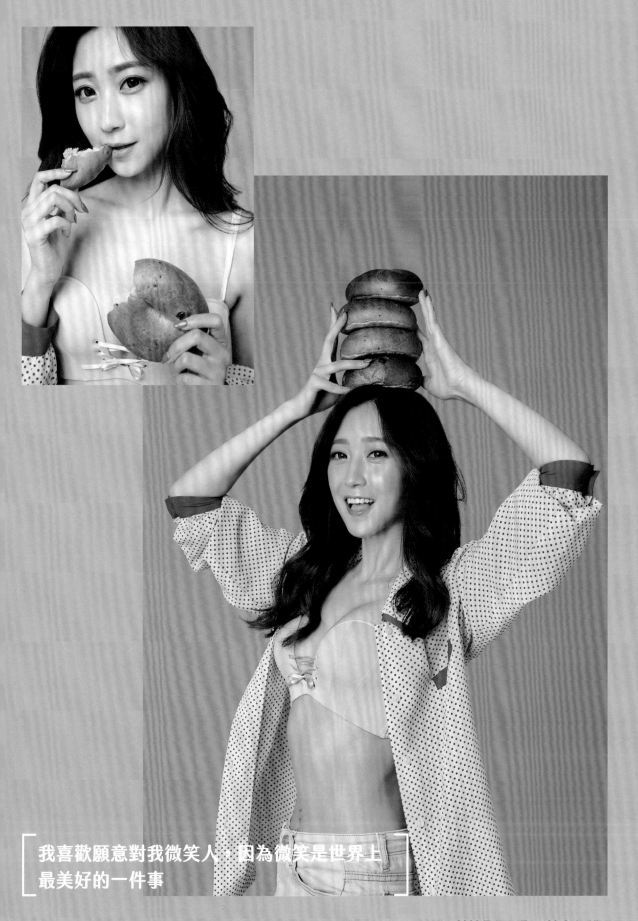

我喜歡願意對我微笑人，因為微笑是世界上
最美好的一件事

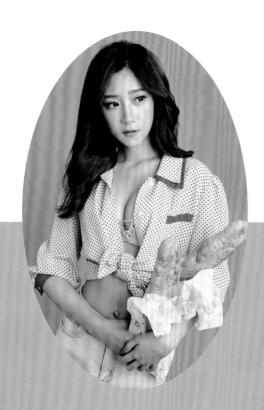

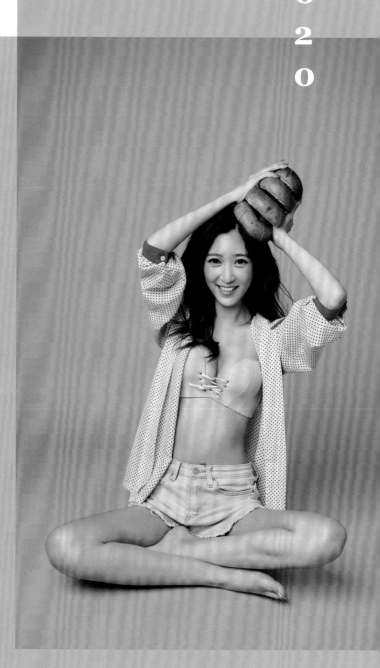

MEI
GIRLS
2020

2020
Taiwan
Top 100 Girls Album

MEI
GIRLS

✕

2020

*Life is like
a box
of
chocolates*

Life is like
a box of
chocolates

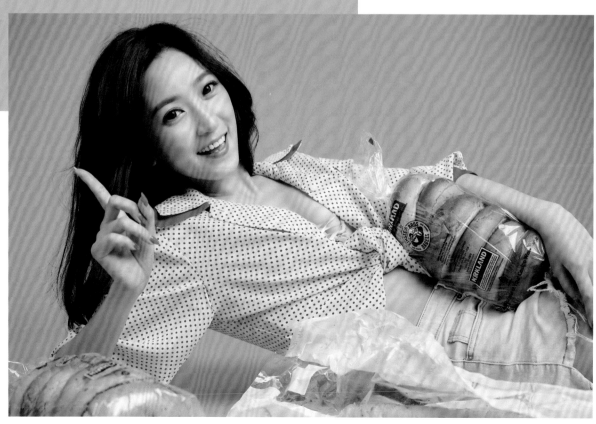

2020 台灣百大網紅 聯名寫真

MEI GIRLS
2020

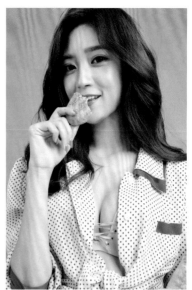

2020

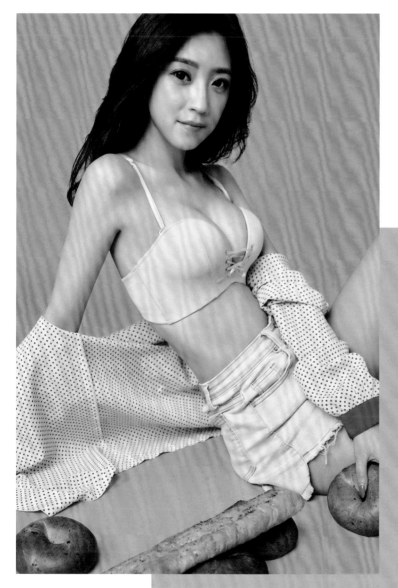

Sail
To
The Sun

2020
Taiwan
Top 100 Girls Album

媚娘兒
Mei Girls

書　　名｜2020 台灣百大網紅聯名寫真
總 編 輯｜陳豪
副 編 輯｜沈琪琪
發行單位｜名媚國際股份有限公司
企劃團隊｜紅紅數位股份有限公司
協力單位｜捷喜多媒體數位股份有限公司
　　　　　熱浪新媒體股份有限公司
攝影團隊｜Zhuo Zheng Song Photo Studio
美編設計｜B.H Studio
整體造型｜FF Fashion Styling Studio
特別感謝｜S'dare Sport
印　　數｜二冊精裝套書
出版年月｜2020 年 9 月
I S B N｜978-986-99582-0-2

定價 – 新台幣 1580 元